KU-767-028

CHRIS TOWNSEND

NEW ART
FROM LONDON

With 139 illustrations, 120 in colour

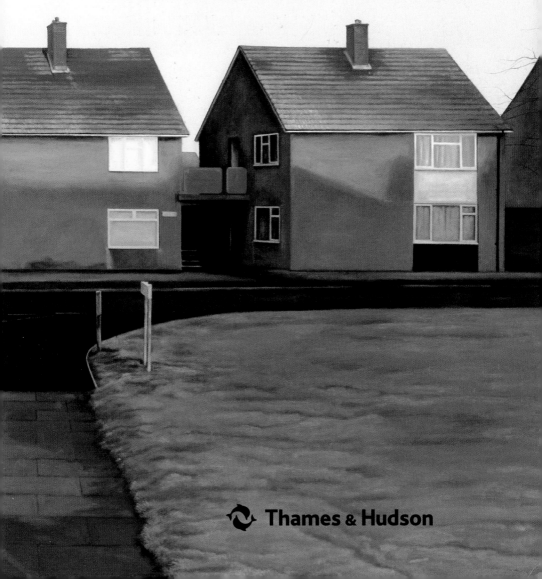

Thames & Hudson

Cover
David Burrows, *Modern Domestic Disaster*, 2002. Polyethylene foam, dimensions variable.
Courtesy f a projects, London & Frederika Taylor Gallery, New York

Frontispiece
George Shaw, *Ash Wednesday, 7.00am*, 2004–05. Humbrol enamel on board, 91 x 121 cm (35 ¾ x 47 ⅝ in).
Photo: Peter White, courtesy Wilkinson Gallery, London

Any copy of this book issued by the publisher as a paperback is sold subject to the condition that it shall not by way of trade or otherwise be lent, resold, hired out or otherwise circulated without the publisher's prior consent in any form of binding or cover other than that in which it is published and without a similar condition including these words being imposed on a subsequent purchaser.

First published in the United Kingdom in 2006 by Thames & Hudson Ltd, 181A High Holborn, London WC1V 7QX

www.thamesandhudson.com

© 2006 Chris Townsend

All Rights Reserved. No part of this publication may be reproduced or transmitted in any form or by any means, electronic or mechanical, including photocopy, recording or any other information storage and retrieval system, without prior permission in writing from the publisher.

British Library Cataloguing-in-Publication Data
A catalogue record for this book is available from the British Library

ISBN-13: 978-0-500-28606-7
ISBN-10: 0-500-28606-X

Printed and bound in Singapore by Craftprint

CONTENTS

CHAPTER ONE
BUT IS IT ART?
culture, identity & the global city
6

CHAPTER TWO
IF NOT HERE, WHERE? IF NOT NOW, WHEN?
aesthetics, history & modernity
36

CHAPTER THREE
THINGS FALL APART
video, the body & space
76

CHAPTER FOUR
WHAT LIES BENEATH
real life & the veneer of cultural economics
88

CHAPTER FIVE
SOME MARK OF INBETWEEN
landscapes, borders & identities
118

CHAPTER SIX
SIGNS MISTAKEN
FOR WONDERS
art & the critique of administered culture
150

CHAPTER SEVEN
THE END OF HISTORY
art & catastrophe
176

CHAPTER EIGHT
CONCLUSION
a new reality is better than a new movie
202

notes 213
acknowledgments 216
picture credits 217
index 221

LIVERPOOL JOHN MOORES UNIVERSITY
LEARNING SERVICES

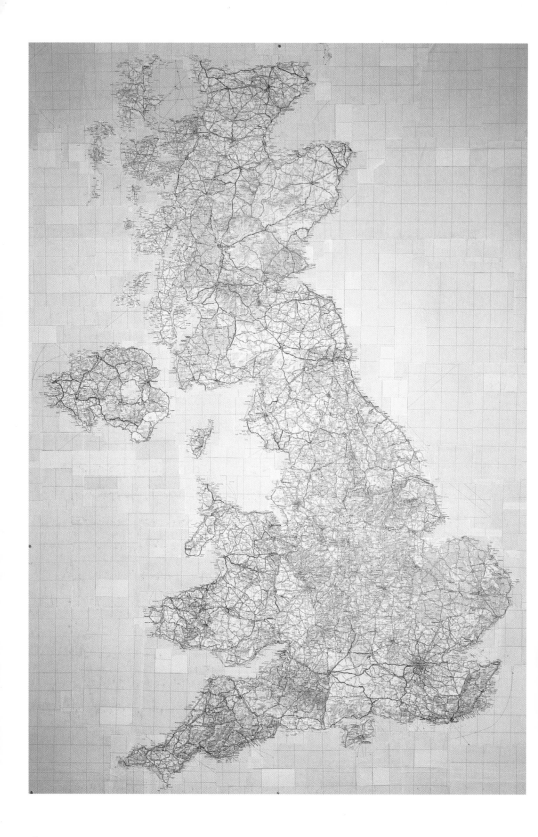

opposite **1** Layla Curtis
The United European Union,
1999, collaged EU road maps,
204 x 140 cm (80 ⅜ x 55 ⅛ in)

CHAPTER ONE

BUT IS IT ART?

culture, identity & the global city

At the junction of two of the major roads that bisect east London, within a few metres, you will find a Vietnamese grocery, an Afro-Caribbean hair-dresser, and a corner store whose TV, wall-mounted in one corner, relays one-day cricket internationals from the Indian sub-continent more or less continuously to staff and customers alike. If you use the local taxi firm it's best to carry an A to Z of the city, for its drivers are still more familiar with the streets of Istanbul and Ankara than they are with Stratford or Stoke Newington. Just around the corner, in a crumbling former factory, is a Pentecostal church whose congregation is drawn almost exclusively from the Ivory Coast; on the floor above, sharing the building, is another church, its congregation largely Nigerian. In the old warehouse opposite these industrial ecclesiasts is a network of artists' studios, one segregated from another by MDF and chipboard; quickly erected, provisional dwellings where paintings

are produced, photographs are staged, assemblages are glued or screwed together. And the next factory along – also long redundant for its original purpose and which was once also, briefly, studio spaces – is now being stripped out and marketed as 'loft style apartments' to 'media industry' types and the junior management of city banks.

In the streets you will hear spoken at the same time Urdu, Turkish, Vietnamese, Hindi and Polish. This is London, and English is just one more language around here; 'Englishness' just one element in a system of communities that do not meld into bland, contented unity, but which rather coexist and relate to each other through difference. The acknowledgment that others exist may be grudging; difference may provoke indifference, but London's culture works through a strange kind of hospitality that comes, perhaps, from the proliferation of ethnic, spiritual and national identities within it. It used to be that the capital city of a nation was peopled largely by incomers, born elsewhere in the nation. One in four of today's Londoners was born in a country other than the UK.[1] As a result, in London it is possible to see inter-racial, inter-faith, inter-cultural exchanges that could not be readily imagined in many other places (including in the rest of Britain) because its citizens have had to learn about, and cope with, each other. Like the art that emerges from it, this city is complex, difficult, multifarious: it cannot readily be encompassed in a sound bite or a facile, neatly bounded cultural product.

We are witnessing, in London, the emergence of a new and different art; it is different both from the longer tradition of British art, even as it sometimes reflects on that tradition, and from its immediate precursors in young British art (yBa). This art, partly a product of the growing internationalism of London as a city and its difference – as a region – from the rest of the UK, is also a consequence of the globalization of the art market: our new art is

simultaneously a local and an international art, rather than a national form. This book is about a selection of the most important artists currently working and/or exhibiting in London and the principal themes of their work. Mostly they are younger than the group of excellent practitioners that emerged in the late 1990s – figures such as Keith Tyson, Darren Almond, Liam Gillick or Jeremy Deller, who now figure in shortlists for the Turner Prize and are often described as being a new generation. Though some of the artists featured here are in their forties, and were around before or during the extraordinary hiatus that the British art world witnessed in the early 1990s, most are in their early to mid-thirties, and a few are barely out of college. It's also worth observing that for the purposes of this book, whether cultural or economic, London casts a wide shadow, as it does in the world: not all of the artists featured here live within the city, or even have their studios there – for all, however, London is the principal city where they show their work.

This book is concerned, then, with a group of mostly young artists, beginning to achieve national and international recognition and find their way with their work. These artists are emphatically not a movement – they sometimes move in completely different networks of friendship and were not necessarily aware of each other's work. This book observes these artists, now and in this place, doing original, challenging and exciting things with art; but it is not a manifesto on their behalf. The difference between these artists' practices and what has gone on in British art in the last twenty years, and the relevance of this art to the world in which we live, makes it an art worthy of our critical attention today. Indeed, the demand for critical attention might be said to be one of the more distinguishing features of this art. Accompanying this is a new seriousness about both the personal practice of making art and the content of the work itself.

LIVERPOOL JOHN MOORES UNIVERSITY
LEARNING SERVICES

How, in general, can we characterize this new art from London? It is an art of complexity, like the city that provides its context and its most common exhibition space. It is an art of the boundary and fluidity, an art that charts new relationships of personal and cultural identity. It is a subversive art: one that satirizes and parodies an over-controlled, over-administered 'society of the secretariat'. It is largely an art of attention, which works against the tendencies of the culture industry to reduce 'difficulty' to 'pap'. It is an art that demands not only that we concentrate upon our own thoughts, but acknowledge, however grudgingly, the existence of others. It is an art that is responsible to history, both in trying to understand how we got here and map where we are now; an art that imagines an autonomy for itself in that relationship and that responsibility. It is an art, therefore, that is not likely to prove 'popular', since at best it resists or at least avoids the phoney enchantments of the culture industry, and perhaps reflects a wider tendency of art in recent years to retreat from the myth of accessibility. It is, perhaps, an art that self-consciously refuses such populism, because the artists who make it have learned enough, from watching the trajectory of older artists' willing assimilation to mass culture, to reassert that art is a superior category of experience and one which can critique historical experience rather than simply being a product of it. It is an art of intellect, of thought and an art of sincerity – even when it's being self-consciously insincere: a significant distinction from the throw-away approach of most artists in the last twenty years, and also from a wider culture where insincere 'wit' can often pass for commentary and acuity.

London is always at least two things at once: it is now an amazingly diverse, cosmopolitan, global city. Indeed, it is as much a point within a network of other, similar cities as it as the capital of Britain. But, as the thinker Bruno

Latour observes, 'the words "local" and "global" offer points of view on networks that are by nature neither local nor global, but are more or less connected', so that 'even a long network remains local at all points'.[2] Simultaneously national and global, London is increasingly different from the rest of the nation it occupies, and in that difference it provokes important questions about ideas of national identity. And if artists live and work in a city that is intimately connected to the whole world, it is nonetheless a city where naked blight conjoins with aesthetic makeovers to paste a disguising veneer over economic monstrosity and exploitation. If London is now as much a metropolis within an international network of global capitals as it is part of a nation with easily marked, stable boundaries, we also need to understand that aspects of new art from London are 'new' because the identity of London and 'Londoners' is increasingly different from the rest of Britain and from being 'British'. If you identify yourself as a Londoner you are no longer simply identifying yourself as being British or English, but rather as part of a more localized and more globalized community. The chances are that your identity is to some extent fractured, fluid and inchoate. Your sense of location is negotiated by relationships and debts to other places that are not always within the same state or even the same continent, but only a few hours away by plane; instantaneously reached by phone, email and money transfer. This fluidity has vital consequences for culture. London was once synonymous with British art: even when its most prominent practitioners were living and working in St Ives, London remained the locus of the national art scene. Now it may be that the relationship is less closely bound than it has ever been before and we have to rethink ideas of what, if anything, a 'national' art might be. Like the citizens of the city, contemporary art from London is connected to a global economy and to global and local networks of affinity and friendship.

Since the early 1990s, visual culture in London has been transformed: the city has become a major international centre for the making and consuming of art, graced by new museum projects and a plethora of commercial galleries dedicated to contemporary work. In the mid-1980s there were perhaps twenty galleries that dealt principally in work by living artists; now there are more than two hundred. The community of artists within the city has grown exponentially, inflated by both home-grown and international talents, and by the 'industrialization' of both art's teaching and marketing. The junction in Hackney I described earlier is somewhere near the spatial and spiritual heart of the London art world. A recent estimate put the number of artists in east London, living and working within a few miles of this spot, at ten thousand.[3] I'd guess that most artists in that number are less than thirty-five years old. That itself is a significant sign of change; a mark of the almost industrial scale of graduate production from Britain's art colleges in the last decade. In the 1970s and 1980s 'young' artists were often aged somewhere between forty and fifty and there weren't too many of them: few could reasonably expect to have a solo show with a gallery before they were forty and so most supported themselves through regular teaching in art colleges. Many of today's ten thousand artists will teach occasionally, but most sustain themselves with the hope that they will have, soon, a successful commercial exhibition. Many, though not all, share the psychic and financial investment that preferably before they turn thirty, however unlikely, they will sell enough work to support themselves as professional artists. In the 1990s, London developed a taste for contemporary art – made most obviously manifest in the monolith that is Tate Modern; it got an audience, it got galleries to sell the work, and it got a steady stream of eager young artists who believed they could work within that system. Art in London used to be a localized cottage industry; now

it participates in a global economy – even when its artists challenge the larger structures within which that economy operates.

Many of the most interesting artists now living and working in london are not 'British'. London's sense of critical regionalism stems in part from the capacity of its artists to communicate that fundamental modernist experience of being alienated in one's own space and seeing it differently, as if for the first time, and in spite of one's own participation in global capital's homogenization of space and time. Those best placed to see the shifts in identity that are occurring are often those who look on as newcomers or from the margins. These are artists who came first as students because of the growing international reputation of the city's art colleges, and then stayed on; or they may be artists who trained, studied and practised elsewhere and moved to London for personal or commercial reasons. One consequence of this marginality is that their work – whether in the high-profile meditation on habitation and nation that was Kutlug Ataman's *Kuba*, or a small-scale piece such as Tobias Ingels's looped video of waves battering Brighton's derelict Victorian West Pier [2] – asks awkward, interesting questions about universal ideas of national identity and the smaller-scale boundaries of the nation states we inhabit. London's art scene is now so cosmopolitan, where once it was parochial, that one of the most significant questions in this book concerns what a 'British' artist actually is. We may need to address a new art from London, but the artists who make it have come from all parts of the world – to such a degree that London's art scene, like the city it inhabits, is perhaps more polyglot, more truly international than New York in its constitution and its conspectus. The artists included in this study are as often Iranian, German, Israeli and Swedish as they are 'British', or else they have multiple, international, origins and passports.

LIVERPOOL JOHN MOORES UNIVERSITY
LEARNING SERVICES

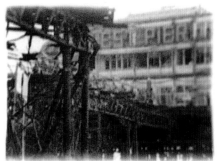

2 Tobias Ingels *West Pier*, 2002, Super 8, 19.18 mins

This transformation of cultural status and scale – in part a consequence of the international commercial success of yBa in the early 1990s – has meant that London, for so long a quiet backwater, has now become one of the hubs of a globalized art world. Increasingly, leading American and European galleries such as Gagosian or Hauser & Wirth have found it necessary to open branches in London, much in the way that corporate finance houses dotted the world with offices. This does not mean, however, that London is the new geographic capital of the art world: rather, we are now living in an art world that no longer needs a permanent spatial centre. It can only be a matter of time before one of the prime international galleries opens a prestigious space in Shanghai. The art world is now so spatially fluid, so temporally continuous, so much a series of art fairs, bazaars, biennales and exhibitions linked by plane, email and fax, that it no longer occupies a bounded, certain space that might have, or even need, a capital. What was once a fixed geography has become contingent, provisional, and perhaps irrelevant: after all, to go to the Basel art fair these days, periodically you find yourself in Miami. As an artist, your work may be shown in galleries in major cities, whether New York, London, Los Angeles or Berlin, and you will probably have representation in several countries. The

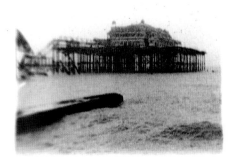

chances are, however, that it will be the galleries operating at international art fairs around the globe that will make most of your sales. As a maker of art, and a figure in an international network, you are no longer linked to a place by economics, any more than you may be linked solely to one place by your ethnic or spiritual identity.

But London is not the one city in the world that you would necessarily choose to live in if you had a free choice – and, in lingering obedience to the myths of bohemia and the avant-garde, artists are probably freer in their choices than most. London is expensive, boorish, dirty and surprisingly dangerous. For quality of life alone you'd do better to chose Paris or Berlin (as many artists do), or Barcelona. And yet, in the very problems it poses to its citizens, we might come to see London as having the makings of a model city, one where boundaries between individuals and between communities are constantly rethought and challenged, where there is a different sense of neighbourliness and hospitality to that found in the country around it.

We need to understand as well, that the identity of artists, wherever they live and work in the world, is formed by very different precepts and ideas to the other citizens that surround them. A young artist in London probably has more

in common with a young artist in New York, Moscow, Tallinn, Helsinki, or even Beijing, than they would have with an estate agent in Stratford-upon-Avon or an office cleaner renting a room next door to their studio in Hackney Wick. (And that cleaner is probably from Moscow or Tallinn, if not Lagos or Kinshasa.) If you are an artist, your space, and your community, is as much elsewhere as it is at home; in the gallery, the museum, the art fair, the international biennale, the departures and arrivals lounges of airports. Your conversations are with other artists, gallerists, critics, students. You live in this city, this country, but you don't come into contact with it as often as you might. Your work is no longer so much part of a national culture as an international commodity, and it is its status as commodity that has rather more to do with your being in London than you might think, as you exercise your 'free choice' of where to live.

There are, of course, diverse causes for this cosmopolitan culture. What's happening in the London art scene is in part a consequence of a larger, continuing transformation of communication and flows of commodities and capital. Britain's membership of the European Union (EU) has meant that other EU citizens can live and work in London, or elsewhere, just as Britons can go to France, or Germany or Spain. Even as Prime Minister Blair proclaimed the emergence of 'Cool Britannia' in the late 1990s, harnessing pop culture to the promotion of one political vision of national identity, some of our foremost artists were heading off to live and work elsewhere: Tacita Dean to Berlin; Hannah Collins to Barcelona; Steve McQueen to Amsterdam; Lucy Orta to Paris. This reverse migration means that a fine artist such as Jonathan Monk, whose engagement with late modernism might be understood as exemplary – given the themes that will emerge in this book – cannot be included in it. 'London', for the purposes of my enquiry and in its effects, goes far beyond the purlieus of the M25, but I cannot, in fairness, stretch its geography as far as Berlin.

Politicians and the popular media are fond of asserting that the first task of a government is to police and keep secure the boundaries of the state. This requirement often accompanies the conjuring of asylum seekers and economic migrants as folk-devils – afflicted with disease but fit enough to steal the jobs of hard-working British families. But despite the retrenchments of nationalist conservatism, the intellectual idea of the boundary, the wider cultural discourse around it has perhaps shifted. Younger artists in London have been inspired to ask the same questions as their 'foreign' peers, sharing the same city, same studio spaces, same social and intellectual milieux, rather than waving the British flag as extravagantly as some young British artists had done. In consequence we might see this art not as 'British', in the way that this was once understood – though we shall see that it still has something in common with the older traditions of a national art, and often critically scrutinizes those traditions – but as international and urban, and an art made with one eye on the rest of the world.

Having remarked that many of the young artists now working in London participate in the market, or more correctly *hope* to, I should caveat that the artists featured in this book, even when they are commercially successful, even when there are waiting lists of collectors for their work, are not especially concerned with exploiting the economic system that is in large part a legacy of yBa. Nearly half of the artists featured in this book do not have permanent gallery representation. But this does not mean these artists don't sell work and it does not mean that they will not have gallery representation soon – during the course of writing the book, two signed agreements with leading London dealers, whilst another chose to end their representation. What this attitude to the gallery signifies is a different relation of artist to work to market, something that conversation after conversation with the artists themselves

LIVERPOOL JOHN MOORES UNIVERSITY
LEARNING SERVICES

also confirmed. Commercial success in this case no longer precludes a serious, critical approach by artists to both work and world.

The painters, sculptors, photographers and video artists featured here have different priorities; the work itself comes first, and it is certainly not work made at the guidance of the gallerist. The best artists of the new generation are distinguished by a seriousness and by a thoughtfulness about their work that has not been a significant feature of British art for many years. (The decision to award the 1999 Turner Prize to Steve McQueen for his self-reflexive videos suggests an early manifestation of this return to art as a serious topic, where concentrated attention is paid to the content and rhetorical forms of the *art work*, rather than to excess publicity or media interest in the *artist*.) Even when it is art that is, quite intentionally, humorous – as Ryan Gander's and David Burrows's often is – it remains an art made with thoughtful intent. The problem that we may have as an audience, seeking to engage with this art, is that the critical apparatus that once accompanied serious art is now largely unfamiliar to us. If the renewed attention of some of these artists to the rhetorical forms of their art is novel, so too are the intellectual demands that their work makes upon us.

One of the central characteristics of this new art, I'd argue, is a sense of responsibility, coupled to a critical acuity that contrasts well with the intellectual scorched-earth policy that marked artists' statements and the critical writing surrounding yBa. As much as it is a consequence of a changed economic and social world, the product of a new fluidity of identity, this is an art that looks critically at its place in that world. As we'll see, new art in London is very often, and quite literally in the work of Tania Kovats and Layla Curtis, an art of mapping; an art that responds to the annihilation of space and time by technology, by reappraising and rearranging boundaries of both space and

self. Crucial determining factors for this study are matters of mobility and boundary, the issue of nationhood and belonging that is raised by the tensions between European integration and globalization on the one hand and a narrower, protective, sense of community and self on the other. The issue of national or regional identity manifests itself most often in a concern with space rather than symbol: rather than looking at flags, these artists look at maps. Unsettled by events, by the transformation of the world through economic and social forces, artists examine edges, interstices and undersides.

If the limits of nations are increasingly unsettled it does not mean that this disturbance is welcome; as Hubert Védrine – the former French foreign minister – recently observed, 'Europe is geographic as much as political. It has to have limits.'[4] Those limits are not only spatial, they are psychic too, both in the way we understand space and our relationships with other people, and also those limits are found in different places for different individuals and different cultures. Our concerns over such limits may manifest themselves in culture before ever they surface in politics – as they sooner or later do – just so long as we have enough residual culture that has not been subsumed into mere entertainment. To a certain extent, important art anticipates history, rather than mirrors it; an important characteristic of new art in London in a variety of its modes, and what renders it important, is the degree to which it is literally or figuratively proleptic, an art of potential. The consideration of boundary manifested itself in the work of Layla Curtis in the late 1990s, as she intricately collaged maps of EU countries to fit all their capitals within the shoreline of the United Kingdom, and then in a series of works where widely separated parts of Europe were juxtaposed and imbricated with each other [1, 5]. We see it too in the maps and sculptures of Tania Kovats [3–4], the photographs of Steffi Klenz [6] and the paintings of

Clare Woods [54–56]. The boundaries of national identity are not only to be found along a coastline where we might seek to deny access to refugees or 'economic migrants'; they can be found too on the limits of our bodies, and above all at the edge of our imaginations and our consciences.

As well as addressing identity, some of these young artists challenge the terms and conditions of life in Britain today. For if, on the one hand, we live in a world where traditional boundaries to self and state are being corroded or rendered meaningless by local networks and global economics, by paradox we also live in an increasingly micro-managed, over-marketed, branded and

below 3 Tania Kovats *Rocky Road*, 1999, acrylic composite and MDF, 50 x 200 x 300 cm (19 ¾ x 78 ¾ x 118 ⅛ in)

opposite 4 Tania Kovats *The British isles*, 2004, mixed media, each framed work 51 x 39 cm (20 ¹⁄₁₆ x 15 ⅜ in)

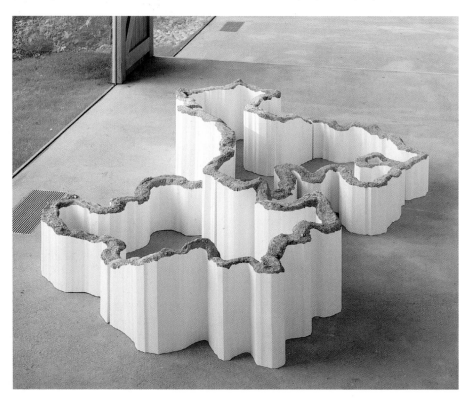

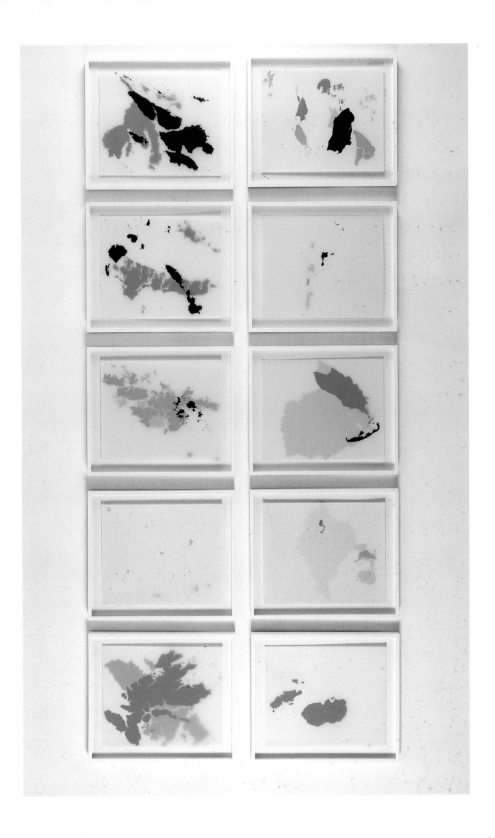

LIVERPOOL JOHN MOORES UNIVERSITY
LEARNING SERVICES

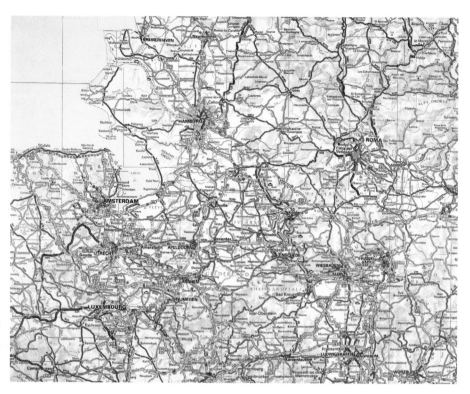

5 Layla Curtis *The United European Union* (detail), 1999, collaged EU road maps, 204 x 140 cm (80 ⅜ x 55 ⅛ in)

trade-marked nation, where increased social control accompanies a socially debilitating economic agenda that endlessly privileges consumption over culture, an instrumentalism of the subject over autonomy. The making and teaching of art itself has been yoked to these processes, not simply in the pure and overt capitalism of the art market, but rather through what has become known variously as 'the knowledge economy' or 'the creative economy'. As J. J. Charlesworth, one of the outstanding critics to have emerged alongside the new generation of artists, has remarked, 'In the realm of the economy, the enthusiasm for the knowledge economy, or Creative Britain, model comes from its role as a workable substitute for an economic policy.'[5]

The question of art's social uses, and how it might 'add value' in an economy where human subjectivity has become the chief commodity, has

6 Steffi Klenz *Tottenham Hale*, 2003, C-type print, 76.2 x 101.6 cm (30 x 40 in)

become crucial to its institutions. The worth of art is now measured – if not by artists then by those who might fund some manifestation of art, from its teaching in colleges to its exhibition in museums – as if it were the product of a 'culture industry', one more object to be bought and sold. The idea of the 'knowledge' or 'creative economy' is not that knowledge or creativity can make you a wiser, more articulate participant in the time and space in which you live (and in doing so, make society better than it is), but rather that it can make you wealthier; it adds value to you as a useful commodity in the market place. We no longer turn to culture to be moral, as if that was all we ever did; we do not turn to culture to become wise, as if that was all we ever did; in the era of the 'creative economy' we are taught to turn to culture to satisfy an avarice that is provoked largely by those who have turned knowledge and culture into

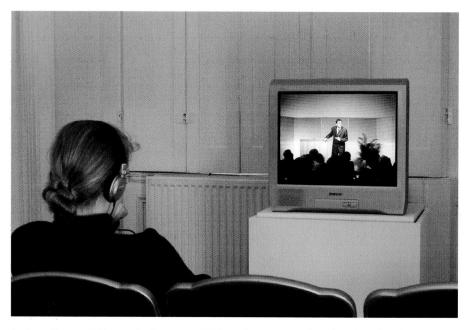

7 Carey Young *Optimum Performance*, 2003, performance at the Whitechapel Gallery documented on video, colour and sound, 14.35 mins

commodities from which they might profit as corporations rather than we might benefit as citizens. This is a fundamental shift in Western culture, a new point in a process that has been going on for decades, and it has important implications for art produced within that culture.

Art's critical address to this commoditizing of subjectivity extends, in the work of Caroline McCarthy, Ryan Gander and Carey Young, to a reading of the signs that organize existence within culture. Responsibility manifests itself in other ways too: most notably in a reaction to history. By history I mean both 'how we got here', the economic and cultural trajectory through the past, and our present-day lived experience in which every moment becomes historical. This responsibility to history – the questioning of where we are in terms of time as much as others ask that question of space – has also inspired a renewed sense of the political. This is expressed not in slogans meeting specific issues head-on, but as a subjective practice within culture, engaging

8 Robert Ellis *Beaconsfield art space* (Vauxhall), 1996, cardboard, glue and perspex, approx. 21 x 29.7 cm (8 ¼ x 11 ¾ in)

an everyday ideology that we are all familiar with. Amongst the ways in which the political is manifested is a deliberate cultivation of failure, an ironizing of the bureaucratic, and a wilful allusiveness and complexity. We can see this in Gander's wry guides to living in an overdesigned world; in the sardonic pastiches of managerial performance and language enacted by Carey Young; and in Robert Ellis's autobiographical revelations of the Kafkaesque world of the civil service clerk [7–8].

This is by no means either an optimistic or a utopian art: too many artists have already established their market positions or filtered into the establishment by posing as revolutionaries. What many of these artists do is try to make us critically aware, firstly of the language used and structures erected around us, and secondly of how idealism is readily recuperated and turned into just one more commodity. At its best, this art does not inspire a revolutionary spirit but rather a healthy critical acuity. It is not art that, either

9 Alexis Harding *Kingsize (Double)*, 2004, oil and gloss paint on MDF, diptych: each panel 183 x 152.5 cm (72 ¹⁄₁₆ x 60 ¹⁄₁₆ in)

through nihilism or naïveté, refuses the cultural conduits of the gallery or established cultural institutions as ideologically tainted, but rather one that, even as it uses them, tries to explain how they work and what their relationship is to the art they contain.

In various ways we have witnessed the return of the aesthetic to art in the last decade. In making this claim I want to draw a distinction between the aesthetic and aestheticization, as Adorno did in *Aesthetic Theory*.[6] Aestheticization, as the American critic Robert Kaufman suggests, is the label Adorno gives to culture's 'unreflective acquiescence to reification'[7] – its blind coming-into-being as commodity. We have an example of this process in the market driven neo-conservatism of much recent painting, fetishizing the

micro-celebrities of pop and film culture in fey portraiture (Kilimnik and Peyton) or dignifying mass cultural banality through 'high art' (Currin). Some of the best and most interesting young artists in London have meanwhile rediscovered and developed the concerns of modernist art, overridden and ignored in the age of 'post-modernism'. This is the rediscovery of the aesthetic as a category of thought and action that allows the individual subject to reveal aspects of history and society that the commercial operations of the culture industry and the blandishments of official culture would happily conceal. Such a recovery of modes is not a sardonic visual mimicry, as it was in the 'neo' movements of the 1980s. Instead, it returns artist and spectator to the fundamental problem of interpreting modernism as a reaction to technological modernity, and as unanswered questions, unresolved paradoxes, that – far from being irrelevant in a new economic and social order – are now intensely pressing.

Alexis Harding, both in the manner in which he works and with his content, invokes antecedents in action painting and minimalism, which then become extended by questions of process and time that were avoided within much late modernist art [9]. But Harding's painting also engages with a schism between rationality and the irrational that whilst certainly fundamental to modernism, has recently become ever more essential to our understanding of the present day. Similarly, the sculptor Eva Rothschild certainly sees her work as engaging in a critique of utopian ideals, whilst also being located within a formal tradition of modernist practice that would include artists such as Barbara Hepworth [10]. Rothschild's project is often concerned with the moments when modernism failed, when in the 1960s, revolution became a commodity for the walls of student bedrooms and record collections, or when the utopian investment of the European Enlightenment in modernity

LIVERPOOL JOHN MOORES UNIVERSITY
LEARNING SERVICES

10 Eva Rothschild *Mass Mind*, 2004, Perspex, dimensions variable

as rational communication between peers descended into value-free mysticism and materialism. Artists such as Shahin Afrassiabi and George Shaw approach modernist utopianism as outsiders: their first encounter with its social manifestations was through what Afrassiabi calls 'flawed emulations', whether in the architecture of the developing world or the project of post-war public housing in the UK.

All of these artists deal with aesthetic issues, but not in a vacuum; rather they are interested in the way that aesthetics and history relate to each other, much as modernist artists were from the late nineteenth to mid-twentieth century. To begin with, the return to modernist aesthetics might seem like nothing more than a return to formalism; and formalism is now understood

as content-free, decorative, art for art's sake. That wasn't, of course, the case within much of modernism – the problem really arose through colour field painting's joining of the retreat from engagement that had begun with abstract-expressionism to a one-dimensional exploration of painting's rhetorical devices. I don't believe that a return to formalism is a necessarily a problem now; at least not for artists such as Rothschild, Afrassiabi, Harding and Peter Peri. To look at such works demands our concentrated attention; even when faced by 'sublimity' or 'beauty' (and for Harding in particular that's what the work may be about), to take anything away from the art work we cannot simply be seduced, cannot wallow in 'pleasure'. Such art demands that we renounce the easy facility of art in modern culture: rather than have answers or pleasures glibly handed to us, we must work to engage with the work. Formalist aesthetics obstruct the reduction of the subject to infantilism and banality in a totally administered culture; they refuse comfort, they demand a capacity for attention and critical reasoning that are, apparently, the antitheses of modernity's aspirations.

Such works demand a new formulation of modernity – or perhaps a return to an understanding of modernity as something more than more things, faster things, more easily absorbed things. This art, like the best modernist art, works against modernity's delirium of the commodity, or its delirium of accelerated technology – something we witness in culture today in the fascination with digital technology. The difference is that, from their historical perspective, these artists can use modernist aesthetics to record modernism's own slide into that delirium; tell us how an art so intent on refusing commoditization itself became commodity. John Wood and Paul Harrison, with their constant and deliberate failures of form produce a similar critique from a different angle, one focused on the 'real' body and objects through video.

The refusal of ease associated to this art is subversive, even shattering, in our culture today – which is why the more extreme modernist formalism was ultimately rejected rather than assimilated by mass culture. (I'm thinking here of composers such as Carter or Boulez, novelists like Bernhard and Sarraute, or Duras as filmmaker and novelist, rather than well-known modernist painters and sculptors.) However, even as the work of these contemporary artists is placed in the art market, they are once more working with forms that resist mass culture, that attempt to re-establish art as something different, something more important, something that 'thinks' or even 'philosophizes'. In this attempt art is even, perversely, dangerously elitist. This is a feature that makes these artists radical and demands our attention as a result; this is something that has not been attempted in art for many years and is something that many critics no longer imagine possible. The revisionist definition of modernity surrounding these art works suggests that the capacity of critical reflection is itself a form of modernity, and that 'modernity' is therefore a demand placed upon communication between ourselves and others. This art imagines us as autonomous subjects, capable of protracted, difficult, independent thought and expressing ourselves; but autonomy is not only about self-expression, it is also about receiving and thinking, from others as much as what we receive from and think about the art work. Acknowledging the autonomy of the art work not only implies our own autonomy as subjects, it implies the autonomy of other subjects. This might be why so much of this art is concerned with the latency of forms; we have to be concerned with what might be, with what might materialize from hospitable, critical exchanges with others. These are the very conditions that London as a city, as a working context, can allow for the critical 'regionalism' or community that shapes its culture, but which the nation state, on the whole, does not.

For this new generation of artists, a response to history, to present-day lived experience, is absolutely vital; is a condition for their making art. Whilst some respond indirectly to the banality of the 'society of the secretariat' and its culture industry, through the development of aesthetic forms, others meditate more explicitly upon events in the world we inhabit. Without being overtly political, art can still, just occasionally and in however an obtuse or obnoxious way, and for however small or seemingly irrelevant an audience, explain everyday facts of life. It can comment upon modernity's capacity for self-destruction and the inbuilt, structural violence that inhabits our present economic and social systems, as well as the violence provoked by our relationship with others. In its complexity, art can even rebuke the notion that it should simply be applied as a palliative for the anomy created by lived experience. One of the effects, since the 1970s, of the loss of the capacity of audiences and critics alike to undertake formal readings of art, and to derive 'pleasure' from formal engagement, has been an ever-increasing emphasis on content, 'meaning' (as form itself was meaningless) and 'relevance'.

An installation as simple as Mauricio Guillen's *3–0*, a photograph of a young black man in a tracksuit, standing outside the gates of Highbury, while the sound of a game is broadcast around him, provides a telling commentary on the social and economic shifts that have led to the disenfranchisement of traditional supporters now that football has been reconstituted as an unaffordable, middle-class spectacle [14]. It may only tell a middle-class gallery-going audience about those shifts, but then, the football supporter, relegated to Sky TV in the pub, experiences such effects on a more-or-less weekly basis. A text-piece as unspectacular as Carey Young's *Disclaimer* series (2004) [11–13], can explain that everything, up to and including whatever aspirations you might have towards your own identity, is already owned by

Disclaimer: Access

Access to this work of art may be interrupted, restricted or delayed for any reason.

The hanging of this work and its lighting may not be optimal.

Its placement in proximity to other works of art may create undesired interferences.

Information provided about the work may be misleading.

No warranty or guarantee can be offered that subsequent viewing of this piece will generate identical or similar emotions, reactions or comments.

Carey Young and Massimo Sterpi: right **11** *Disclaimer: Access*; below left **12** *Disclaimer: Value*; below right **13** *Disclaimer: Ontology*; each work 2004, inkjet print mounted on board, 76 x 76 x 2 cm (29 ⅞ x 29 ⅞ x $^{13}/_{16}$ in)

opposite **14** Mauricio Guillen *3–0*, 2001, C-print and sound, 51 x 61 cm (20 $^{1}/_{16}$ x 24 in)

Disclaimer: Value

The artist does not guarantee that this piece can be sold as a work of art.

The artist disclaims that its value may be higher than other works of the same kind.

No guarantee is offered that this piece may be sold at all, at the original price or with profit, should the need arise.

No guarantee is made that the economic value of this piece is free from influence by hype, speculation, advertisement or any other phenomenon not related to artistic content.

The artist and her/his representatives disclaim that acquiring art is a sound form of investment, and/or that it could satisfy the cultural or any other need of the investor.

Disclaimer: Ontology

This piece is provided 'as is'.

The artist does not represent this to be a work of art. S/he hereby disclaims any liability for considering this piece as a work of art and excludes any guarantee or warranty, both expressed or implied, as to the fact that this may be exhibited or marketed as a work of art.

Any representation or claim that this is a work of art is the exclusive responsibility of the person who asserts it. The artist shall not be held liable for any damage or loss deriving from any such representation, guarantee, warranty or claim, including any legal fee or costs deriving therefrom.

someone else, trademarked, copyright protected, and franchised out, and that consequently, you have no rights of redress. And the installations made by David Burrows and the paintings of Nigel Cooke can draw our attention, in fresh ways, to the sense of catastrophe that pervades our culture.

That sense of catastrophe – that we have both already witnessed such a traumatic event, through the mass media, and are, ourselves, about to experience such an event as the real thing – permeates the recent work of a number of artists. Foremost of these are Burrows, whose emphasis upon 'the event' is perhaps the most effective commentary upon 'where we are' and

Cooke, whose minutely detailed canvases are, almost because rather than in spite of the sardonic indifference to human catastrophe they manifest, the most chilling anticipation of the horrors bound up but still, just about, latent within our culture. We have, of course, endlessly witnessed trauma through the mass media, both in the form of fantasy narratives in the horror and disaster genres, and in the real life events of the terrorist attack on New York's World Trade Center in 2001. We have, at least in London, experienced something of that trauma ourselves. We are told, endlessly, to anticipate more disasters, but what those disasters are is not specified. Rather we live in a situation where catastrophe is a penumbra to everything we do, an excess produced by us as much as it is an external threat, a shadow that drifts to the margins of our culture, a universal ghost. If Cooke's complex works can be distilled to a single point – and I don't happen to believe they can – then it is that we are, just by being, catastrophic, and that the universe is equally indifferent to our suffering and our triumphs. Disaster therefore becomes simultaneously inevitable and meaningless.

Walking around the debris that constituted Burrows's *New Life* exhibition at Chisenhale Gallery in mid-2004 [15], there was a sense of treading not only

LIVERPOOL JOHN MOORES UNIVERSITY
LEARNING SERVICES

in the shadow of the devastated office buildings of downtown Manhattan, but that there had been a convulsion of the boundary which art galleries conventionally erect between interiority, as a condition of subjective experience, and the outside world. One might equally have been treading the paths of a nearby Bethnal Green or Hackney estate – the kind of places around which most young artists in London live and work. But with *New Life*, Burrows made explicit uncomfortable questions about catastrophe and causality within the structural violence of Western, capitalist culture; he was illustrating just one possibility of the capacity of forms explored by Afrassiabi, Rothschild and George Shaw, and of the violence enacted on the body, in a comedic way, by Wood and Harrison. If these devastated spaces were as much Hackney as Manhattan, one had to admit that the difference between existing reality and paranoid fantasy was not that great: such places were already catastrophes, because of some violence other than terrorism. With *New Life* we were contemplating the results of a clash of ideologies, perhaps, whilst also looking at the consequences of the end of history, the supposed end of ideology – the structural violence of neo-liberal consumer capitalism in which the catastrophe of history is elided by a welter of commodities or illusions of commodities. It was not a pretty sight.

New Life was a kind of architectural drawing, its bare lines raised up as model and then ruined – it was a life-sized sketch of disaster, a location of where you, the spectator, might be in space. Perhaps the most marked aspect of new art, as it is being made and shown in London today, is the manner in which the best of it reflects, as a matter of intention, upon the state we're in as a culture. That reflection comes back, in an odd way, to the sketching of time and space. The important artists of any era and any place are those who go beyond aesthetic, economic or institutional obeisance to make a kind of map:

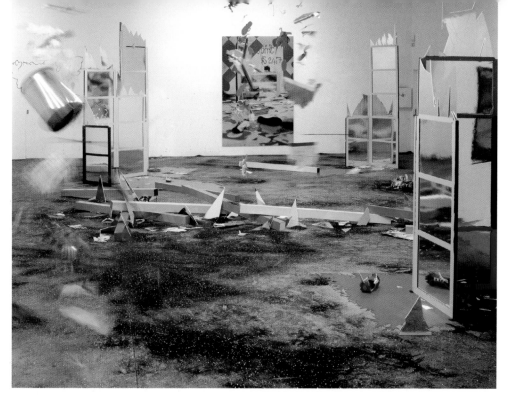

15 David Burrows *New Life* (installation view), 2004, mixed media, dimensions variable

a map that shows the space and state we're in, and which anticipates where we might go. The state we are in right now, in addressing a new art from London, is in fact a city that still belongs but simultaneously feels as though it doesn't quite belong, to a nation state. So both state of being and state as constituted in space are what the Italian philosopher Giorgio Agamben describes as 'states of exception';[8] states whose identity is called into question; states in which all the things you thought were yours by right, turn out to be rights already owned by somebody else; states where most culture may be nothing more than an entertaining façade pasted over problems that neither it, nor the society which produces it, cares to properly address, and far less change. And it is in the questioning of these conditions, the scrutiny of our time and place, the continued assertion of the possibilities of our being, that we see our new art at its best.

opposite **16** Shahin
Afrassiabi *Aluminium Stand*,
2004, aluminium, vinyl and
steel, 180 x 40 x 120 cm
(70 ⅞ x 15 ¾ x 47 ¼ in)

IF NOT HERE, WHERE?
IF NOT NOW, WHEN?

aesthetics, history & modernity

It has become a customary practice for critics 'of a certain age and temper' to bemoan 'the end of art' and variously claim that contemporary art is in crisis, valueless, and little more than an extension of the entertainment industry.[1] Having failed to notice that 'crisis' is a condition inherent to both art and history, and perhaps yearning for the mythic stability of olden days, their generic solution is a return to 'serious painting'. In their accusations of art's descent into entertainment, these critics belatedly and often perversely reiterate observations that have been made by philosophers and academics about art and culture since the late 1970s. However, given the stylistic and self-promotional tendencies of some artists over the past two decades, these curmudgeons perhaps have a point: much of what's been presented as cutting edge in those decades is of questionable value even as entertainment. It could

LIVERPOOL JOHN MOORES UNIVERSITY
LEARNING SERVICES

also be argued that art's capacity to comment on or affect our culture, has recently been largely without point – unless the point was purely its status as decorative or controversial commodity, a rearrangement of those features of mass culture that you, as a person of discriminating taste, wouldn't otherwise have in your home or museum. Certainly art, since the late 1970s in America, and since the late 1980s in Britain, has been largely premised on a break with the practices and debates that characterized the modernist art of the earlier decades of the twentieth century; even up to, and including, such movements of the 1960s and 1970s as minimalism and its successors. (For even if minimalist and post-minimalist artists and theorists, such as Donald Judd, Robert Smithson or Robert Morris, saw themselves in opposition to archetypal late modernist critics like Clement Greenberg and Michael Fried, both were, playing within the same, limited field.[2] Artists and critics alike presumed that art acted *upon* culture, rather than functioned as a product *of* mass culture.)

The turn to popular culture as a rhetorical source for art – first by the 'Pictures' artists, Cindy Sherman, Richard Prince, et al., but then more generally – marked an important turning point, one symptomatic of a moment generally defined as post-modern. It was not the act of appropriation from popular culture by these artists which was the difference (after all, that had been a common enough modernist strategy), but rather it was their tacit acknowledgment that, within that appropriation, there was no corresponding elevation of their materials. A work such as Sarah Lucas's *Sod You Gits* [17] may have found its rhetorical materials in tabloid newspapers, but the tenor of the piece seemed to suggest that this was also the domain in which it delivered its riposte. With Damien Hirst, shark and artist alike seemed suspended in a medium that was the mass media, rather than formaldehyde. Taken together with the pastiche modernisms of the 1980s (neo-geo; neo-expressionism)

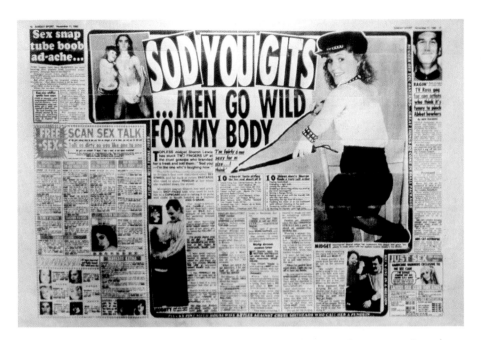

17 Sarah Lucas *Sod You Gits*, 1990, photocopy on paper, 218 x 315 cm (85 ⅞ x 124 in)

there was, if you like, an admission that art was inseparable from the world constituted by advertising, feature films, pop music, fashion and 'celebrity'. Rather than commenting on this culture from without, art now belonged within it, if only as an entertaining sideshow. Art could be at one with the mass culture that surrounded it, rather than its agonist. The art world *was* now a domain in which forms of celebrity – being drunk on TV; being friends with pop stars and TV comedians; having photos of one's marriage (or one's openings) published in 'style' magazines – were to be more highly esteemed than critical respect, or even self-respect for one's work.

So to hear young artists acknowledging a critical relationship with artists or modernist theoreticians such as Kasimir Malevich (Peter Peri), El Lissitzky, Piet Mondrian and Le Corbusier (Shahin Afrassiabi), or Barbara Hepworth (Eva Rothschild) is somewhat peculiar. Even John Wood and Paul Harrison's recognition of affinities with a late modernist artist such as Bruce Nauman, and an early modernist icon such as Charlie Chaplin, and the way in which

they use video, is profoundly at odds with recent trends in that medium. These artists are invoking as a frame of reference, however partial or contested, an aesthetic tradition and a form of art's relation to history that has seemed at best irrelevant, and worse, reactionary, for almost two decades. These artists are expressing the hope that art can 'think', that it can exist beyond the regimes of mass culture and even prove wholly destructive towards it.

This could simply be the mark of a self-conscious conservatism; a turn to the outmoded as a sign of distinction of the sort that routinely convulses the world of fashion. It could be a deliberate strategy, although a reference to modernism could hardly be deemed to be a nakedly commercial ploy in the contemporary art market. It could also represent a claim by these artists for institutional acceptance – perhaps at the expense of short-term commercial success or public recognition. Certainly art institutions, which until now have tended to be more adept than commercial galleries at writing art's official history, have a vested interest in modernism: it's already part of that history and it's a major part of their collections. It is easier, after all, to establish continuities than it is to provide the kind of intellectual and curatorial framework that might encompass the failure of a major part of one's collection at the expense of another. So institutions might well be keen to 'discover' artists who seem to belong to a longer-established tradition. On the other hand, it may be that institutions are responding to a genuine shift in the temper of contemporary artists: their rediscovery, in differing ways, that modernity is, in the words of the German philosopher Jürgen Habermas, 'an incomplete project'[3] and so too are forms of 'modernist' art.

The paintings of Alexis Harding (b. 1973) make a number of obvious references to twentieth-century modernism: they are abstract; they are based upon a field of a single colour and hence almost monochromatic; that attempt

at monochrome is then distorted through the imposition of a grid. As Rosalind Krauss has observed, since the early part of the twentieth century the grid 'has remained emblematic of the modernist ambition within the visual arts'.[4]

The grid is a device that declares the autonomy of art from the domains of nature and of representation: it is, ultimately an epistemic, rather than an ontological construct. The grid is a declaration of a particular, distanced and rational mode of seeing, through which the world's phenomena are *understood* rather than simply being a tool through which those phenomena are *ordered*. For this reason it is an epistemological rather than an ontological form. Just as science began to use the grid to dispassionately apprehend nature, so art, in the modernist era, applied it to the register of aesthetics.

But if the grid, for artists, began as a device in the Renaissance whereby perspective could be imposed upon the depicted, natural subject, by the time of modernism, and its abstraction, it had become concerned only with the status of the art work itself. As Krauss remarks:

> Unlike perspective, the grid does not map the space of a room or a landscape or a group of figures onto the surface of a painting. Indeed, if it maps anything, it maps the surface of the painting itself. It is a transfer in which nothing changes place. The physical qualities of the surface, we could say, are mapped onto the aesthetic dimensions of the same surface. And those two planes – the physical and the aesthetic – are demonstrated to be the same plane: coextensive, and through the abscissas and ordinates of the grid, coordinate. Considered in this way, the bottom line of the grid is a naked and determined materialism.[5]

Despite this emphatic concern only with that which is there, that by which it is constituted, the grid continues to be haunted by what we might term the persistence of vision. As Krauss ultimately acknowledges, the grid permits simultaneously the rational knowledge of a defined space (what she calls the

LIVERPOOL JOHN MOORES UNIVERSITY
LEARNING SERVICES

'beyond-the-frame' attitude in which the grid seems to refer to a world beyond the edge of the canvas) and a set of contradictory origins and intentions (the within-the-frame attitude) grounded in symbolism. Setting up a further, limited opposition, Krauss contrasts those late modernist artists (such as Agnes Martin, Sol LeWitt and Patrick Ireland), who in conceiving reality in an abstract way tend to abolish or dissolve the visual field, with those who stress its materiality (Alfred Jensen), yet who would also emphasize its symbolic values. So for Krauss, the grid seems like a kind of dialectical resolution of antagonisms within modernism of the spiritual and the rational, between the impulse to represent one's relation to the unknowable and the assertion of one's capacity to know completely.

Harding, however, is neither a simple grid painter nor a post-modern *pasticheur*. Rather he experiments with the relation of grid and field, much as Martin did when she came to make paintings in which the grid appeared like a kind of negative within the monochrome; or as LeWitt did with solid and space in sculpture; or as Ireland accomplished with the perceptual field of exhibition space itself. Harding's grids seem to be falling off the painting, skeins which would provide the capacity for apprehension but which prove wholly inadequate [18–22]. If the grid is a form of dialectical resolution, Harding's relation of grid to colour field is a relation of one kind of 'pure' modernist rationalism to another that equally contains the purely rational and the symbolic.[6] Modernist artists at their best sought a 'language that should express both the spiritual evanescence of inner experiences and the formal rigour of a conscious and perfectly responsible artistic operation'.[7] That Guido Salvetti, whom I cite here, was talking about Debussy indicates that the pursuit of an ideal relation between seemingly antagonistic rhetorical forms was not restricted to visual artists.

Harding's work suggests that bound up in that idealized relation are other dialectics – interior/exterior; spiritual euphoria/formal rigour; irrationality/ responsibility – whose conjunction until now went unexplored, and which do not appear to sustain comfortable syntheses. Harding's grids not only *seem* to be falling off the painting, in some cases they actually *do* fall off the painting: his art depends upon a precipitous and unstable relation between forms of art that are representative of radically different tendencies within modernism.

18 Alexis Harding *Ruinart II*, 2001, oil and gloss paint on MDF, 152.5 x 152.5 cm (60 ¹⁄₁₆ x 60 ¹⁄₁₆ in)

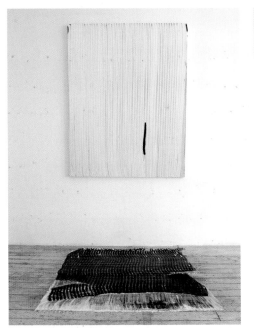
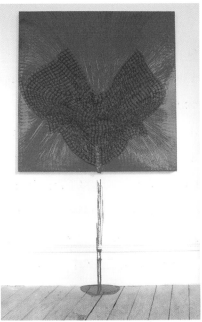

Alexis Harding: left **19** *Double Crossed*, 2005, oil and gloss paint on MDF, 152.5 x 122 cm (60 1/16 x 48 1/16 in); right **20** *Pulmonary III*, 2005, oil and gloss paint on MDF, 122 x 122 cm (48 1/16 x 48 1/16 in); opposite **21** interior photograph of the artist's studio, London, 2002

Harding works on a horizontal surface – a practice itself evocative of American high modernism, at least as practised by Jackson Pollock. The monochrome is made from oil paint heavily diluted by linseed oil on a hard surface such as MDF or stainless steel. Whilst the surface is still wet, Harding pours a gloss paint of a different colour over it – making two passes – with the second at ninety degrees to the first. To do this he uses a length of plastic guttering, with holes drilled at regular intervals: the result is a crude grid. Because of the chemical reaction between the two types of paint a skin forms as the paint dries, but there is a period of instability between the paints that may last several months. By tilting or shaking the canvas, or by pushing the skin, Harding causes the grid to slide across the substrate [19–20]. The grid becomes distorted, the skin puckered and sometimes torn, depending on the degree of energy with which the artist works. Although there is a degree of

control here, that 'energy' is also redolent of modernist action painting, of a not wholly directed dynamism. The element of chance, and the continued operation of process within the painting, is properly introduced, however, with the act of rotation, with making the work into an object of vision by placing it in the line of the spectator's gaze, rather than beneath it. When he takes the work off the floor, Harding is never completely sure that the bond between the paints has become sufficiently stable to either prevent movement by the skin or limit any further slippage. Gravity may continue to do, dispassionately, what the motivated artist has set in train. To an extent, this is what Harding wants, a continuing process built into the painting as it is hung; the problem is that in allowing this, the skin may slide off the surface altogether, effectively destroying several months of work.

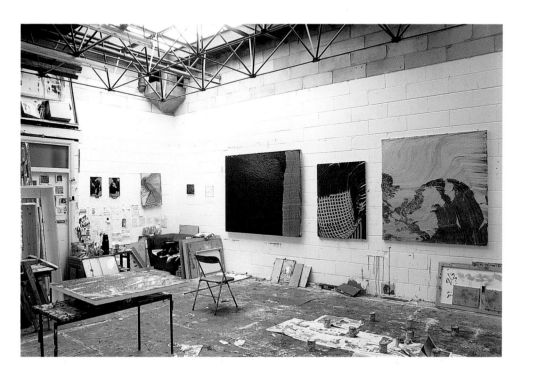

Rather than there being a materialism as the bottom line of the grid, Harding's use of process within the work suggests that this materialism resides in the very attachment of figure (grid) to field (substrate) – conceptually, materialism is then a surface, not a line. Indeed, the slippage of the skin over its substrate employs the base materiality of that surface embodied as paint. One of the distinguishing marks amongst monochromes is the different use which artists make of texture; it is, for example, the way that a painter of the 1950s such as Ad Reinhardt – who was an artist wholly committed to peering into the void – can introduce symbolism within the negation of vision that is an all-black canvas. The striation that characterizes the monochrome fields of Harding's paintings is not, however, made in an expressive gesture by the artist himself; rather it is a product of the sliding of the grid away from its anchorage, as it is pushed, or as gravity takes hold [20]. Once the chemical incompatibility of one kind of paint to another is established, the painting is responsible, to a degree, for its own dissolution, rather than being the product of artistic sensibility.

In making such work isn't Harding actually engaged in a typically playful post-modern critique of modernism's failings? Certainly that was a challenge often levelled at his early work, but within Harding's painting there are a number of fundamental modernist concerns that he develops rather than undermines with an ironic scorn. The first of these is the relation of figure to field – the question of what has primacy within the field of vision. Certainly this was of as much interest to LeWitt, Ireland or Martin as it was to high modernist abstractionists such as Mondrian and Hans Richter. One could also see in Harding's use of the sloughed skin of paint to disrupt the edge of the work that same concern with framing and the relation of painting to wall or to room that so preoccupied Mondrian, Rothko or Barnett Newman.[8] Perhaps as

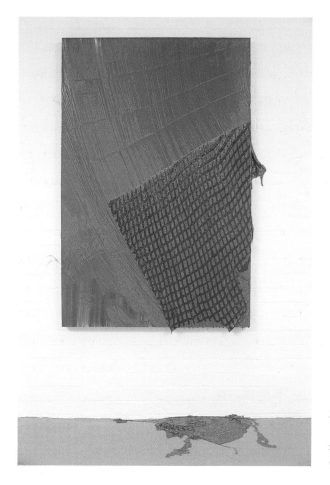

22 Alexis Harding *Liar*, 1998, oil and gloss paint on stainless steel, 153 x 100 cm (60 ¼ x 39 ⅜ in)

significant, however, is the tension between the near-catastrophic collapse of the grid and the field over which it slides. A crisis of organization is fundamental to modernist art, manifested in narratives in which institutions are designed to create order but actually do the opposite.[9] Harding crystallizes this very modernist anxiety by stressing – as a kind of autotelic narrative of painting – the unstable relation between what might be seen as its form of ordering, the grid, and its form of 'pure' pleasure, colour.

J. J. Charlesworth also sees in Harding's project an interest in understanding, rather than parodying the formal problem of 'the conceptual confusion that

LIVERPOOL JOHN MOORES UNIVERSITY
LEARNING SERVICES

exists between materiality and vision, expressed in the usual symbiosis between material and support ... by endangering the stability of the conventional relation between the two'.[10] That peril comes in large part from a commitment to process: Charlesworth remarks that the work contravenes a 'founding assumption of painting – that the medium should stay where you put it'.[11] In making this unwarranted intrusion, Harding brings to his painting a strategy of post-minimalist sculpture – the use of the entropic by Smithson and the invocation of process and ephemerality within sculpture by Richard Serra, Eva Hesse and Robert Morris. Just as post-minimal artists such as LeWitt, Robert Rohm or Fred Sandback exported the problem of figure–field relation from the register of the purely visual towards the haptic, the better to encounter it, so Harding shifts the question of temporality, worked out in post-minimalism, largely within 'process-sculpture' – from the haptic to the visual.

Where Harding perhaps literalizes a dialectic between two tendencies of modernist practice, in Peter Peri's recent paintings we see a further delving into, and reflection upon the neglected tradition of mysticism and the spiritual within modernism. Peri (b. 1971) first came to attention after leaving Chelsea College of Art in 2003, exhibiting extraordinarily detailed drawings such as *Rotary* (2003) [23]. With their emphasis upon the crafted, Peri's works were indicative of a more general return to drawing by artists in recent years, a renewed interest in a largely forgotten form.

Metamorphosis seemed to be at the heart of skilled draughtsmanship: a drawing of a bunch of flowers could take on the quality and texture of wood grain, almost as if it had been carved; the detail was so great that the real seemed to overwhelm itself and become abstract. Interestingly, a similar sedulous attention could also be found in the work of the expatriate Hungarian painter Károly Keserü (b. 1962). Unlike Peri's drawings with their

23 Peter Peri *Rotary*, 2003, graphite on unbleached paper, 64 x 64 cm (25 ³/₁₆ x 25 ³/₁₆ in)

origins in the real, however, Keserü's work is abstract – relying upon minutely detailed repetition and variation [24].

Peri's paintings represent a move towards abstraction by a young artist that, as with Harding's work, embodies the tension between two different registers of modernism as reactions to the world they inhabit. The paintings are characterized by black fields, worked with incised lines and geometric forms rendered in a subdued palette. But where a modernist painter might

24 Károly Keserü *Untitled (0204)*, 2004, acrylic and thread on linen, 152 x 132 cm (59 ⅞ x 51 ¹⁵⁄₁₆ in)

have insisted on a boundary to such forms, on edge and definition, and – in the case of constructivists at least – on more vibrant colours, Peri's shapes are nebulous [25–26]. Despite the shift from drawing, metamorphosis remains the central stake in Peri's work here: one senses that these shapes are about to become something, or perhaps have been something and are now dissolving; we think that the lines might lead us somewhere, or else guide us away. Through a very different aesthetic, Peri leads us towards a similar problem to that diagnosed by Harding: the relation of regulation to formlessness. He then adds to it, introducing a dialectic between the historical and the personal.

On the one hand these paintings depend upon an abstraction that is not a distillation of something 'real' but rather the expression of latency within forms. (It is this, perhaps, that has led Peri's gallerist, Carl Freedman – who as a

curator and critic must loom large in any future history of yBa – to talk about his work in relation to Malevich.) In taking this approach, Peri is perhaps also tracing out a personal lineage – for his grandfather was the fine Hungarian modernist artist László Peri, who worked in Britain during the later years of his life. So there is about these paintings the attention to geometry of constructivism – with all of that movement's commitment to aesthetic potential, which meant the form *might* be realized as architecture or political ideal – without any necessity of that realization inhering to the work's content. But meeting that aspiration is the sense of constant change, within the art work

25 Peter Peri *Projection 6*, 2004, acrylic and enamel paint on canvas, 101 x 101 cm (39 ¾ x 39 ¾ in)

26 Peter Peri *Monstrance*, 2002, graphite on unbleached paper, 72 x 64 cm (28 ⅜ x 25 ³/₁₆ in)

itself, which informed the works of Vassily Kandinsky before he came under the influence of the Bauhaus in the 1920s. In the former case, change is related to history, it is a metamorphosis of external relations; in the latter this transformation is personal, one of interior relation. In Kandinsky's case, furthermore, his path to abstraction lay in the distillation of objects rather than

the articulation of potential. This is apparent in the development of the Russian painter's oeuvre around 1911–12, where recognizable objects in studies for the *Improvisation* paintings are transformed into abstract motifs in the finished work. Where, for Constructivism, abstraction promised a potential engagement with the exterior world, Kandinsky's practice is one of withdrawal from it.[12]

The ambiguous quality of Peri's geometries means that his paintings occupy a field in which these two contrasting, even diametrically opposed, aspirations coexist. Where Harding strains grid against field to emphasize this tension, Peri embeds it within a single modality. We are never sure if these shapes are coming or going; they lack the complete definition of the concrete yearning for realization, and yet neither do they promise an unproblematic spiritual resolution with the world. Like Harding, and rather like the two young sculptors to whom I shall now turn, Peri's work at once embodies modernist aesthetics and establishes a critique of modernism, pointing out the tensions that led to its rejection by artists in the 1970s and 1980s. But that challenge to modernism is not one of absolute failure, but rather a revival of interest that seeks to extend its future capacity and capability to respond to the world.

We can see in Eva Rothschild's practice both a return to modernist values and a critique of the utopianism that modernism fostered. Rothschild's work is made in a number of different media – she is not purely a sculptor (just as Harding, with his side interest in reclaiming and repainting damaged road barriers as 'sculpture', is not purely a painter). Rothschild (b. 1972) has made videos and wall pieces that take her beyond the realm of the tangible object, which is, despite the introduction of process and temporality to the mode in the 1960s, where we still best understand what sculpture is. Indeed, Rothschild's work pays attention to the idealism of the 1960s counter-culture and its simultaneous recuperation in commodity forms, and to that kind of

loosely bounded, provisional, 'soft' sculpture that characterized the projects of Eva Hesse, and for a while, Serra, Robert Morris and Alan Saret.

As Beatrice Ruf has observed:

> The subculture of the 1960s and the fetishisation of autonomous objects is ... brought to mind by the frequent presence of tassels and fringes. ... These occur in the woven leather objects which hang on the wall or hover in groups as if they were abstract Beatles, and in the paper pictures with long carpet-like tassels, which are reminiscent of the leather jackets and the faux ethnic garb of the romantically blinkered hippy world. In formal terms the fringes also serve to continuously dissolve the images and objects the artist has created.[13]

Modernism was often premised on forms of utopianism, which could be as nebulous in their definition, and as specific to a time and place, as the label of modernism itself.[14] Certainly the attachment to the idea of a better place and time, however that was to be realized, is only one aspect of those vanguard practices of Western culture undertaken between the mid-nineteenth century and the late twentieth.[15]

If, indeed, we can say that modernism has ended: one of the central tenets of this book is that modernism, as much as the reconfiguring of human subjectivity by the forms of industrial modernity with which it seeks to deal, is an evolving project, even if the historical development of those forms to which it responds has made it ever harder to maintain. If the historical catastrophe of the Second World War was one event whose consequences and aftermath (the Holocaust; the atomic bomb) made the naïvely formulated hope for the future manifested in Dada and Surrealism seem delusory, then the 1960s perhaps represent a kind of aftershock.

Not only is there a resurgence of utopianism – at its most decadent in the investments in the commune and narcotics; at its most noble in the

campaigns for women's and workers' rights and in post-colonial liberation struggles – that utopianism, or perhaps the misunderstanding of historical shifts on which it rested, was itself the catastrophe.

One of the central studies of the modernist avant-garde, that of Peter Bürger, declares one of the principal aims of its movements, in particular Dada and Surrealism, to be the reintegration of art and life. Bürger understands this project as impossible in the wake of the Second World War, with subsequent manifestations of modernist aesthetics, even in the 1950s, being simulacra of the historical avant-garde designed to satisfy the art market. That assumption is profoundly flawed – since the market hardly embraced the 'pastiche' of assemblage art in the late 1950s and early 1960s – but the historical catastrophe of the 1960s, for those artists still committed to extending modernism's legacy, was that the gap between art and life was largely closed, though not in the way the avant-garde might have wished.

As Hal Foster puts it, 'The old project to reconnect Art and Life ... was eventually accomplished, but according to the spectacular dictates of the culture industry, not the liberatory ambitions of the avant-garde.'[16] What made this closure such a catastrophe was that most artists failed to notice, or merely ignored, the transformation and failed to recognize the way in which their very utopianism became complicit with those historical forces which they sought to overthrow, stem or simply critique.[17]

If – as it is for Jürgen Habermas – modernity is not a historically constrained moment, associated to technical developments or historical aspirations, but rather a way of thinking and communicating, the problem it confronts here is one in which the rationality that premises the exchange between communicating individuals is suborned to an irrational euphoria. It becomes a delirium first of the individual and then of the commodity whose

gratifications act as a substitute for the impoverished historical and social agency of the human subject.

It is this disaster, in its various manifestations, that becomes one of Rothschild's principal topics. It's notable that those manifestations often stem from the same tension between the rational and the spiritual that Harding and Peri confront in their paintings. Rothschild makes works that reflect upon the commodified, pick-and-mix spirituality that became a substitute for political engagement in the 1960s – for example the wall piece *Night of Decision* (1999–2000) and *Burning Tyre* (2004) [27–28], a car tyre stuffed with incense sticks that was first installed in the Dominican monastery of La Tourette, designed by that archetypal modernist, Le Corbusier. The burning tyre, sign of the 'revolutionary' barricade and also, incidentally, a form of execution for police informers in the townships in the anti-apartheid struggle, becomes a bearer for the tools of meditation – a figure of exterior relation to the world, itself profoundly romanticized, is transformed into one of interiority and withdrawal from the world.

In their formal properties, other works by Rothschild seem to directly evoke the formal rigour of modernist aesthetics. *Mass Mind* (2004) [10], *Fort Block* (2004) [29], and *Your Weakness* (2003) [30], apparently cite constructivist art, through their emphasis upon intersecting triangular forms. Encountering *Mass Mind*, with its highly reflective surfaces, inter-penetrating triangles and lacunae that allow one to see other surfaces, partially and obliquely, it is hard to avoid reference to that extraordinary kinetic device, the *Lichtrequisit*, built by Moholy-Nagy to make his constructivist, abstract film *Lichtspiel, schwarz, weiss, grau* (1930). And looking at *Early Learning* on the floor at the Whitechapel Art Gallery's exhibition, 'Early One Morning', in the late summer of 2002, could not but help provoke a further set of relations

27 Eva Rothschild *Night of Decision*, 1999–2000, woven photocopies, 90 x 120 cm (35 ⁷⁄₁₆ x 47 ¼ in)

LIVERPOOL JOHN MOORES UNIVERSITY
LEARNING SERVICES

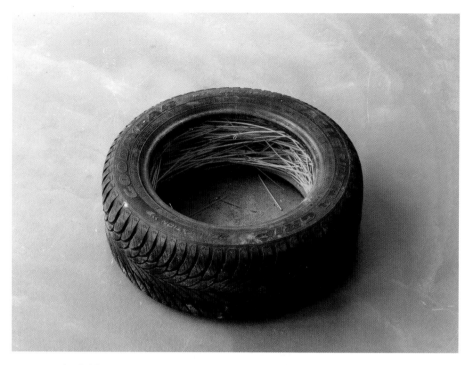

28 Eva Rothschild *Burning Tyre*, 2004, tyre, incense, diameter 58 cm (22 ¾ in)

to modernism. If the title of the exhibition, taken with extreme self-consciousness from a defining work of British 1960s sculpture by Anthony Caro, were not enough, one couldn't help seeing Rothschild's work as the kind of piece you might stumble across in Tate St Ives, comfortably poised alongside a Barbara Hepworth and a Grenville Davey, holding its own in a particular, institutionalized and safely domesticated construct of British art history.

Much of Hepworth's own style came from the influence of constructivists such as Gabo, so that comparison was perhaps not wholly surprising. Nor would one necessarily want to be critical of Hepworth and the British modernist tradition, so much as one does want to challenge the ways in which aspects of that tradition, particularly its formalism, have been exploited by the interests of British art museums, whilst the socialist utopianism of these

artists is neglected. Rothschild's work has in common with Hepworth a sense of balance between volumes and spaces; in their use of asymmetry and their alignment of mass, both artists create a delay in looking for the spectator,

29 Eva Rothschild *Fort Block*, 2004, lacquered wood, 273 x 205 x 190 cm (107 ¼ x 80 ⅝ x 74 ¾ in)

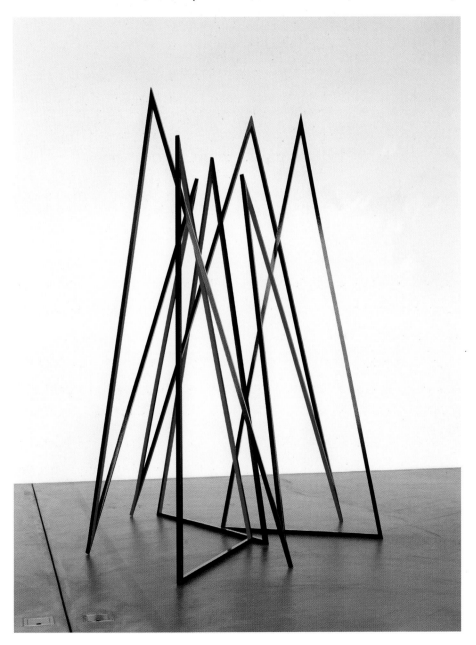

so that form is, to a degree, temporal. One simply cannot comprehend the whole work in a single sweeping gaze: to this extent time is as much embodied in their sculptures as it is, for example, in Richard Serra's large-scale pieces, and there is too a similar, concomitant, instability of the spectator.

Perhaps seeing Rothschild's work employed to fit one particular curatorial agenda at the Whitechapel suggested other, happier, models for the future. Certainly Rothschild was happy to acknowledge Hepworth as a more fitting ancestor than Caro, and one with whom she felt a real affinity.[18] This is not to suggest that Rothschild, any more than Harding or Peri, is a modernist transplanted into the twenty-first century, engaged in a satisfying return to old fashioned aesthetics. Rothschild sees much of her practice as 'anti-

30 Eva Rothschild *Your Weakness*, 2003, ebony, lacquered wood, 61 x 118 x 63 cm (24 x 46 ⅜ x 24 ¾ in)

modernist'[19] – though we might qualify this by seeing that opposition as challenging the separation of modernism into formalist aesthetics and utopian projects that became little more than design schools, producing luxury items for the haute bourgeoisie. Rothschild's critique of modernism would then reside in illustrating the consequences of that separation for utopianism – because few modernist artists were prepared to fully think through the historical relevance of aesthetics to the subject, preferring instead to subside into the mantra of 'art for art's sake' or an elitist consumerism. Rothschild sees her project as making work that looks formally satisfying, but which then bears a whole set of other values. None of the artists in this study, whose work addresses modernism, is interested in nostalgia or retrenchment. For if modernism, like modernity, may be an incomplete project it is necessarily one in which the discourses of aesthetics and history are not sealed off as bankrupt or failed. Rather, to borrow the words of Robert Morris, modernism itself is a 'continuous project, altered daily', as much as everyday life is.[20] In this situation art historical 'continuity' looks less like obeisance to precedent and more like an ongoing dog fight between form, content and history, which, despite the visions of some 'post-modern' theorists, is what modernism always was.

'Early One Morning' was, in retrospect, a hugely important exhibition; one of a few key shows in the shift of recent British art towards seriousness and responsibility. Discussing her work, one point that Rothschild was keen to emphasize was the degree to which it was 'work', a serious practice, in which she as an artist was singularly responsible for what she did. (A condition that sounds interestingly close to the kind of subjective autonomy and agency on which modernism so much relied, and rather remote from the couldn't-care-less attitude which many young British artists presented to the public,

Shahin Afrassiabi: above left **31** and right **32** *Display with Nails & Paint* (details), 2001, mixed media, dimensions variable

no matter how serious they were in secret.)[21] In staging a show of abstract sculpture by five young artists (Rothschild, Shahin Afrassiabi, Gary Webb, Clare Barclay and Jim Lambie), the Whitechapel was acknowledging that kind of seriousness, coupled to a renewed interest in non-figurative art, which had been manifesting itself in small shows around London for several years.[22] Where 'Early One Morning' twisted that new work to its own curatorial agenda was to suggest, in its construction of particular art historical relations, that formalism was back in fashion. What the show actually represented was, as J.J. Charlesworth diagnosed, 'a very contemporary problem afflicting the status of gallery aesthetics and its relation to the wider culture'.[23]

Perhaps nowhere was that problem more visible than in the work of Shahin Afrassiabi. Afrassiabi (b. 1967) presented sculpture that was at once coolly

modernist in its arrangement of forms, yet which used appropriated, everyday materials [31–32]. Such was the destabilizing effect of this sculpture for the spectator that in the same moment one could be looking at a profoundly formal exercise in the relation of shapes, and an interrogation of the effects that one form has upon another in juxtaposition, *and* at a wildly informal, heterogeneous assemblage cobbled together out of necessity. In fact, you weren't certain that 'sculpture' was what you were looking at: these structures might have been life-sized architectural models, or even informal spaces where lives might actually be squeezed in. Afrassiabi's raw materials were those of the DIY store: MDF boards; gyproc panels; wooden frames; plastic piping; cardboard boxes. The unopened tins of paint, bottles of cleaning products and rolls of paper suggested the structure was yet to be completed [34]. Modernism here, as 'work of art', certainly seemed to remain open-ended and in process, even as its forms appeared to be fixed in 'artistic' relation.

The conscious antagonism between formal and informal was, for its artist, rooted in a critique of modernist architecture as much as it was in sculpture. Two vital points of reference for Afrassiabi are Le Corbusier's formal, purist, design for living and the informal architecture of the shanty town and the squatter settlement, spaces for living, but not 'designed'. These seemingly incompatible forms – one the apotheosis of urban and architectural utopianism, the other both symptom and consequence of its debacle – find themselves in intimate juxtaposition in those non-Western cities (Niemeyer's Brasilia or Corbusier's Chandigarh) where mid-century modernist ideals were laid down as universal paradigms by developing economies without thought for local histories or the very economic conditions from which that utopianism sprang. At the edges of almost every city south of the equator there are settlements of 'houses' built like Afrassiabi's sculptures.

LIVERPOOL JOHN MOORES UNIVERSITY
Aldham Robarts L.R.C.
TEL. 0151 231 3701/3634

(Except there the materials may not be so new but rather scavenged; the very newness of his materials accentuates the pathos between aspiration and reality even as it contributes to our reading of the work as 'sculpture' rather than 'assemblage'.) Built without apparent rhyme or reason – except for the pressing reason of having a roof above one's head, the reason of having a more private space than the street – these homes nonetheless strangely mimic the abstracted juxtapositions of the perfectly modulated, rationalized architecture of the concrete monoliths they fringe. For an exhibition seemingly so premised on a history of formalism, the Whitechapel's curators could have found few artists more concerned with the politics of form than Afrassiabi.

That interest in the architectural manifestations of modernism in part springs from the artist's own experience, growing up in Iran in the 1970s surrounded by what he calls 'compromised emulation'.[24] But a vital point of address for Afrassiabi is also the moment at which the aesthetic, as pure form, rather than a form that might have a social purpose, emerges within modernism. Looking at a recent untitled work, its intersecting planes of wood demanding references to the corner structures of Tatlin or the *Prouns* of El Lissitsky, one was suddenly struck, as Afrassiabi moved one part of the work away from the rest, by the ease with which it became modernist 'furniture': one was looking at a coffee table and corner seat, made in the manner of the De Stijl artist Reitveld's famous chair.

Here Afrassiabi, as a sculptor, touches upon that fundamental condition of modernist abstraction which is also understood by Peter Peri, as a painter, and recognized by Andrew Benjamin as a philosopher, that it is a generative term – it has potential and will become something, and cannot be understood as representation since it had not pre-existed.[25] The displacement from the abstracted aesthetic that nonetheless contributed to the imagination of

33 Shahin Afrassiabi *Jalousie gelocht als blendschutz*, 2000, mixed media, dimensions variable

a utopian project, to a realized aesthetic that operated only as object for the privileged few, is a process repeated in modernism's history from the *maison cubiste* and Delaunay-Terk's 'Casa Sonia' to the Bauhaus. It is also a model for that closure of the gap between art and life, by commerce, which Hal Foster addresses. Central to Afrassiabi's project is 'a bloody-minded attempt at turning the equation round', an effort to move the designed, and the utopian, even as it 'becomes' a thing, out of the register of the aesthetic object.[26]

Afrassiabi's willingness to use materials from everyday life provokes a further set of questions, concerning how artists can establish forms of practice relevant to their own historical moment, and regain some degree of

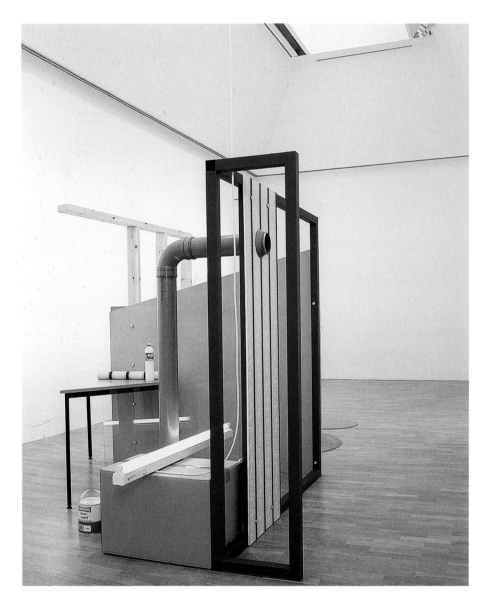

34 Shahin Afrassiabi *Display With Table*, 2002, mixed media, dimensions variable

syntactical control over their art. The modernist's gestures of appropriation –
whether in collage or assemblage – presumed that the salvaged or sampled
object could be elevated to the superior plane of art. The citation of the forms

35 Shahin Afrassiabi *Window 2000*, 2000, mixed media, dimensions variable

of mass culture that characterized post-modern practice laboured under no

such burden. Rather, post-modernism ceded the rhetorical felicity of art – the

extraction of a different syntax from everyday material – to the syntactical pre-

eminence of mass cultural forms. Where modernist art had laboured to speak on behalf of the human against oppressive forms and effects, the language of post-modernist artists was exactly that of those dehumanizing and diverting features of industrial and post-industrial society – advertising, feature films, popular music – that stopped you being a participant in your culture and made you a consumer. Because the gap between art and life had closed there was, it seemed, nowhere for artists now to act autonomously. One of the reasons why Afrassiabi's art is so fascinating is the degree to which it re-engages modernist syntax with everyday materials, without ever sliding into the hyperbolized 'design as art' strategy that characterizes the work of an artist like Andrea Zittel. Rather Afrassiabi makes that engagement in full knowledge of modernism's second catastrophe, instead of acting as if it never happened. For if the first catastrophe was one of history, the second – post-modernism's slide into citation – is one of language, where the capacity for expression yields to the rhetoric of the designed object.

Afrassiabi's sculptures work because they vitiate the aesthetic content from objects where 'design' or the aesthetic is crucial to commerce. They are, in a way, IKEA's worst nightmare – flat-pack assemblages that look like flat-pack assemblages rather than simulacra of 'design'. There is a limited tradition of this kind of practice – grounded in late modernism, with Gordon Matta-Clark's deconstructive architectural projects, and developed more recently by the Portuguese artist Pedro Cabrita-Reis [36], the Frenchman Mathieu Mercier, and the Israeli Nahum Tervet. But Afrassiabi's work concentrates its attention in a particular way on the point at which aspiration becomes commoditization. This often leads to an attention upon information; his sculptures include assembly instructions. One piece carried an advertisement for a senior officer with a local government authority, responsible for the

36 Pedro Cabrita-Reis *Longer Journeys*, 2003, painted aluminium, standard plywood doors and fluorescent lights, 400 x 2300 x 440 cm (157 ½ x 905 ½ x 173 ¼ in)

renewal of housing stock and phrased, of course, not in the language of utopia but the optimistic yet neutral double-speak of social management.

But there were also moments when modernity's aspirations were its own worst nightmare – as an artist you perhaps needed do nothing more than be a witness. Ori Gersht (b. 1967) is an Israeli-born photographer who has lived and worked in London for many years. Modernism's capacity for self-inflicted wounds has become one of his principal subjects. Gersht has always shown an affinity for high-rise housing, some of his earliest exercises in creating

sublimity from the mundane urban experience came from leaving his camera pointing at the sky on a long exposure, out of the window of the fourteenth floor of the tower block in Vauxhall where he lived [37–38].

His pictures from Sarajevo deliberately stressed the damage done by war to the blocks of flats in which the city's residents mostly lived. A recent series of images, made in Poland, strikingly combine the problems of modernity addressed by Harding and Afrassiabi through a negation of aesthetics, with the everyday problem of making and living in a concrete, and inevitably

Ori Gersht: opposite **37** *Rear Window I* (Vauxhall), 1998, C-type print, 120 x 120 cm (47 ¼ x 47 ¼ in); above **38** *Rear Window II* (Vauxhall), 1998, C-type print, 120 x 120 cm (47 ¼ x 47 ¼ in); overleaf **39** *Border Line, Colour Block I*, 2000, C-type print, 180 x 120 cm (70 ⅞ x 47 ¼ in)

flawed, attempt at a utopia. These multi-coloured buildings were decorated in this way during the Communist era: the colour fields were applied to make these expressions of modernist architecture more habitable. On its own the grid was either inadequately utopian or simply aesthetically insufferable [39–41].

The grid was the foundation of utopia – an equal division of space for all that could be realized in the street plan, and rotated into the vertical to create communal and identical living spaces. As Harding's work implies, the grid not only fails, it exists in a tension with surface and with colour – the appeal to a pure, individual phenomenology of perception, and to an anti-modernist, bourgeois, convention of beauty. Looking at Gersht's photographs of some of the more ebulliently decorated buildings in this city, you might be looking at Harding's work on the grand scale. Unconsciously, and in a failed attempt to stave off the chilly implications of a rationalist, modern utopia, the town planners worked out Harding's thesis on the architectural surfaces of modernism itself. The grids, of course, do not slump irrationally – their 'irrationality', their pattern, is itself a product of rational thinking – and that, in itself, was part of the problem rather than a solution to the demands of standardization of space and subject that utopia demands.

Ori Gersht: above **40** *Border Line, Colour Block II*, 2005, C-type print, 180 x 120 cm (70 ⅞ x 47 ¼ in); opposite **41** *Border Line, Colour Block III*, 2005, C-type print, 180 x 120 cm (70 ⅞ x 47 ¼ in)

LIVERPOOL JOHN MOORES UNIVERSITY
LEARNING SERVICES

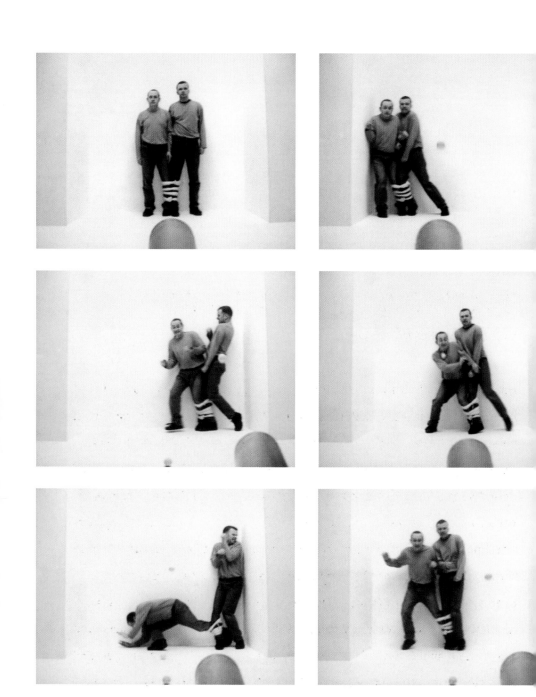

42 John Wood and Paul Harrison *3-Legged*, 1996, video (Hi8 transferred to DVD), 3 mins

THINGS FALL APART

video, the body & space

Having dealt primarily with painting and sculpture, and with a revival of interest in aesthetics and the modernist thematic, it may seem somewhat perverse to introduce the work of John Wood (b. 1969) and Paul Harrison (b. 1966): Wood and Harrison work collaboratively using video – apparently the definitive 'post-modern' medium. Rosalind Krauss suggests that when artists began making videos in the late 1960s they used the medium simply 'as a technologically updated continuation of the mode of address organized by the new attention to the phenomenological although it was a perverse version of this since the form it took was decidedly narcissistic'.[1] (Krauss had been discussing the shift of conceptual artists and structural filmmakers, and colour field painters in the 1960s, towards concerns with 'opticality' and characteristics of the subjective relation to the work.) That initial 'modernist' use of video, simply as a substitute for the film camera, seemed to depend

43 John Wood and Paul Harrison *Hundredweight*, 2003, six-channel video installation (Mini DV transferred to DVD), continuous loop

upon a failure to analyse video's *difference* from film – in the terms of modernist theory, its own distinctive properties as a medium – perhaps because, as the cultural theorist and scholar Fredric Jameson has observed, historically it 'came too late for that kind of theoretical codification'.[2] This may, indeed, have been an impossible task since Krauss suggests that video occupied 'a kind of discursive chaos, a heterogeneity of activities that could not be theorized as coherent or conceived as having something like an essence or unifying core'.[3]

In their use of a fixed camera, their emphasis on their own presence in the work and their widespread refusal of editing, Wood and Harrison's projects seem to refer back to those first 'narcissistic' encounters between artists and the new medium that we find in the late 1960s and early 1970s in the oeuvres

of Vito Acconci and Bruce Nauman. Crucially, however, I'd suggest that Wood and Harrison's work does more than recapitulate performances of the self, for the self. Rather, in the performative element of their work and in the attention paid to the relationship between body and space, Wood and Harrison revive – within video – the late modernist attention to process that is manifested in sculpture by an artist such as Richard Serra or in performances and works for film by Gordon Matta-Clark and Bas Jan Ader. Furthermore, we might see them as providing, belatedly, a kind of link between video artists such as Nauman and Peter Campus and Serra's project, as it was realized in both film and large-scale, site-specific sculpture. Fundamental to that project is the revelation to the spectator of how he or she is placed within the world – a revelation largely achieved by an insistence on transitivity between spectator and object, either as material process or impermanent location. Without overtheorizing video, Nauman and Campus's installation projects, and Joan Jonas's performances where she incorporated the medium, refused the equation that video equalled television – that it was a medium 'that splinters spatial continuity into remote areas of broadcast and reception'.[4] Instead works such as Nauman's *Going Around the Corner Piece* (1972) or Campus's *Interface* (1972) and *Optical Sockets* (1972–73), and Jonas's *Organic Honey's Visual Telepathy* (1972) used a medium-specific characteristic of video (live signal) to explore the transitive relation of the body in space to human subjectivity in a defined performative field. Wood and Harrison, like Nauman in his studio films and videos or Ader in his *Fall* films, work this relation out through the mismatch between body and space.

An early piece such as *3-Legged* (1996) [42] – in which the duo, tied together by a leg, dodge tennis balls being fired at them – has overtones of the kind of performances enacted for video (and film) by Vito Acconci. We might parallel it with *Blindfolded Catching* (1970) in which Acconci, blindfolded, tries to grasp

balls being thrown at his body [44]. We might also see *3-Legged* as a parody of Chris Burden's *Shoot* (1971) – in which the artist was shot at, and wounded, by a companion – and related, not least in its humour, to Rebecca Horn's *Keep those legs from cheating each other* (1974–75), a film that's very much about the relation of one body to another in space. At the same time, however, the increasing tiredness of the performers reminds us of the entropy that characterizes the isolated human gestures and engagements with objects in Serra's early films *Hand Catching Lead* and *Hands Scraping* (both 1968). When Richard Dorment, writing of *Hundredweight* (2003) [43, 46], commented that the work looked 'as though Harrison and Wood sat down before beginning work and made a list of all the verbs that describe the actions an artist could perform on a white surface: to bisect, to circumscribe, to outline, to coil, to splash, to roll.'[5] he was, I think,

44 Vito Acconci *Blindfolded Catching*, 1970, super 8 film, 3 mins

deliberately, if silently, referencing Serra's *Verb List* (1967–68), a text work that acts as a primer for his subsequent project of process art.

Poise, the possible transitivity of both object and spectator where both have the potential to become something else, is central to Serra's questioning of the relationship of forms in space once he moves on from the relationship of forms to time. In *Hundredweight*, however, Wood and Harrison seem to work consciously against such a delicate equilibrium. In one tape, for example, the movement of the figure amongst a field of delicately balanced grey plastic tubes causes a collapse of one against another [46]. But the consequence of this corporeally induced catastrophe is not 'chaos'; rather – because the event is shot from directly overhead – it is an arrangement of lines that seems like an abstract, constructivist drawing rendered on a flat white plane. What was three-dimensional and tangible becomes two-dimensional and abstract. What

81

happens with the body in a Wood and Harrison video is, then, very different from its self-obsessed fate in much late modernist performance. In part this difference is achieved through humour: many of these tapes are, deliberately, funny. The humour often lies in failure – much as there is a humour in Nauman's *Bouncing Two Balls between the Floor and Ceiling with Changing Rhythms* (1967–68) because the banal proposition goes wrong, and the refusal to intervene in its representation, by editing, is essential to this. If repetition, rhythm and the idealizing of success are essential to the conception of modernity – whether in the operations of capital or the resolving, uplifting, narratives of the central protagonists of Hollywood movies – Nauman is intent on telling us, as Samuel Beckett does in his plays, that things fail, and next time all you can do is fail better. If individual success is an ideology of technological modernity, promulgated in extreme bad faith, failure is its revelatory twin within modernism. Wood and Harrison are working in this tradition. When we see Paul Harrison, in *Plastic Bag* (2002) – from the series *Twenty Six (Drawing and Falling Things)* (2002) – where a heavy shopping bag that he has been carrying on his head flies upwards, out of frame, and then crashes to earth, just missing him, we are seeing the body imperilled, learning that things can go badly wrong [45]. But we learn this in a comedic way: we are watching slapstick.

45 John Wood and Paul Harrison *Plastic Bag* from the series *Twenty Six (Drawing and Falling Things)*, 2001, video (Mini DV transferred to DVD), 50 seconds

Comedians from the age of silent cinema, and the first years of sound, have been invoked often enough already in reference to Wood and Harrison, whether Buster Keaton or Laurel and Hardy, along with Beckett's clownish tramps Vladimir and Estragon. Richard Nonas, one of the key artists in the Anarchitecture project that included Matta-Clark, has remarked that Harold Lloyd was a hugely important figure to young artists in the early 1970s post-minimal art scene in New York – to whom Matta-Clark paid tribute in his extraordinary performance *Clockshower* (1974).[6] One senses a similar appeal to Lloyd's bathetic tradition, as much as to Keaton's, in many of Bas Jan Ader's films, and even in the early work of Steve McQueen in the mid-1990s. The master of such comedy, however, was Charlie Chaplin; and Chaplin, despite being rooted in mass culture, is a figure of crucial significance to modernism. This is because he makes himself symbolic of the relation of the bewildered human subject to modernity; he is always out of step. As Michael Jennings puts it, Chaplin allowed 'the mass of humans to see their own alienation, to recognize the fragmented, oppressive character of history'.[7] Chaplin accomplished this through the fragmentary relation of his body to space and time, to 'modern' experience – his is a body that does not 'understand' the speed and repetition of the conveyor belt, of mechanized transport, or even, as the German philosopher Walter Benjamin observed in the 1930s, the film with

which he was depicted.[8] That fragmentation was acknowledged in modernist film's most obvious engagement with the effects of industrial mechanization – Léger's *Ballet mécanique* (1924), where Léger films the disintegration of a puppet figure of the comedian. In returning to the alienation of the body to space, Wood and Harrison are perhaps returning to the same problem that concerned Léger – for contrary to the way in which the film has often been described, *Ballet mécanique* is as much a resistance to modernity as it is a celebration of it.[9] Léger perhaps wishes to endow with character the very thing that is being drained of character in the machine age – the human. After all, Léger himself would remark, only a few years later, of the industrial regulation of time and the body that became known as 'Taylorization': 'This merciless mechanic of time takes away all fantasy, all feeling of adventure from life.'[10]

Is it, surely, a declaration of irrelevance as far as our current, everyday lives are concerned for artists to remain concerned with issues that were pressing in the 1920s? After all, we have moved from an economy of manufacture, in which the subordination of the human subject to the machine was essential, to economies of 'service' or 'creativity' or 'knowledge', haven't we? But do those economies, far from delivering the subjective autonomy they promise – and I hastily exclude the service economy from even that false prospect – actually bind us in a different form of servitude: one that substitutes the digital and the electronic for the mechanical? Subjective time and space are at least as managed now as in the industrial revolution: you may not punch in and out on a factory clock, but you may be electronically tagged, conversation-recorded or video-monitored by your employer so that you can operate more efficiently. Adventure itself becomes permitted only as a form of social discipline so that players are played *with* by the electronic games they play, games that become diverting simulacra from the possibility of real experience.[11]

I'd suggest that central to Wood and Harrison's project, and most obviously manifest in *Hundredweight*, is a further dialectic in the relation between body and space. This concerns another characteristic that is specific to video as a medium and its relation to the possibility of play. As the American theorist Miriam Bratu Hansen has pointed out in an acute analysis of the relevance for our own time of Walter Benjamin's writing on cinema in the 1920s and 1930s: 'Today, the "huge gain in room-for-play" inaugurated by the photographic media is more than matched by the industrial production and circulation of phantasmagoria.'[12] What we get in the thirty-six individual 'cells' that constitute *Hundredweight* are 'rooms for play' in which real experience is recorded, and lived with, rather than edited to be wholly efficient fantasies, in which everyone is always a winner – the promise of both computer games and consumer capitalism. There may be limits to the extent of that experience – Wood and Harrison don't try to match the narcissistic punishments enacted on the body by 1970s performance artists like Burden, Gina Pane or Kim Jones, let alone Rudolf Schwartzkogler – but what we see are real, if rehearsed, actions – as much as Serra's hand, catching lead. What we also see are disconnected actions rather than narratives; things happen without much point. It is as though what we see are the actions of 'clowns'. And there is, as both Jean Starobinski and Gian-Paolo Biasin have separately pointed out, a continuous rearticulation of the figures of the *commedia dell'arte* by modernist artists as diverse as Stravinsky, Schoenberg, Picasso, Cézanne and Svevo.[13] Chaplin, and those in his wake such as Lloyd and Keaton, can be understood as working out, largely intuitively, that same anti-heroic misfit of body to modernity as interested, in a more calculated way, the poets, painters and composers of high modernism. It is this, I would suggest, that is being acknowledged by Léger in *Ballet mécanique*.

46 John Wood and Paul Harrison *Hundredweight*, 2003, six-channel video installation (Mini DV transferred to DVD), continuous loop

But where Serra's repetitive play, and Chaplin's ludic disintegration, were enacted on single screens, and where experiment in multiple screens in 'expanded cinema' during the 1970s never got beyond a handful of projectors, Wood and Harrison use *Hundredweight* to deal with multiplicity. They use that multiplicity to defeat a teleology that is, perhaps, implicit to film, and which makes it so useful as a mass cultural form harnessed to economic and social ideologies that are equally dependent on the prospect of a historical resolution (be it individual prosperity or the dictatorship of the proletariat). Video may be a medium of remote broadcast, but it is also a medium of simultaneity (within the screen) and multiplicity (numbers of screens) in a way that film can never be. *Hundredweight* consisted of six monitors, each

playing six videos, against each other, but it might have been sixty. In its fragmentation of the visual field, the work was true to our own experience of the fractured reception of images, and the oversaturation of public space by the image, so that we may never concentrate properly upon a single image again. In such circumstances our gaze becomes as ill-fitted to the image as Chaplin's body was to space and time. Wood and Harrison's 'clowning' made clear our alienation from the image and from the possibility of attention, and yet, with the technology that now should achieve a diverting phantasm, it refused to show us anything beyond two ordinary men, doing ordinary things in a room. There is a profound, and illuminating, discordance between the medium and what it mediates. In this sense *Hundredweight* 'unveils and refracts the everyday ... making it available for play'[14] with the same radical possibilities for the spectator as Benjamin saw in the montage of Eisenstein's *Battleship Potemkin*, which Svevo found in his anti-heroic Zeno, and Serra then discovered in the space around his sculptures.

47 Clare Woods *Finger Post*, 2004, gloss paint on aluminium, 152 x 122 x 3 cm (59 ³⁄₄ x 48 ¹⁄₁₆ x 1 ¹⁄₄ in)

WHAT LIES BENEATH

real life & the veneer of cultural economics

The photographs made by Anne Hardy (b. 1970) present us with what Julie Milne calls 'a dark and convincing parallel reality'.[1] In some ways she is like Shahin Afrassiabi, only his parallel reality is that of the shanty-town to the modernist utopia. Hardy's world is rather closer to home, and there is a pervasive sense of catastrophe or at least the foreboding of catastrophe, rather than of making do, of striving to live despite the odds. Against the once dominant conventions of photography, but within an equally old, parallel tradition, Hardy's work is completely staged. But this is not photography arranged on the scale of Jeff Wall or Gregory Crewdson, using actors, assistants and the budgets of independent filmmaking to produce one picture. Her bleak architectural spaces are constructed within a tiny studio in a disused hardware store on an east London side street; indeed they are only a little smaller than that studio. Hardy's first act is work out where the camera will be,

what will be visible through the viewfinder; then she builds the set around it. With her images, fabrication and fiction always ends just a fraction outside the edge of the picture. But at the same time, the attention to surface in Anne Hardy's work, the manner in which the image creates the sense of a veneer hastily fixed over decay, a veneer that will eventually come loose, causes us to question what fabrication is, and in turn try to construct the truth that the fiction is trying to conceal.

Hardy comments that it's important to her that her spaces are ones that 'start doing their own thing'.[2] By this she means both that the structures she creates establish a certain autonomy from her as an artist, and that process – in particular that of decay, of entropy or 'winding down' – is vital. It's that interest in process that separates her from other, now well-established photographers, such as Crewdson, Thomas Demand and James Casebere who create architectural spaces. Much of Crewdson's work in the 1990s invoked the catastrophe, but in a way that was profoundly cinematic or theatrical, and always concentrating on the event rather than the process. The same could be said of Casebere's scaled-down models of flooded American colonial buildings or Japanese houses half filled by landslips. For both it was as if the tradition of the decisive moment, exemplified by Cartier-Bresson, had been imported from the realist tradition of photography as a ready-made condition for the intelligibility of the staged image. Hardy deliberately allows nature a hand in the work; as she puts it, time is built into the image through detail and the working process, the act of construction, becomes part of history. Each photograph she makes may take up to two months to complete, in part because the set needs to gain its own atmosphere, its own sense of presence. Talking about the set of *Drift* [48] as it was under construction, Hardy remarked: 'It looks very new and clean and fresh. I am

48 Anne Hardy *Drift*, 2004, C-print diasec mounted, 120 x 180 cm (47 ¼ x 70 ⅞ in)

49 Anne Hardy *Cell*, 2004, C-print diasec mounted, 120 x 150 cm (47 ¼ x 59 ¹/₁₆ in)

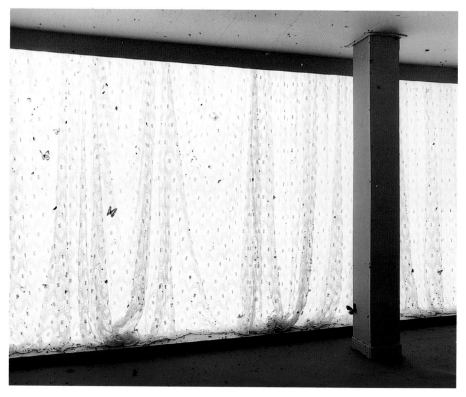

50 Anne Hardy *Untitled III (Office)*, 2005, C-print diasec mounted, 120 x 150 cm (47 $\frac{1}{4}$ x 59 $\frac{1}{16}$ in)

using new glass. I just try to get it to a stage where it looks like it's been occupied;
not necessarily lived in, but as if there have been activities going on in there.'[3]

The signs of decay are everywhere in Hardy's photographs, whether it's the
leaves piled up in *Drift* (2004), the insects in *Untitled III (Office)* (2005), the
ingrained dirt on the wall in *Swoop* (2003) or the needle-shedding Christmas
trees in *Lumber* (2003) [48–52]. What's also pervasive about these works is their
confusion of inside and outside. Not only are you made aware that the cheap
panels used in this architecture are inadequate to the task of covering
whatever it is that lies beneath; you are constantly confused about which side
of that divide you, as spectator, are on. Are you being protected from this decay,
or are you part of the problem that's being swept under the carpet or tacked
behind a fake wood board? The insulating foam squeezed between those

51　Anne Hardy *Swoop*, 2003, C-print diasec mounted, 120 x 150 cm (47 ¼ x 59 ¹⁄₁₆ in)

panels in *Untitled IV (Balloons)* (2005) is extruded towards you like a weird fungal growth [53]. You know that the smooth, presentable surface is facing away from you, excluding you.

Drift, with its defunct dials and levers, is perhaps the work that most directly addresses a failure of modernity, but throughout Hardy's oeuvre there is a sense that what seems modern, clean, fashionable is simply the fixing of a surface over problems that have not actually been dealt with, but simply covered up [48]. Furthermore, that pristine exterior has a limited shelf life; it's not built to last, merely to persuade you that it works right now. This is where Hardy's work becomes particularly interesting as metaphor. In a way, she is resolutely modernist: though staged rather than 'real' or found, her photographs remind one of the images that the philosopher Georges Bataille

52 Anne Hardy *Lumber*, 2003, C-print diasec mounted, 120 x 150 cm (47 ¼ x 59 ¹⁄₁₆ in)

used to illustrate his brief 'scientific' definitions of processes, objects and categories in *Documents* in the early 1930s. There is a real affinity, for example between Bataille's illustration for his essay *'Pousser'* ('Dust'), on entropy, with its stacked-up mannequins, and Hardy's 'behind the scenes' pictures. Bataille, of course, was equally as fond of the fly as a symbol of decay as Hardy is when she introduces it in *Untitled III (Office)* (2005) [50].[4] His bleak, at times 'excremental', counter-surrealism – so antagonistic to André Breton's official line, is, of course, a modernism that counters modernism, which forces us to rethink the utopian potential (the idealism) that was laid upon materialist philosophy in the face of history. (Bataille, perhaps more than any other 1930s thinker, analysed the implications of Fascism even as he consciously flirted

53 Anne Hardy *Untitled IV (Balloons)*, 2005, C-print diasec mounted, 120 x 150 cm (47 ¼ x 59 ¹⁄₁₆ in)

with its motifs in novels such as *Le Bleu du Ciel*.) The 1930s thinker and the artist of the new millennium both see the warped, dilapidated underside of the project of modernity, its dialectic of abjection and elevation. For Hardy, of course, the reference is to where she is today, as an artist of the present moment, rather than a self-conscious point of historical allusion.

Hardy's locale – for a while – has been synonymous with British art; many of its studios, a number of its more influential younger galleries, such as Modern Art, IBID Projects and Wilkinson, and many ephemeral artist-run spaces are in the district. Looking at her cramped, provisional studio space one can't help seeing the work as an oblique commentary on 'modernity', fashion, and art's role as a catalyst in that process. Increasingly, those parts of London where

artists chose to live and work – which were often the most deprived, damaged, dilapidated spaces in London, with social problems to match – have become districts characterized by an appearance of fashionability and improvement. Art has been part of that process of refashioning, though it is increasingly redundant, increasingly an irritant to the real business of property development. Just down the street from Hardy's studio are several large buildings that were once factories; left empty by the early 1980s they became artist's studios – not because they were advertised as such, but because they were large, cheap spaces and no one else was much interested. Recently they were converted into 'loft-style spaces' and sold or rented to trendy metropolitan types, who without the sheen of glamour given to the area by the artists (who'd just been evicted) wouldn't have been seen dead in the area. The glamour of British art in the 1990s created a situation in east London where the presence of artists acted as a not-altogether-inadvertent catalyst for the growth of property values. And one consequence of that economic transformation of space is that artists are increasingly squeezed out of areas that were once 'theirs'.

Actually, those spaces weren't ever 'theirs': one characteristic of inner-city areas is that no one really much belongs. From the 1970s onwards artists took advantage of decrepitude in east London as much as they once did in Bankside in the 1960s. But at least they lived and worked within those spaces; the freshly suborned graduates moving into converted factories and schools down the street from Hardy's studio won't work here. What was once a community is now, increasingly, a dormitory for apprentices to the digital mills of late capitalism, still bright-eyed and flush with salary. And the suggestion of modern, clean, attractive housing doesn't actually mean that the real social problems these districts contained have been solved. In some ways they've

been made worse: what was once a cheap place to rent housing, relatively near your work, if you were a £6-an-hour cleaner in the City, for example, is now an expensive place, because better-paid office workers just moved in. Patrick Wright's seminal book from the 1980s – *On Living in an Old Country* – understood places like Hackney and Bow as real because they didn't have a surface; always visceral, life was sometimes too raw to touch.[5] Looking at Hardy's work you can't help reflecting on living now in a society where appearance, surface, is everything, because that's not only her subject, it's where the work is made. But, as Hardy is keen to make us see, there are two sides to every façade – and you might not be on the right side of the divide.

Clare Woods's studio is equally emblematic of the way that art has catalysed particular social effects and is now threatened by them. Her building, preserved by an intransigent and idiosyncratic leaseholder against the blandishments of construction companies, sits in the middle of what will soon be a huge complex of new, 'designer' flats. Access is not easy – the place could almost be a spatial manifestation of one of those crypts in the unconscious, proposed by the psychoanalysts Nicholas Abraham and Maria Torok, where we keep memories we didn't know we had. This building is a memory of old, artists' London, a relic of community and practices that weren't necessarily driven by the art market, buried as an irritant in a structure of the perpetual present where nothing exists but the market.

This part of east London was once upon a time mythologized by right-wing newspapers as a district where every house was a crack-den and every other person on the street a mugger. Even if it really wasn't like that, it's true that even today the Metropolitan Police parks a few vans from an armed response unit just up the road – though whether that's to save time or just for old-times' sake is a matter of opinion. Clare Woods (b. 1972) feels safe and comfortable

LIVERPOOL JOHN MOORES UNIVERSITY
LEARNING SERVICES

here – at least in comparison to the English landscape that is so often the subject of her paintings. In a brief meditation on her work for the art magazine *Frieze*, in which she admitted to 'a real fear of the countryside',[6] Woods quoted a line from Sherlock Holmes: 'The lowest and vilest alleys in London do not present a more smiling record of sin than does the smiling and beautiful countryside.'[7] Conventionally, we expect images of the countryside to be tranquil rural arcadias in contrast to typical representations of the city as redolent of dystopia and bedlam. This is especially the case with English art, where even with the coded and buried representations of rural change and poverty that John Barrell has discerned in eighteenth-century painting,[8] or the depictions of the impact of modernity upon the land found in inter-war painters like Roland Vivian Pitchforth, we may comfortably set off Constable

Clare Woods: left **54** *Charley Boy*, 2004, enamel on aluminium, 218 x 175 cm (85 7/8 x 68 7/8 in); opposite **55** *House of Hill*, 2001, enamel on aluminium, 152.4 x 244 cm (60 x 96 1/16 in)

against John Martin's 'city-as-hell' or even the gloom and grime of Sickert. The land is assumed to be the place of safe retreat, where one goes to think and paint; Woods contradicts the privileging of Charleston against Bloomsbury, or of St Ives against Chelsea. Why stay in Hackney to paint Hertfordshire, Herefordshire and Hampshire? Perhaps because the countryside is not always as benevolent as it seems; perhaps because there is a rethinking of national identity going on, in our major cities and amongst our intellectuals, which sees the kind of Britishness that's so embedded in our landscape as an increasingly introverted brutishness.

In itself this attitude to the countryside is not completely new: at much the same time as British modernism celebrated the British landscape in the 1920s and 1930s, whether in Paul Nash's paintings and photographs, avant-garde films like Braun and Nicholson's *Beyond this Open Road* or Auden's early poems, Stella Gibbons was delivering her wonderful comic novel *Cold Comfort Farm*. Woods's paintings may be nearer in feel to feature films of the 1960s and later, such as *The Wicker Man* and *The Hills Have Eyes*, but there is a pervasive sense of

56 Clare Woods *Failed Back*, 2004, enamel on aluminium, 330 x 800 x 2 cm (130 x 315 x ¹³⁄₁₆ in)

there being 'something nasty in the woodshed' about them. These paintings continue a tradition of dialectical relation between the country and the city that has long characterized British culture,[9] and also find something new to say about that coupling. Woods demonstrates that something of our present historical situation and identity (what it means to be British) can still be articulated within a representational genre (landscape) *and* a traditional mode (painting).

Perhaps being 'British' is now more founded in a schism between urban and rural than it is in finding any kind of commonality in either the long-standing traditions of the landscape or the 'heritage' myth that was peddled in the 1980s. That was the decade in which the contentious issues of the national past, debated and investigated as a grounding, however inadequate, for the public sphere, were transformed into spectacle and consumer goods. As examples of what happened in British culture one need only invoke the films of James Ivory and Ishmail Merchant. E. M. Forster's novel *Howard's End*, alembicated from rich debate on class and gender relations to its wishful desire to 'only connect', became a honey-lit advertisement for thick curtains

and the delights of Edwardian country-house living. The tensions that have emerged in our society between town and country in the last decade, for example between those who would ban hunting and those who see that ban as an assault on a particular way of life, between those farmers who produce food at basement prices for supermarkets and those urban dwellers who consume it without thought for the impoverishing consequences of cheap food, perhaps signify that there are, crudely, two kinds of 'Britishness' engaged within this island. It is, however, a debate between parties who can no longer appreciate where the other stands, and why. The ignorance of historical relation, both one's own and that of others, means that there is no connection

57 George Shaw *Scenes From The Passion: The Way Home*, 1999, Humbrol enamel on board, 75 x 100 cm (29 ½ x 39 ⅜ in)

58 George Shaw *Souvenirs*, 1999, photograph, 21 x 31 cm (8 ¼ x 12 ³/₁₆ in)

now between urban and rural, just as, for Forster, there was no connection between the culturally aspiring proletarian and savant bourgeois. Questions of boundary and identity, about that relation, are now amongst the central preoccupations of British art. Woods's paintings are a sign of how exacerbated that tension between town and country has become, of how we now have an increasingly international urban culture that sees boundaries of identity as mobile and permeable, and an arguably ever more harassed and impoverished rural culture that cleaves to long-gone notions of nationhood.

Woods's paintings don't say that of course; perhaps her greatest skill is in inhabiting an ambiguous space between abstraction and figuration. Her paintings are rendered in enamel on MDF or aluminium with intricately worked-out layers of colours, without shading, in lines or intricately edged shapes [54–56]. We seem to be in a tangle of branches in a wood at night, crawling through tree roots, up against a hedge, or face to furze in a field. But

these are not overtly representational paintings: the photographs that Woods published to accompany her 2004 exhibition 'Failed Back' are not a direct visual reservoir – rather they capture a certain unhappy or potentially malign spirit of the countryside [56]. The paintings themselves were based on photographs taken in woods at night, but we do not see that starting point. Woods is an abstractionist who evokes a particularly Gothic landscape, a mood and a mode of existence, rather than depicting directly what she sees. We can as easily read the paintings formally, through the arabesques and intersecting angles of their lines, the relation of dot to line to field. This is work with a very clear sense of its relation to a 'purist' modernist aesthetic but which nonetheless manages to gear its formalism both to traditions of representing landscape and to the pressing sense of being in the present moment.

Looking at a painting like George Shaw's *Scenes from the Passion: The Way Home* (1999), with its extraordinary attention to realistic detail, we perhaps see made plain the path through the trees that Clare Woods cannot find [57]. Yet there is still a threat, in those dark shadows and in the shrubbery. But as Shaw's other paintings quickly make clear, this is no rural space, but rather one of those back-path, interstitial spaces of suburbia, a short cut between a friend's house or school and home, in that idealized meeting space of rural and urban. In *Souvenirs* (1999), the half-grown arcadia is littered with pages from pornographic magazines [58]. These are the places where, as a kid you sneaked off school, built a den to smoke in secret and kept your shoplifted goods, spent afternoons masturbating over the magazines you stole from under Dad's side of the bed. If Woods's countryside is characterized by threat, Shaw's vision of another slice of Britain's space is pervasively melancholy and frustrated, both for adolescents and adults. At the same time, Shaw's is a strangely spiritual England; a land in search of redemption.

59 George Shaw *Scenes From The Passion: Back of the Club and the Bottom of the Steps*, 2001, Humbrol enamel on board, 77 x 101 cm (30 ⁵⁄₁₆ x 39 ³⁄₄ in)

Like Woods, Shaw (b. 1966) works from photographs and his preferred medium is enamel. But his enamels are the proprietary paints of aircraft and military modellers; designed for detail, to cover no more than a few centimetres of metal or plastic, not boards a metre square. (Not incidentally, most of the users of Humbrol are, I'd guess, teenage boys in their bedrooms, assembling model airplanes and tanks. With Shaw the medium itself is the memory.) As Tom Morton commented of Shaw's paints: 'brilliant at capturing looking-glass surfaces, they're pretty ineffective if you want to model something as complex as a bushy tree with a handful of brushstrokes. The medium forces Shaw to build up the woodland leaf by leaf, overlaying them one by one like tiny discrete memories.'[10] This is why the microscopically

detailed background of an early painting such as *Scenes from The Passion: The Burnt Tree* (1991), with its jewel-like foliage works better than the subject in the foreground. Shaw's vision is lapidary, but its reflective surfaces show us a grey, overcast or twilight world, devoid of people to walk on its rain-slicked pavements and amongst its graffiti-covered walls. The stone in this landscape is cement. Few signs of the human crop up in this environment – much of it modelled on the Tile Hill area of Coventry where Shaw's family still lives.

Shaw's paintings are a testimony to failure, to being a kid of the 1970s. And in particular they testify to the melancholia that informed that decade. Shaw manages to finally express a cultural depression founded on what couldn't then be spoken, even if it was, intuitively, understood. This was the certainty that the civic, collective post-war project, the yearning for a liberal, humane society, conceived as a corrective to the economic depression of the 1930s and its human consequences, simply wasn't going to work. From here on in there would be no such thing as society, only families and go-getting individuals. Tile Hill was built as a municipal development in the 1960s and 1970s, if not a utopia for the city's factory workers, then at least 'a better place'. But if his paintings have a colour it is grey – grey walls and paving, grey skies.

George Shaw: above left **60** *Ash Wednesday, 8.00am*; above right **61** *Ash Wednesday, 8.30am*; both images 2004–05, Humbrol enamel on board, 91 x 121 cm (35 ¹³⁄₁₆ x 47 ⅝ in)

Shaw's principal subject is concrete, and the detail demanded by his chosen medium is such that it is rendered in an almost obsessively 'concrete' way. Concrete was not only the chosen medium to structure and clad the kind of buildings that Shaw depicts in *Scenes From The Passion: Back of the Club and the Bottom of the Steps* (2001), concrete was the symbol of that new and hopeful age [59]. But concrete, it quickly transpired, was sensitive to both a lousy climate and bad publicity. Ugly names clung to it like the most adherent and gaudily graffitied name tags. Ian McEwan's definitive novel of the 1970s, *The Cement Garden*, is perhaps the ultimate cautionary tale about suburbia's erotic repressions – the crypt improvised by incestuous teens out of

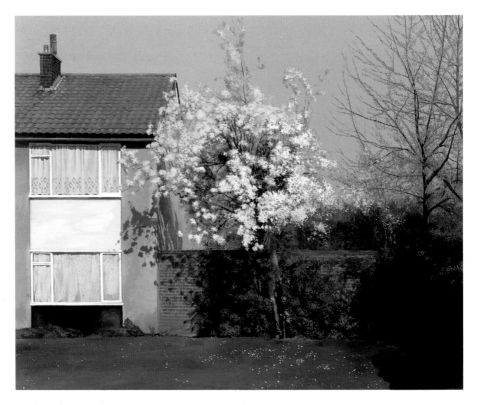

62 George Shaw *Scenes from the Passion: The Blossomiest Blossom*, 2001, Humbrol enamel on board, 42 x 53 cm (16 ⁹⁄₁₆ x 20 ⅞ in)

dead dad's unused sacks of cement to accommodate their now dead mother splits open, and the reek of putrefaction leaks into the neighbourhood.

Concrete was always doing that in the 1970s: rotting, breaking apart to reveal corruption. If it wasn't bodies corporeal and sexual it was bodies politic: a screen for sinecured councillors and dodgy businessmen siphoning off public funds in a miasma of civic sleaze. Intended to provide low-cost, enduring, public housing, concrete always seemed to fail in its promise. In that failure, these grey, miserable structures became a metaphor for the failure of modernist architecture and the political ideals – the sense of civic belonging and responsibility – for which that architecture stood. Shaw's painting has something in common with Shahin Afrassiabi's sculpture [31–35] or Ori Gersht's photographs of blocks of flats [39–41]: the subjects of his studious attention are equally 'compromised emulations' of modernist aspiration, they are an attempt on utopia without adequate information, a proper budget, or the collective will to achieve such a goal. And the absence of figures suggests that this is a space that no one wants to inhabit, or perhaps can't, without having their humanity so utterly diminished that they become invisible. The failed utopia reduces human presence to mere traces: paths in woods, litter and graffiti.

And yet there is a warmth about much of Shaw's painting, especially visible in his recent *Ash Wednesday* series. Perhaps there is a tint of nostalgia here, added by an artist grateful that he has escaped the confines of this stultifying world, perhaps a recognition that, even as we flee them, the suburbs make us what we are. We might become street-wise bohemians, savvy artists, metropolitan sophisticates – but there is some part of us that is forever the local idyll of suburbia [60–61]. If there's one thing that recent British artists have been good at, whether Tracey Emin with *Why I Never Became a Dancer* and *Self-Portrait* or Georgina Starr with her caravan, it's evoking memories of

their own childhood, or creating myths about origins. Often the memories are singularly bleak, ferociously aggressive towards the past. Perhaps this is something to do with punk's legacy – young artists continuing the tradition of rage against the perceived mediocrity of suburbia that was half-articulated by other middle-class kids who'd practised four chords in the garage or their bedroom. Shaw may be doing this, but there is too something larger and more generous in his work. Like other emerging painters – for example Melanie Carvalho, with her delicate, child-like figures in simply delineated, open landscapes, redolent in their deliberate innocence of Klee – Shaw's paintings are neither vengeful nor completely alienated. Rather they are charged with wistfulness about a past that didn't work, and perhaps a hope that something can yet be reclaimed from the human race.

This, I think, is where the concern with redemption manifests itself. The titles that Shaw chooses for his series depicting Tile Hill – *Scenes from the Passion* and *Ash Wednesday* are overtly religious in their reference. With the former we follow Christ's passage through Jerusalem from Gethsemane to Calvary, in the latter we are at the start of Lent – a time for penitence. Tile Hill was meant to be part of 'the new Jerusalem' of course; a material achievement of the kind of utopia – secure, affordable shelter, it's not that much to ask – for which working people had yearned for generations. There's something oddly Dante-esque about Shaw's work: he plays Virgil conducting us around the steps of Purgatory rather than the spheres of Paradise. The references to stairs in his painting are not only literal, but also a kind of spiritual, moral location for a culture that has yet to be redeemed. To reinforce this theme I'd first of all connect Shaw's evocation of Ash Wednesday as a penitential beginning to Eliot's opening of *The Four Quartets* with a poem of the same title. But Eliot separately published the third section of 'Ash Wednesday', *Som de l'escalina*

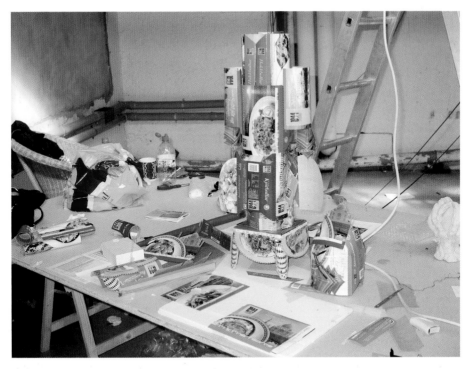

63 Caroline McCarthy *Endeavor (1944)*, 2004–05, mixed media, 180 x 130 x 80 cm (70 ⅞ x 51 ¼ x 31 ½ in)

('top of the stair') in 1929 – taking his title from Canto XXVI of Dante's *Purgatario*. I'm not proposing for Shaw the kind of ascetic, introverted and conservative piety that marked Eliot's turning away from an already politically conservative modernism – although we should not forget that Eliot himself perfectly captures the futile melancholy of London's middle-class suburbs; think, for example, of the thousand lost golf balls in the choruses for *The Rock* (1934). But I am suggesting that for Shaw, in different media and for different reasons, in a different age, there is a shared thematic of social failure through a misplaced emphasis on materialism.

What happened to utopia is also perhaps the central subject of the young Irish artist Caroline McCarthy's work. Her concerns are the popular

imagination of landscape and nature and the synthetic manner of our engagement with it, and the distortion of utopian projects and ideals into commodities. In some senses McCarthy (b. 1971) is an artist adapting traditional modernist strategies: those of appropriation and collage. Her materials are not, however, the artefacts of popular culture like magazines and newspapers that modernists such as Kurt Schwitters, John Heartfield or Ray Johnson chose; they are far more mundane than that. Amongst other objects, McCarthy uses food packaging, in particular the cartons that contain ready meals [64]. Her interest in this utterly and immediately disposable chaff is, the artist suggests, a result of the surface detail and design they carry.[11] The packaging of ready meals is almost utterly generic, as a quick visit to any supermarket, or perhaps a look inside your fridge will confirm. The back of the thin card sleeve will carry cooking instructions; the front will bear an idealized photograph of the cooked meal and, since such ready meals are almost universally 'classics' of distinctive national or regional cookery, there will be some kind of visual symbol of generalized ethnicity or location alongside it. A spaghetti dish might have somewhere an image of the Leaning Tower of Pisa; a curry, the Taj Mahal; a boeuf bourguignon, the Eiffel Tower.

Despite the fact that we rarely notice such packaging, even as we buy, these cartons are overwhelmingly familiar to us. Despite the fact that they are so utterly disposable, despite our fleeting encounter with them, these cartons are 'designed'. The achieving of a particular appearance helps support teams of researchers, food photographers and graphic artists, as well as brand managers engaged in a constant process of appraisal and redesign. Such cartons bear witness to that ineluctable press of design upon us to which I have already referred in Chapter 2. But they also seem to support what Fredric Jameson has asserted:

> The very sphere of culture itself has expanded, becoming coterminous with market society in such a way that the cultural is no longer limited to its earlier, traditional or experimental forms, but is consumed throughout daily life itself, in shopping, in professional activities, in ... various ... forms of leisure, in production for the market and in the consumption of those market products, indeed in the most secret folds and corners of the quotidian. Social space is now ... saturated with the culture of the image.[12]

Jameson's less-than-sanguine vision of modern life would suggest firstly that if you are 'an artist' your 'art' is more than likely directed towards the production of everyday products – you are a food photographer or graphic designer of food cartons. Secondly, it suggests that Jameson's 'closed space of the aesthetic'[13] creates a problem for artists who use appropriated everyday materials as modernists did. There is no longer a separate cultural register called art to which the everyday can be elevated and transformed. We have already seen how Afrassiabi manages to escape this dilemma by refusals of design and nostalgia; a similar problem confronts McCarthy. If the 'post-modern' artists of the early 1970s turned to advertising, fashion and the feature film as a resource, without rearticulating the syntactical forms of mass culture as modernists had , thereby ceding art's responsibility to express itself through its distinctive critical languages, isn't she, in turning to this 'most secret corner' of the quotidian as source and subject, doing much the same thing? Hasn't McCarthy noticed that the gap between art and life no longer exists, or is she, like those artists of post-modernity, acting naïvely or in bad faith?

There is a degree to which McCarthy still adheres to a fundamentally modernist principle of collage and assemblage, at least as Dada artists used it: that the nomination of the everyday in the place of art makes visible the ideological inscriptions borne, however covertly, by its objects. This is most obvious in the 1930s photo-collages of Heartfield or Hannah Höch, but it is also

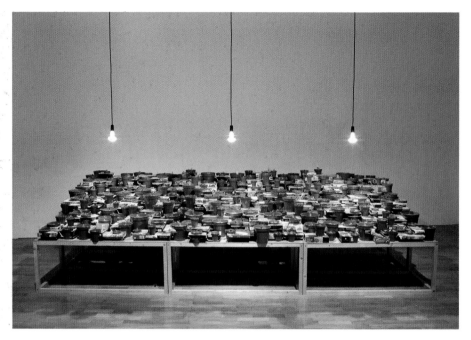

above and opposite **64** Caroline McCarthy *Promise*, 2003, mixed media, 366 x 183 x 122 cm (144 ⅛ x 72 ¹/₁₆ x 48 ¹/₁₆ in)

vital to the work of post-war collagists like Wallace Berman. What McCarthy does with her cartons is to extract detail from them by turning them into visible objects, and particularly by making them into extraordinary, composite landscapes and architecture. Each of those generic photographs will be elaborated in some way, making the meal into an exaggerated promise of experience – even if we know it's just a ready meal, something utterly prosaic. There may be gleaming cutlery, a glass of wine; certainly the meal itself will be garnished with a clearly visible herb, perhaps a sprig of parsley or basil leaves [64]. It is this tiny, irrelevant sign that is the hyperbolizing mark; it removes the meal from your kitchen, your microwave, and transports it into a restaurant that is, by association with the tropes of ethnicity and the exotic spaces of tourism the pack also bears, somewhere other than here. (After all, when did you last garnish

113

LIVERPOOL JOHN MOORES UNIVERSITY
LEARNING SERVICES

a meal? Ready meal packs certainly don't contain them.) McCarthy takes this barely visible figure of nature and glamour, cuts round it, and lifts it so that the pack becomes a surface from which it springs.

Seen together, with these small shoots of cardboard nature rising from architectural slabs, McCarthy seems to create a forest or a garden [64]. Certainly what we see is a debased mimesis of nature arising from a system of signs that communicate for a purely commercial purpose and that have no other intended function as sign. McCarthy's fragile saplings bring out the possible meaning in those signs that *design* would seek to close; she shows us how the designation of the sign by the designer relies upon stereotyped

opposite **65** Caroline McCarthy *1, 5, 11, 21, 27, 32, 33, 40, 55, 56, 64, 79, 87, 92, 112, 123, 127, 164, 27001, 27004: (from the Humbrol series)*, 2000–03, mixed media, 125 x 91 x 26 cm (49 $^3/_{16}$ x 35 $^7/_8$ x 10 $^1/_4$ in)

cultural imaginations of both the natural and the exotic. These food products are about as distant from 'nature' and the 'exotic' as you can get; assembled from a multitude of ingredients in a sterile factory in Lincolnshire or west London by cut-price labour and machinery in a matter of seconds. Any connection with the countryside is almost tangential; the labour of love, or at least application of technical mastery, that we fondly imagine is restaurant cooking, is wholly absent; what really matters in the product is the 'added value' realized for its manufacturer and retailer through the application of cheap labour in the name of convenience. That, at least in part, is the ideological inscription carried by food packaging which McCarthy exposes.

But McCarthy's work is not simply about the potential of signs, rather it is concerned with how we understand them – and this is how she evades any charge of innocence or irrelevance. Where a Dadaist would have been content (as if a Dadaist could ever be 'content') with that exposure of alternative meaning, McCarthy wants us to understand how one sign works upon us, and how changes to that sign may change not just 'meaning' but our perception. In doing this she not only begins a critique of the process of design – the designation of the sign – she returns, by a rather unexpected route, to that subject for art which so concerned artists of the post-minimalist generation – the phenomenological relation of subject and object. McCarthy remarks:

> At heart I am interested in the way a veneer of colour or an image (such as a garnish or picture of the Eiffel Tower) applied to a thing can change our perception of it. I began by painting familiar objects so they looked like high-end objects of desire, and as a consequence, became interested in other forms of packaging. I wanted to know how it was we understood an image of a landscape in the same way we 'understand' a milk carton.[14]

Silver-coated with Humbrol enamel, McCarthy's humble plastic bottles and boxes assumed the allure of 'designer packaging' – those disposable wrappings of luxury goods that, despite their complete disposability, make the completely frivolous, completely necessary – so that containers for toilet cleaner or fabric conditioner started to look like video cameras [65]. Here she was, perhaps, exploring the same terrain as the Swiss artist Sylvie Fleury, who in the early 1990s made installations out of shopping bags from designer stores, with the wrapped, luxury product, still inside. But there is a certain inadequacy about these transformed objects, just as there is a marvellous bathos about a garden made out of cardboard parsley. It is this incompetency of the sign as fetish that exposes the sophisticated and expensive mechanisms whereby an object or a sign is convincingly transformed. Surfaces between the object and the subject, the concealment of the gap between authentic experience and debased simulacrum, between aspiration and realization, aren't cheap – you have to pay those brand managers, food photographers and graphic artists. Or rather, they don't look cheap unless they are made to look that way by the artist's intervention in what Mark Hutchinson – discussing *Souvenirs (Blue) and Golden Wonder* (1998) [66], where McCarthy juxtaposed silhouettes of swimming pools cut from holiday brochures with similarly shaped potato crisps, mounted as if they were sculptures – astutely describes as 'a mutual embarrassment of display'.[15]

The exposure of such voids had been central to McCarthy's work since her video *Making Something Beautiful* (1997), in which she seemed at first to be playing Beethoven's *Piano Sonata No. 14, in C# minor* (op. 27, no. 2). But the video only showed the artist's head and upper body, never her hands upon the keyboard, and the movements of the body eventually revealed a discrepancy between 'performer' and performance. First with the elevation of mundane

66 Caroline McCarthy *Souvenirs (Blue) and Golden Wonder,* 1998, mixed media, approx. 500 x 20 cm (196 ⅞ x 7 ⅞ in)

objects to the status of spurious luxury commodities, and then with the food landscapes, McCarthy set about illustrating how we are induced to read signs in a particular way, and how those signs are continually changed in pursuit of capital's ceaseless repetition of the new.

This was not, then, work that simply dealt with ideological inscription, as an early twentieth-century modernist might, but one which – recognizing the impossibility of transplanting the sign from the everyday to a separate sphere of art – instead exposed the processes by which that gap had been closed. McCarthy did not make her collages and assemblages into straightforwardly critical objects but instead made visible the act of design, the appropriation of 'art' as veneer, by which modern mass culture encloses and neuters art's critical vision of modernity.

opposite **67** Helen Barff,
*Drawing done by touch in
blacked out car – gear stick*,
2004, pencil on paper,
30 x 40 cm (11 $^{13}/_{16}$ x 15 $^{3}/_{4}$ in)

CHAPTER FIVE

SOME MARK OF INBETWEEN

landscapes, borders & identities

I have already suggested, in looking at the work of Clare Woods, that a number of artists in Britain today are examining afresh aspects of national identity and exploring familiar forms of our culture in new ways. One of the most striking things about this reappraisal is that many of the artists who pursue it don't have the traditional British roots we might expect. After all, when Richard Long began to tramp across the countryside in the 1960s, recruiting the landscape tradition to conceptualism, it was still the kind of project an artistic West Country boy might be half expected to undertake, akin to the cross-country passages of romantic novelists and poets in the early nineteenth century. One of the consequences of London's high-profile as an 'art city' during the 1990s has been the eagerness of young European and North American artists to study and settle here. These newcomers have explored in

perhaps more subtle ways the character of their new home – as have the younger home-grown artists they work alongside – than many native artists of older generations. Certainly there has been less interest in pastiches of cheery, beery working-class culture such as Sarah Lucas's *Charlie George* (2002) or her collaboration with Colin Lowe and Roddy Thompson, 'Temple of Bacchus' in 2003. The expatriate's feeling of deracination, or perhaps the adventure of a search for a wider reach of origins has led artists to an interest in landscape that is expressed in representations and explorations of boundaries, edges and interstices.

Steffi Klenz (b. 1979) is a young German photographer, who has recently finished a master's degree at the Royal College of Art (RCA). Klenz's 'A Scape' series consists of large colour prints made of marginal sites in the kind of places in London that tourists don't usually visit. These photographs were made in Tottenham Hale, Roding Valley, Greenhithe and Dagenham Heathway, at Pudding Mill Lane, Hornchurch and Sunbury [68–70]. In a perverse parallel with Long's excursions into Dartmoor or Dorset, for a recent project Klenz asked writers who were interested in discussing these works to walk to them, from central London. In the manner of the writer Iain Sinclair, who similarly uses the 1960s Situationist idea of the *dérive*, Klenz wanted them to use that journey through the city as an experiential filter through which the original sites could be seen. There are further resonances of course, in Klenz's project – of which she's fully aware.

Her landscapes are man-made, but at first sight they seem like natural deserts or mountains. That vision however is granted precisely because Klenz

Steffi Klenz: opposite above **68** *Dagenham East*, 2004, C-type print, 101.6 x 127 cm (40 x 50 in); opposite below **69** *Dagenham Heathway*, 2004, C-type print, 76.2 x 101.6 cm (30 x 40 in)

LIVERPOOL JOHN MOORES UNIVERSITY
LEARNING SERVICES

70 Steffi Klenz *Beacontree*, 2004, C-type print, 101.6 x 127 cm (40 x 50 in)

photographs fragments of these sites as if they were chanced models of a full-scale world: she removes our sense of scale. There's a paradoxical appeal to the sublime in them, that awe-inspiring power of nature identified during the Enlightenment by Burke and Kant, which is here seen through the miniature. We shall see that miniaturization – whether in the map, with Layla Curtis or Tania Kovats, or the diorama, with Kovats and Mariele Neudecker for example – is a common strategy by young artists concerned with landscape. But in Klenz's work we have an oxymoronic 'industrial sublime', so that the man-made mimes the naturally awesome in what the artist herself defines as 'non-places'.[1] This is deliberately close to the term 'non-sites' that Robert Smithson used in the mid-1960s as he recorded the industrial landscapes of New Jersey. But Klenz's sites are also completely transitory: the photograph does fix a moment. If you were to pass this way, now, holding onto one of the

photographs, you would not find it. These mounds of gravel and sand are utterly unstable, used up in extending or maintaining the modern city.

Klenz's London sites have much the same spatial relation to the city as Smithson's New Jersey had to Manhattan; mostly they form a kind of unseen limit to the metropolis. It seems to me, however, that in her representation of that boundary, Klenz addresses a peculiarly modern notion of the relation of country and city. Indeed, Klenz sees her work as concerned with the renunciation of those kinds of oppositions between urban and rural, in order to reveal an ambiguous space, an 'in-between'. The idea of the 'Green Belt' was born in British urban planning immediately after the Second World War, and then exported throughout Europe, even to East Germany, where Klenz was born. The policy was intended to limit London's sprawl, which had engulfed many satellite towns that were further and further removed from the metropolitan core. In the future, London would be girdled by a rigorously protected circle of rural, agricultural space and the pressure for growth diverted into scientifically planned, idealized new towns such as Milton Keynes, themselves guarded by smaller 'green belts'.

As anyone who lives in London or southeast England will know from experience, the Green Belt is a pleasant myth of post-war utopianism, long-since abandoned in practice. It disappeared along with the idea of detailed spatial regulation by a benevolent state, which had as its fundamental concern the welfare of its populace rather than the needs of entrepreneurs. That idea itself, was probably never more than a myth, but now 'rural' England is often little more than a succession of suburban 'developments' given bland, 'natural' identity by marketers, image consultants and focus groups. The imagination of a Green Belt presents urban and rural spaces as dichotomies: Klenz's photographs are of the city's suppressed term – here swept to the edge,

LIVERPOOL JOHN MOORES UNIVERSITY
Aldham Robarts L.R.C.
TEL 0151 231 3701/3634

rather than concealed beneath the surface – but her subject's 'strangeness' is another form of difference, invisible, but on which the city depends, and on which cities have always depended.

An alternative sense of the edge is present in the work of Swedish video and film artist Tobias Ingels (b. 1971). Based in London since studying at the RCA, Ingels's work is often concerned with the formal properties of film – his principal medium – in the manner of structural filmmakers of the 1960s and 1970s. Ingels's primary interest, therefore, lies in much the same rhetorical domain as painters and sculptors such as Harding or Afrassiabi; he questions the language of his medium and then relates that aesthetic problem to the historical moment. However, in a looped piece shot on Super 8 film for video, showing waves battering against the decrepit West Pier at Brighton during a storm, Ingels offered up a commentary on the corrosion of 'British' values and the notion of a boundary to this island nation [2]. Designed by Eugenius Birch and built in 1867, the West Pier is the only Grade 1 listed pier in Britain. I should perhaps say *was*, since such is its current state of neglect and the impossibility of repair that it will soon have completely collapsed. The pier is, simultaneously, a historic monument, a marker of a particular tradition of 'British' engineering and entertainment, and a symbol of the way in which that tradition is being neglected and rethought. Legal disputes, largely concerning proposals for the development of a new retail and leisure centre adjoining the entrance to the pier, have so delayed repairs, for which the Heritage Lottery Fund had granted money, that the money is unlikely ever to be put to good use. Without the development, the trust which has taken responsibility for the pier claims there can be no restoration, yet to construct such a site, obscuring the architecture that it supposedly preserves, seems to render meaningless all effort at restoration. The Heritage Lottery Fund is

71 Tobias Ingels *The Big Sleep*, 2002, mini DVD, 18 mins

perhaps aptly named: the preservation, and even the identification of 'heritage' has now become a lottery. There is little agreement on what constitutes an acceptable national heritage, and its maintenance depends not on society as a whole, with government as its representatives, but on a combination of private charities desperately seeking to retrieve an impossible 'authenticity' and on corporate capital seeking a return.

Ingels certainly didn't have this situation laid out as a detailed programme for his work, but the film nonetheless used the pier as a telling metaphor. If Victorian municipal architecture symbolized old-Britain, representing fixed values, a confident national identity, and a nation with certain limits, its imminent collapse under continual attack seemed to characterize the changed state of nationhood in the early years of the new millennium. That the attack came from the sea, which has so often defined Britain's status as a maritime nation, secured from invasion by a strong navy, building its

economy and empire through ocean trading, held aloof by the Channel from the ways of nefarious continentals, seemed utterly paradoxical. What had long served as one sign of national identity had finally turned against another.

At least part of the historic forces that were causing this re-evaluation of identity, which created a sense that the nation no longer knew where it began or ended, or where its origins lay, had been made plain by Layla Curtis (b. 1975) in the late 1990s. Curtis's work is intimately concerned with the map, and in particular with the map as collage. That is, she applies an explicitly modernist aesthetic strategy to an explicitly modern form of knowledge – and she uses that strategy to represent modernity's effects on time and space. One of her earliest pieces, in the late 1990s, had carefully fitted into the outline of the British Isles elements of all the other members of the EU, including their capital cities [73]. There were, it was true, some startling conjunctions of borders, but the piece as a whole provided a remarkable commentary on the changing geographic relation of Britain to Europe at the end of the twentieth century. On the one hand, Britain had fully subsumed the EU, reflecting the attitude, largely shared by government and people, that we were the most important country in Europe and that the whole arrangement was worthwhile only as long as it was suborned to our national interests. On the other hand, Britain was now fully occupied by European space: 'Britishness', the sense of place found within the national boundaries, had been overtaken by a European identity. Such a situation might not have appealed to national government: resisting calls to join a single European currency or negotiate a European constitution that might guarantee a common set of rights for citizens throughout the community, but seemed increasingly attractive to those campaigning for devolved national identities at the (Celtic) fringes of the British state.

Curtis's *The United European Union 2002* (2002) [72], was a similar exercise in compression and conjunction: Rome now lay to the north of Wiesbaden; Hamburg and Amsterdam were separated by a peninsula that had intruded from southern Greece. Strangely, most of the major roads joining these once widely distant places seemed to connect in rational ways. In undertaking this project, Curtis engaged in a number of interesting critiques of historical situation, and indeed appeared to challenge the very epistemic presumption of the map. Maps are not simply to show us how to get from one place to another: like grids they are a rational ordering of space which are necessarily distorted in order to render it intelligible within particular, learned, forms of knowledge. As with the grid itself, the map as we know it today is fundamentally a product of the European Enlightenment. Within the West, in the period, roughly, from the 1680s through to the 1840s, science and philosophy shared the notion that the world could be wholly ordered and described. Everything could be put within its place. There was, therefore, something quite subversive to the very nature of maps about the disorder and irrationality that lay concealed beneath the 'natural' appearance of Curtis's

Layla Curtis: left **72** *The United European Union 2002*, 2002, collaged EU road maps, 1 of 4 panels, each 60.5 x 40.5 cm (23 ¾ x 15 ¹⁵/₁₆ in); right **73** *The United European Union* (detail), 1999, collaged EU road maps, 204 x 140 cm (80 ⅜ x 55 ⅛ in)

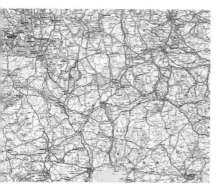

LIVERPOOL JOHN MOORES UNIVERSITY
LEARNING SERVICES

assemblages. That Curtis also mapped the European Union, an ideal of a united Europe that promotes itself too as a product of the Enlightenment, (consider, for example, the use of Beethoven's music and Schiller's poetry in its anthem) was somehow appropriate: because these maps disclosed that this union, this Europe, as a conceptual space, depended upon the annihilation of experienced space.

As geographers such as David Harvey have been pointing out for several decades, and as nineteenth-century commentators as different as Marx and Balzac, living through specific historic effects in the railway age, were quick to point out, the compression of time and space, or their annihilation, is a distinctive phenomenon of industrial capitalism. The very fact that you can get from one place to another more quickly has certain economic benefits; the removal of barriers to movement, whether of goods or of labour, has had similar effects. Even as the EU is a project which has benevolent social and historical purposes – the removal of the threat of national conflicts, the protection of individual and collective rights, freedom of movement across once near-impermeable national boundaries – it is also one which is constructed around the interests of capital.

Before it was ever thought of as a political federation with enormous potential benefits for its subjects in terms of their protection from the excesses of capital or the nation state, 'Europe' was imagined in the mid-twentieth century as a space for free trade. It is still understood in that way by some neo-liberal politicians acting in both government and principal opposition in British politics today. Curtis's European maps become metaphors of this dual compression and the tension it creates: on one side a civilizing project that gives freedom of access across linguistic and national boundaries, and rights to the individual against the state and against capital; on the other,

a project that serves capital in its supra-national forms, and undermines the dignity of the individual subject.

Curtis's maps seem to sketch out the very possibility of an art concerned with British identity to be made by Europeans, living and working in London. They also mark a change in the scale of compressions of time and space made possible by modern transport and communication. In the early 1970s, in *Soft City*, the writer Jonathan Raban produced a personalized account of how the social and spatial boundaries of London, limits that had once seemed fixed, had become seemingly permeable and flexible. Thirty years on, we live in a 'Soft Europe' characterized not by boundaries (at least, not geographic ones) but by flows, mobility and contingency. Indeed, for certain classes, or social groups, that Europe is part of an increasingly soft planet, despite the recent emphasis on homeland security in Britain and the USA. That this permeability is granted more to some classes than to others and more to some races than to others – a situation in which Western artists seem to be especially privileged – is given horrible force by the tithe of African bodies washed up almost daily on the shores of Mediterranean Europe as tribute to the lure of Western material prosperity and the chaos and subservience caused by post-imperialist economics. Given this social and economic mobility, it's striking that so much art about space and identity should concern itself with the edge, something Klenz, Ingels and Curtis are so clearly preoccupied with. This is, perhaps, a reaction by artists to the ways in which problems of mobility and boundary are exacerbated in Britain, a nation where limits to movement – whether of inward migration of foreigners or internal movements between classes – have been keenly felt and contested for centuries.

In some ways this interest in identity and landscape by artists who at first glance would seem excluded or marginalized from these themes, represents

a return to a trend in British art that was largely suppressed in the 1990s. In retrospect, we can see the affinities of an emergent figure of the early 1980s like Anish Kapoor – even as he emphasized his roots in the Indian sub-continent – to home-grown modernist sculptors such as Hepworth and Moore or Nicholas Pope who, in very different ways, were profoundly concerned with landscape, and in particular with stone.[2] Tania Kovats (b. 1966) is, I'd suggest, an increasingly important artist within this tradition – British born and educated, of mixed Hungarian–English parentage. And, like Curtis, part of her practice is concerned with mapping while another is fundamentally sculptural, and all about stone.

Kovats's *Vera* (1997) [74], was a small, wall-mounted diorama of that iconic symbol of the English landscape; the white chalk cliff. Made of plaster, capped with the flock that model makers use to simulate grass, *Vera* called to mind the early, miniature landscapes made by Richard Long in the mid-1960s, before he turned to conceptualism. However, in a text she used to accompany *Vera* in the catalogue for the Ikon Gallery's exhibition 'Lost', in 2000, which she also curated, Kovats used the work to comment on the misleading myths of national identity that are invested in the landscape, and then related this to a separate sense of space and time – that of the geological process.

> The White Cliffs of Dover are a deeply encoded text inscribed with issues of nationality, history and identity. Dover itself is a bit of a dump, and the cliffs don't look that white close up. But viewed from the sea they gleam. This is an emotional landscape. Sentimentality is a denigrated emotion, the domain of mothers, fascists and drunks. The White Cliffs of Dover are a coastline of sentimentality.[3]

Lit from above, *Vera* generated a shadow on the gallery wall that in contrast to the smooth and rounded 'maternal' landscape had the ragged profile of a mountain range. In 'Lost' Kovats juxtaposed this with three topographic

profiles of the ocean floor of the North Atlantic – a 'landscape' that cannot be seen and that belongs to no one.

Kovats's use of these scientific illustrations may emphasize the importance of geology to her practice. Geology allows us to think about the landscape itself as 'sculpted' by weathering and erosion over time. The incredible time-scale involved in such processes also forces us to rethink landscape beyond the investments we make in it in terms of our limited imagination of temporality, which begin to seem somewhat petty by comparison. It's difficult to be sentimental about something whose 'time' is so utterly different from the human experience. But because that time is incomprehensible; because, even if we are ignorant of the time, the scale of the landscape overwhelms us, all we can do is map it and explain it using our limited terms – as fiction.

Those profiles also point towards an interest by the artist in 'process'; the ridges that bisect the middle of ocean floors are not fixed lines, but one part in a dynamic, if grindingly slow, economy by which rock is added to the earth's crust and taken away from it elsewhere. That rock became the subject of a series of sculptural works which Kovats exhibited in 2004 – *Basalt* [75, 77]. Basalt is a vital component of the landscape of the British Isles; features such as the Giant's Causeway and Fingal's Cave, which we have repeatedly

74 Tania Kovats *Vera*, 1997, plaster, flocking, steel bracket, 33 x 210 x 22 cm (13 x 82 $^{11}/_{16}$ x 8 $^{11}/_{16}$ in)

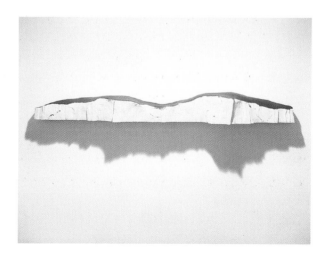

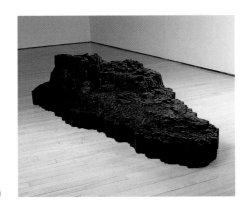

Tania Kovats: right **75** *Basalt*, 2004, mixed media, 230 x 106 x 58 cm (90 ⁹/₁₆ x 41 ³/₄ x 22 ¹³/₁₆ in); far left **76** *Strike*, 2001, mixed media, 150 x 105 x 95 cm (59 ¹/₁₆ x 41 ⁵/₁₆ x 37 ³/₈ in); far right **77** *Basalt (inverted)*, 2004, mixed media, 160 x 110 x 75 cm (63 x 43 ⁵/₁₆ x 29 ¹/₂ in)

romanticized and mythified in our cultures, are made from its distinctive black, hexagonal columns. (Think, for example, of Turner's magnificent painting of Staffa, our fondness for Mendelssohn's *Fingal's Cave*, or the great Irish narrative cycle of Finn mac Cumaill.) These cliffs were formed by vast, cooling sheets of lava. This now solid landscape by which we set so great a store was once completely unstable liquid (basalt is formed from a particularly mobile type of lava). Kovats, however, did not sculpt her work from stone; rather she replicated stone through miniaturizing it in resin.

However, as with Eva Rothschild's very distinct sculptures, there is a striking affinity between Kovats's work and that of the British modernist artist, Barbara Hepworth – also a wonderful stone-carver. Hepworth's abstract forms emerged from an intimate relationship to the British landscape; as she wrote in 1943, 'all my sculpture comes out of landscape – the feel of the earth as one walks over it, the resistance, the weathering, the outcrops, the growth structures....'.[4] I don't think it any coincidence that Kovats, like Hepworth, is a landscape artist who is perhaps as comfortable in a direct encounter with terrain, walking fields and moors, as she is in a city studio making representations of landscape. Beyond this, though, both artists have a fundamental interest in the expressive potential of forms, which we've already seen is a fundamental characteristic of modernist art. If Hepworth's sculptures are often abstractions *from* a natural object (as in her adaptation

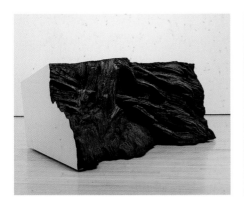
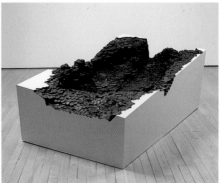

to sculpture of the pierced stone from the Neolithic stone circle of Men-an-tol) they also manifest a vital interest in how landscape is changed over time – that is, how its hidden structure is exposed by physical and chemical processes. As Kovats defined it, 'Landscape is a series of incidents coming into being.'[5] These are the kind of incidents that are fixed by Kovats in pieces such as *Strike* [76], the title referring to the movement between strata split by a fault-line, the permanent trace of a catastrophic event, an earthquake.

The process of one thing becoming another was a central feature of Kovats's 'Metamorphic Series' of 2001 where she produced a set of sculptures

78 Tania Kovats *Schist no. 9 (black & crimson)*, 2001, mixed media, 32 x 45 x 28 cm (12 ⅝ x 17 ¹¹/₁₆ x 11 in)

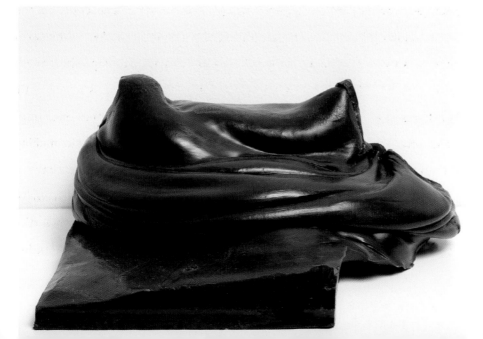

79 Tania Kovats *Pilgrim No. 2*, 1999, pencil on paper, 50 x 66 cm (19 $^{11}/_{16}$ x 26 in)

from wax using a lateral mechanical pressure in much the same way that early geologists such as Bailey Willis had followed to replicate the pressures that led to the deformation of rock strata into folds [78]. Entitling these works *Schist* after a particular type of metamorphic rock, Kovats made reference to the capacity for existing rocks to be transformed, through heat and pressure, over

time, into another type of rock altogether. What is solid is therefore malleable and, although seemingly fixed, has a capacity for change: rather than being carved, stone, given the right time-scale, can be moulded. A similar concern with underlying forces can be seen in the relation of two earlier works: *Rocky Road* (1999) [3], where the mark on a map that represents a road, and which is flattened into a single plane by the map, is resuscitated as sculpture by introducing elevation as a physical characteristic of the line; and the drawing *Pilgrim No. 2* (1999) [79], where the dispassionate distribution of the line in space – which assumes for us as viewers a God-like eye, directly overhead any point in space – is submitted to perspective and given a sense of actuality through texture. Each work makes actual – in that we experience it, in one way as haptic and in another as realistic representation – that which is normally coded and which we would otherwise know only through the intellect.

If sculpture represents one vital part of Kovats's practice, then drawing and mapping has always been its counterpoint. In her set of drawings *The British isles* (2004) [4], Kovats charted each of the more than two thousand islands that dot the coastline of the UK, filling in the meticulously traced outline with drawing ink. She then made palimpsests, laying sheets of tracing paper one over another, so that the sixty sheets with which she began were reduced to ten, and created some peculiar, disorienting juxtapositions – not least because the main island of the work's title was missing.

We can understand *The British isles* as an extension of Kovats's concern with geological time and process: our landscape is the product of a series of shifts in which one part of a landscape may be driven over another, in which the material fact of land may be submerged by the ocean. At a broader conceptual level, however, *The British isles* points towards a concern with the marginal, and the paradoxical centrality of the marginal. Most of our islands

Helen Barff: left **80** *Rabley Farm Object – Felt Series*, 2005, felt, metal hinge, 15 x 6 x 8 cm (5 ⅞ x 2 ⅜ x 3 ⅛ in); right **81** *Rabley Felt Object – Felt Series*, 2005, felt, metal cog, diameter 12 x 6 cm (4 ¾ x 2 ⅜ in)

are peripheral, not simply in space, but socially, economically and politically. Kovats makes this edge the very centre of our attention.

The work of Helen Barff (b. 1975) is concerned both with landscape – in the sense that her 'sculptural' objects and photograms are often site-specific – and with boundary, because, as the artist puts it:

> Location seems to have to become linked with time/space (including the history/shaping inherent in an object/place). Therefore there is shifting (something like Derrida's idea of *différance*), the continual deferment of this/that location (here). There is a constantly shifting membrane in-between presence/absence. But location necessarily has to be continually linked to earthy material, matter, stuff.[6]

Found objects – traces of history in a particular place – are fundamental to Barff's practice. They may become the basis of photograms – placed directly on photographic paper so that it retains their trace [83–86]. But it is also transformed by the artist when she creates a 'barrier' around the object, simultaneously protecting and imprisoning and also defining it as the object of our attention. Barff wraps the object in a tight layer of felt, usually white, and made by a sedulous process of brushing loose fibres with water as they lie on the object until it is completely, thickly and securely coated [80–81].

The object, often a stone or industrial waste (though Barff also works on the grand scale, intertwining felt sheets into a piano), remains visible, understandable, as an object, but transformed into something abstract and mute.

There are echoes here of Joseph Beuys's use of felt as a metaphor for protection – and it's interesting to note the enthusiastic attention recently paid to Barff by Beuys's great Scottish advocate, Richard Demarco. But Barff is not positioning herself as a kind of shamanic artist, nor clearly articulating the kind of democratic, universalizing function for art that Beuys proselytized. (Though we might see something of that as implicit in her magpie-like approach to recovering ordinary objects.) Rather, Barff is working through a whole series of boundary situations by her use of those objects. One of these is the substitution of touch for sight – as the artist puts it there is a kind of 'blind indexicality'[7] to the wrapped objects; they are both the thing they are and yet also prevented

82 Helen Barff *Drawing done by touch in blacked out car – steering wheel*, 2004, pencil on paper, 40 x 40 cm (15 ¾ x 15 ¾ in)

LIVERPOOL JOHN MOORES UNIVERSITY
LEARNING SERVICES

Helen Barff: left **83** *Thames Series – Photogram*, 2005, photographic paper, 30 x 35 cm (11 ¹³/₁₆ x 13 ¾ in); right **84** *Rabley Farm Object – Photogram*, 2005, photographic paper, 50 x 60 cm (19 ¹¹/₁₆ x 23 ⅝ in)

from communicating their indexical status. In her earlier work, Barff experimented with this in a different way; having used a blacked-out car as a pinhole camera, she began to experiment with making drawings of the car's interior in the dark, based wholly on her touch [67, 82]. At the same time, in the wrapped objects, there is a constant shift between the positive and the negative, and between two and three dimensions, because they are simultaneously 'photographs' – the subjects of photographs that are responsible for their own status as photograph through direct contact, a drawing with, or casting of, light – and 'sculptures', cast in felt. Barff comments of this:

> What I am trying to get by working with 'objects' is the negative of the object – not a copy: negative space/negative skin, casting negative light (there are no photographic 'negatives' for my photograms, the light is cast black straight onto the paper). By casting this negative from positive I am attempting to capture movement in-between positive/negative, presence/absence – the constantly shifting membrane – becomes a permanent skin (a remnant).[8]

This concern with positive/negative, or inside/out, manifested itself early on in Barff's use of pierced forms – whether gear wheels or worn stones. The first stone photograms she made used stones with holes in them; as she puts it 'that was the attraction. A negative within a positive, right through the body'[9] [85–86]. That aspect of the object 'drawing' itself was recognized in an exhibition of Barff's work at the Drawing Centre near Marlborough, in Wiltshire. But what that project – located in the heart of rural England, close to the prehistoric site of Avebury that so fascinated British modernists like Paul Nash – also made clear was the degree to which Barff is concerned with the specificity of place. All the pieces she exhibited, photograms and objects, were made from objects found around the site of this exhibition space and working farm [80–81, 83–84]. The work spoke about a recovered history through fragments of agricultural machinery, found in fields, dating back to the nineteenth century. This practice has now been repeated in other projects, most notably in work made for Demarco's archive at Skateraw, near Edinburgh, as a follow-up to the Marlborough exhibition. In Barff's words:

Helen Barff: left **85** *Skateraw Stone, no. 26 – Photogram*, 2005; right **86** *Skateraw Stone, no. 18 – Photogram*, 2005; both images on photographic paper, 30 x 40 cm (11 13/16 x 15 3/4 in)

The project only makes sense to me if the work is made 'site specific', that is, from the landscape there, rather than transported up from Wiltshire. An exhibition in Deptford will have the same specification. This ... will involve objects washed up from the Thames and hopefully lead to a further study of the whole river or river-bed objects/stones. So the content of exhibitions is beginning to be determined by the gallery location.[10]

Such a project, involving the survey of a whole river's detritus from source to mouth, also assumes the quasi-scientific enterprise of Tania Kovats's work [74–79]. Where Kovats is concerned with the degree to which time shapes our experience of landscape as lived experience, Barff's attention seems to be turning to the relation of geomorphology – the processes that shape landscape within human time – to a uniquely human experience of place.

The importance of landscape to national identity has recently become the subject of mass-media interest – with a major television series on art and the British landscape, and a corresponding exhibition at Tate Britain. Central to such projects, even as they try to educate, inform and widen public experience of the differing and often antagonistic ways in which culture and landscape are knitted together, are a few familiar images. We are many of us comfortable with Constable's *The Haywain*, Turner's *Rain, Wind and Steam*. But actually we are no longer all so familiar, as a single community, with such a specific iconography of British landscape, and even when, as individuals, we have such a relationship, it is often overfamiliar. We may not understand such pictures as anything other than picturesque pleasures for our gaze, rather than see them as commentaries on a rapidly, and ruthlessly, transformed countryside, or a simultaneously fascinating and terrifying 'industrial sublime'. Familiarity breeds contempt, if not for what the image represents to us, then for what the image might actually mean if we were to think about

it in more depth. Indeed, in the work of an artist like Jo Broughton (b. 1975), photographing landscape familiar to her – where 'rural' space meets suburban sprawl and industrial skyline on Canvey Island – we see how even the most constrained and compromised of places can be recruited as idyllic by our imaginations. The countryside is now, seemingly inevitably, compromised by pylons and phone-masts, bisected by flyovers; over the next horizon is as likely a pleasing prospect as a refuse tip; over the river mouth, a line of chimneys; in the river itself, a forest of masts, where the privacy of nature has been exploited by an economy of recreation [87–92].

That such familiar images as *The Haywain* permeate our unconscious understanding of nature, and that we all, to some extent, use such images to tame landscape through representation rather than contemplate them as reality, is central to the work of James Ireland (b. 1977). As Lucy Byatt wrote of Ireland's 2003 exhibition 'All of the Known Universe':

87 Jo Broughton *Gasworks No. 1, Canvey Island*, 2005, panoramic photograph, 120 x 160 cm (47 ¼ x 63 in)

Jo Broughton: opposite top **88** *Gasworks No. 2, Canvey Island*; opposite centre **89** *Harbour, Canvey Island*; opposite below **90** *Motorway, Canvey Island*; top **91** *Seaside, Canvey Island*; above **92** *Pylon, Canvey Island*; each work 2005, panoramic photograph, 120 x 160 cm (47 ¼ x 63 in)

He has ... provided the viewer with a landscape, his version of a perfect natural world, whatever the word natural has come to mean. It's much closer to the nature of the water feature of the garden centre, or the shrubbery of the leisure complex, the indoor world of nature, tame, controllable, with a slight odour of chlorine.[11]

LIVERPOOL JOHN MOORES UNIVERSITY
LEARNING SERVICES

If the sublime, as a phenomenon formulated by Kant and Burke in the late eighteenth and early nineteenth centuries, in part as a reaction to industrial modernity, was something that defied representation – being beyond language, overwhelming it in its capacity to take our breath away and imbue us with terror – then even a painting as committed to the manifestation of sublime experience as Turner's is to some degree picturesque. (It represents a framing of sensation that exceeds framing.) Henceforth, the path is easy and downhill: we arrive at the point where nature becomes a water feature in a garden; where a forest is the location for closely monitored, packaged, 'adventure' holidays, synthetic experience staged only five miles from the nearest shopping centre. A work such as Ireland's *Let's Go Away For A While* (1999) [93], creates an image of nature entirely out of synthetic materials – and it's significant that the final image exists only as a reflection. We see landscape with our back to it, both as Ireland has suggested, via the rear-view mirrors of our cars as we head back to the city, or, as the landscape artists of the

93 James Ireland *Let's Go Away For A While*, 1999, mixed media, dimensions variable

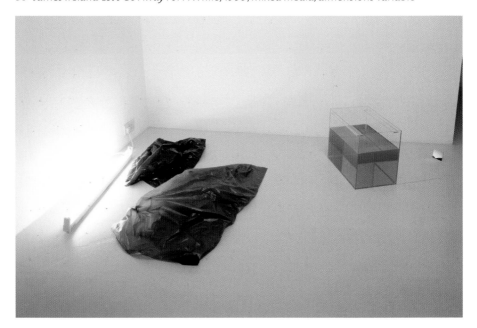

eighteenth century and the dilettantes who aped them on the Grand Tour did, in a Claude Glass.

Let's Go Away For A While starts with a fluorescent light, illuminating two plastic bin-liners, one black and the other green. Then there is a tank filled with water dyed bright blue, and at the end of the chain, the mirror in which we see not industrial detritus but black hills and a blue sky, with a white glow of incipient dawn behind them. Ireland repeatedly shows us how modernity, quite literally, constructs nature. This construction is both based in objects – through juxtapositions of industrial and domestic products as well as through found images of nature – and also understood to be an outcome of modernity. We couldn't really see 'nature' without having the mechanical-industrial 'nightmare' of the nineteenth-century city as contrast and incentive, and indeed without having the rent of urban land and profits from coal mines to subsidize the Grand Tours of the sons of the gentry in the early nineteenth century, or the income from shares to fund the bourgeoisie's Cook's Tours in the Victorian era. We might even see Ireland's production of imagery as a kind of manufacture – modernity's industrial production of its supposed antithesis. If an artist such as Caroline McCarthy [63–66] shows us how our imagination of 'nature' can be harnessed to industrial processes and design, Ireland works at a different level to demonstrate how nature itself – whether in the Welsh Hills or the Swiss Alps – as a category in which we imagine and consign our experience, is 'produced' rather than simply existing naturally.

With the installation *How and Why* (2001), Ireland produced projections in one part of the Arnolfini Gallery that showed 'sublime' images of nature [94–95]. As one walked further through the space it became clear that these projections emanated from small tableaux in which mirrors, propped on

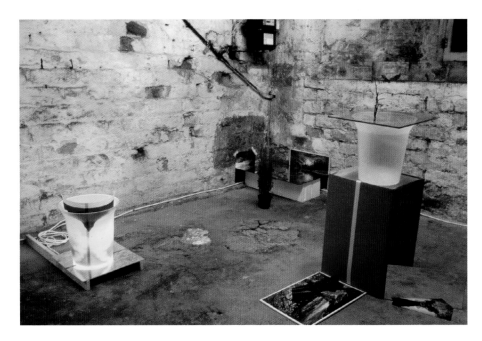

wooden blocks, reflected both fragments of larger, picture-postcard images –
the ultimate in the picturesque, their lakes reeking of chlorine – and twigs
or potted plants.

James Ireland: opposite top **94** and below **95** *How and Why*, 2001, mixed media and slide installation, dimensions variable

Mauricio Guillen (b. 1971) is one of those cosmopolitan artists who has made London his base, when he could choose to live almost anywhere. Born in Mexico City, Guillen first studied in New York and then at the RCA in London. After graduating from the RCA he was quickly selected for both the Whitechapel Gallery's 'East End Academy' and the 'New Contemporaries' exhibitions of 2004. Guillen's work is often concerned with a neo-conceptualist approach to the inversion of space that has been compared to the project of the American artist Michael Asher in the 1970s, and we shall see later how other aspects of his art reflect the political situation of our times. However, in two of those projects – *Property Line* (1999) and *Mingle* (2004) – the manner in which Guillen involves himself with the politics of landscape serves to link such politics to questions of boundary, and takes us back to the fundamental problem of the division of space as a troubling property of both modernist aesthetics and the history of modernity [96–97].

In *Property Line* we see two men walking in a wood; they are playing with a ball of string, unravelling it in the space around them. It's only by spending some time with the picture that we understand that the string is being used as a marker: it's the beginning of a division and categorization: the conversion of nature to culture, and of raw material to profit. *Mingle*, by contrast is a sculptural piece that is wittily and explicitly concerned with boundary: two children's slides straddle a wooden fence that divides the exhibition space. The slides traverse this boundary in opposite directions. In the maquette for the piece it's worth observing that Guillen proposed a red brick wall as the dividing element, and in the background positioned a photograph of a rural landscape.

Fences and walls abound in our 'soft planet', to be crossed only by the right sort of person: as much as demarcating nation states, we find them where one economic or social terrain abuts another, whether in the proposed wall between Israel and the Palestinian Territories, or between the USA and Mexico – a division of which Guillen must have been acutely aware. We also find them in the razor-wire fences of British prison camps for asylum seekers – so that, suspected of economic motives for your migration, you are both within a national space and excluded from it. Interestingly, it is the play of art, rather than the serious business of 'work', that may guarantee your ability to cross such boundaries. As an artist you get to toy with boundaries, and you get to slide over the kind of real obstacles that confront other people. The inversion of *Mingle* seems to suggest that the two sides of the fence are identical – something that is patently not the case in real space and real

96 Mauricio Guillen *Mingle*, 2004, C-print, 40.6 x 61 cm (16 x 24 in)

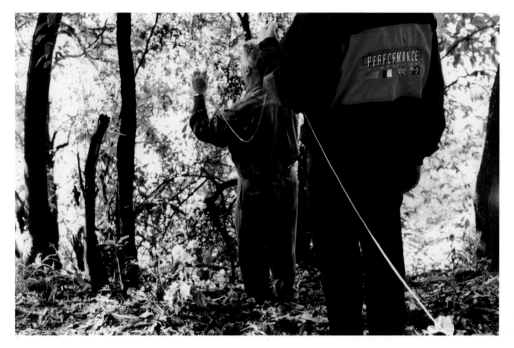

97 Mauricio Guillen *Property Line*, 1999, C-print, 40.6 x 30.5 cm (16 x 12 in)

history, unless of course you operate at the kind of level where the division doesn't matter. With *Mingle*, Guillen is perhaps telling us as much about the situation of contemporary artists as he is about migrants and asylum seekers, about fluidity as much as limit, and the degree to which the 'freedom' implicit in that fluidity is historically, as much as spatially, irrelevant. Artists whose work really threatened authority and confronted history might have to live near a convenient border and have rather more difficulty in crossing the limits of the state.

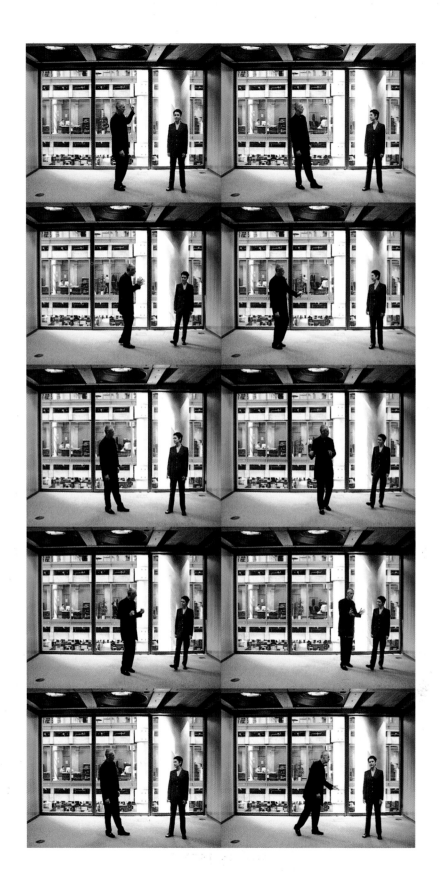

opposite **98** Carey Young
sequence of video stills
from *I am a Revolutionary*,
2001, single-channel video,
colour and sound, 4.08 mins

CHAPTER SIX

SIGNS MISTAKEN
FOR WONDERS

art & the critique of administered culture

One characteristic of modernism is a tension between the authority of the sign and the collapse of the meaning that sign purports to convey, the order that it seeks to impose. In the high modernist era, this tension is manifested in works such as Kafka's *The Castle* or the Dadaist poetry of Hugo Ball. We can see the ways in which young artists have returned to this theme through works as different as Alexis Harding's paintings [18–22] and Anne Hardy's photographs [48–53]. We live, maybe, in an age that can be defined, as it has been by Ernest Mandel, as 'late capitalist'. Maybe, we also live, in consequence of that economic condition, in an era of 'post-modernity' – as defined and related by Fredric Jameson – in which the fluidity of the sign is as much a given as the fluidity of capital. But, strangely, we also live in an era in which the legacy of the sign's authority remains pervasive. The logic of the

Ryan Gander, Stuart Bailey and Will Holder: above **99** *An evening with Perl Gray*; opposite left **100** *An evening with Perl Gray*; opposite right **101** *An evening with Perl Gray*; each work is a photographic documentation of an event at the NAi Rotterdam, The Netherlands, 2002

sign, that words actually mean what they say, is appealed to as frantically in our culture as is the notion of a free, autonomous subjectivity. This happens just as the remnants of that personal agency are increasingly corroded by the activities of those very agencies – governments, corporations and the producers of mass culture – that invoke them as structuring myths for our lives. The sign seems to operate in two contradictory registers in our culture: one in which language remains authoritative, and another which we know to be malleable, without real substance, even as we obey such signs, even as we use them. Connecting these apparently antipathetic modes of use is a kind of fetish: a denial that suggests 'I know this to be a fallacy, but ...'.[1]

The work of Ryan Gander (b. 1976) addresses the ways in which such signs operate in our lives, looking in particular at the way in which they are designed to tell us one thing and are persistently adapted to our own communication systems to do another. In doing so he tells us much about the utopias, or just the

pragmatic solutions that planners press upon us, and the way we subsequently construct our own spaces, languages and lives in reaction to this. Gander offers, often with profound irony, a user's manual for interpreting an overdesigned, hortatory world. His materials for this are documents, photographs, lectures, artist's books, and just occasionally, recognizable 'objects' such as his chess set made to a Bauhaus design from the wood of threatened species in tropical rainforests. What we can discover from this 'manual', whether in an early work like *Brief for a 12-inch Record Cover* (2002), or through his recent 'mitim' project (2005) [108], is how signs can be made to appear natural, despite, or indeed through, their calculated construction. Despite a post-modern playfulness, Gander's project is ultimately a scrutiny of ideology, of how the idea of language functions upon us, around us and through us.

Brief for a 12-inch Record Cover was one of a series of projects, published in the artist's book *Appendix* (2003). It's interesting to consider these projects together in order to examine in detail how Gander thinks and works. As a group they illustrate effectively how signs are constructed in order to market something that seems to be completely natural, and relies upon myths of spontaneity and opposition to marketing for its success as a marketed commercial product. The 'brief', given to a designer, was to produce the cover for a promotional copy of a 12-inch single, *With Coyote Eyes* by a fictional pop band called Perl Gray. The artist made himself into the boss or A&R executive of

a fake record label, with a project that 'commissioned and involved as many other people as possible, so that the ideas and aesthetics wouldn't appear too linear'.[2] Gander was reproducing here the kind of materials that eventually turn faceless, and musically talentless, groups of suburban kids into icons of mass culture, whose records become either cult objects for other suburban kids who want to imagine themselves as 'different' or else break through to be incisive commentators on modern culture for the mass audience. The difference was that in Gander's project, there was no band to promote; the materials were autonomous exemplars of marketing culture. The brief's remarks on the band's music hints at a similarity with real groups like Belle and Sebastian – who ran the full gamut of pop's marketing possibilities – but the point is that, in commercial terms, they could as easily be Coldplay, Magic Numbers or Franz Ferdinand: they are a product, but a product given a stylistic twist. Perl Gray are described as:

> Poetic and beautiful ... about love, life and aspirations. There are many references to the everyday (Toffee Crisps, shagging a girl behind Halfords on an out-of-town retail park, tea [of course], other bands etc.). There are a couple of guitars, a bass, female posh melody vocals and male drone/talking vocals.[3]

They are, in other words, just another generic 'indie' band. Gander's project illustrates the kind of work involved in producing signs of a minimal, but recognizable difference in order to elevate the band to the point where its creative production becomes a saleable product. In the early stages of such a process it does no harm to include the band's very wariness of being marketed as a marketing tool. This reinforces their credibility in a particular niche market as being 'outside' or opposed to the record industry. As Adorno and Horkheimer remarked of the culture industry, 'Something is provided for all so that none may escape'[4] – though I doubt that they could have

anticipated, in even their deepest despair, the micro-differentiation of the market disguised as subcultures within popular music. As the commissioned designer annotated the brief:

> Every styled piece of clothing (the lyrics/the cover/the press release/the second hole in the record and its effects on reception) is an undisguised hook for the discerning reviewer of such a promo, appealing to his personal choices as to whether he wants to sleep with this professional tart. The record company probably doesn't care about the band's true intentions, and therefore translates them in a way they themselves deem professionally fit.... This results in a cobbled together 'Chinese whisper' press release, underlining the sensitivity to early stages in marketing and promotional activities. Our tart feels misunderstood and uncomfortable in the expensive clothes the pimp has chosen for her.[5]

Gander's fake label, Jacksie Records, then produced a press release for Perl Gray. Written by the graphic designer 'goodwill', this was a fake endorsement of the single signed in the name of that self-mythologizing figure of rock's marginal and spurious play with art and politics – Bill Drummond of 'K Foundation' – and a parody record review from the music press.

The press release mimed perfectly that tone of confiding innocence cultivated by 'indie' record labels – which may, in any case, be specialized companies wholly owned by international corporations, designed to cater to specific 'anti-industry' consumers – to promote their latest signing. The release of the 12-inch was, it appeared, motivated entirely by 'the constant ring of phones and after-concert buzz'.[6] The release also included two pictures through which, crucially, Gander reinforced the sense of the constructed image. This also provided a historical commentary suggesting that there was no age of innocence preceding this commoditization of culture, into which one might escape through nostalgia. The second page carried a photo of Perl Gray, posed in the arbitrary 'unposed' manner that typifies promotional

photographs of pop bands. It was, Gander thinks, taken at random from the internet by the designer: the point was not that the image was real, but that it was convincing. At the same time, Gander employed a group of actors to pose as members of Perl Gray and perform in front of an audience. In the appropriated photo one of the group's female members, presumably the provider of 'posh melody vocals', sits on the bottom step of a staircase, staring at the camera with profound disinterest, or even hostility, whilst doing her best to emphasize her legs. Though off-centre in the photograph's composition, she is quite clearly posed as an erotic object and is the main focus of attention as a result.

That this photo, despite its appearance, is anything but natural, casual and spontaneous is pointed to by some of Gander's other projects made around this time: *Brown Corduroy Lounge Photo Shoot* (2001) – a piece inspired by Gander's seeing, in close order, a lecture by the artist Liam Gillick and the cover of Serge Gainsbourg's record *Comic Strip* – and the text that accompanied and explained the photographs: *The Mechanics of Form 2 – z, x, y* (2001) [102–105]. These works illustrate the photo shoot as mere process and, therefore,

the artificiality of even the most natural pose: Gander does not show us the sign,

he shows us the making of the sign, much in the manner of modernist filmmakers

like Dziga Vertov or Godard self-reflexively illustrating the creation of their work in

Man with a Movie Camera or *Le Mépris*. *The Mechanics of Form 2 – z, x, y* then shows

us how the models look when photographed by different formats of camera and

film, and by different types of photographer. As Gander commented:

Ryan Gander: opposite left **102** *The Mechanics of Form 2 – z, x, y*, 2001, contact print, 24 x 36 mm ($^{15}/_{16}$ x 1 $^{7}/_{16}$ in); opposite right **103** *The Mechanics of Form 2 – z, x, y*, 2001, contact print, 42 x 55.1 mm (1 $^{5}/_{8}$ x 2 $^{3}/_{16}$ in); above **104** *The Mechanics of Form 2 – z, x, y*, 2001, contact print, 55.6 x 69 mm (2 $^{3}/_{16}$ x 2 $^{11}/_{16}$ in); left **105** *The Mechanics of Form 2 – z, x, y*, 2001, installation – light-box, film and sheepskins, dimensions variable

There are various hierarchies at work in the piece. Firstly concerning the quality of photographic detail: the larger the format, the higher the resolution. Secondly, concerning the amount of visual information: due to the fact that each image was taken from a different perspective; one shows the finished image whilst its opposite shows the context of the studio situation. Thirdly, concerning the artistic value in relation to the professional value: not only in terms of the professionalism suggested by the formats of the film, but also ... that the first camera was operated by an established fashion photographer, the second by a semi-professional photographer ... and the third by me, a non-professional photographer.[7]

The band members in the Perl Gray photo are posed: consciously or subconsciously they ape the poses of other bands and other artists presumed to be 'different', marginalized and counter-cultural. (The history of bohemia is in part, one where each generation apes the anti-bourgeois posturing of its forebears. In a mass cultural age where bohemia has no real temporal or spatial identity, but has itself developed into a brand, it has become a tradition continued in the largely spurious opposition manifested by bourgeois children playing music to annoy their parents.) The photograph is generic – it must be generic in order to be recognized – but simultaneously strives for difference in order to establish its subject as an essential commodity. Gander remarks in an interview that 'Brown Corduroy Lounge Photo Shoot is a cover version, because it's a remake of the original Serge Gainsbourg record, only visual rather than musical'[8]. I think Gander is acutely aware that everything within the culture industry is a cover version: whether it's the song or the singer, the pose or the poster, everything is endless repetition. He shows us how these signs must be subtly altered through marginal differentiation in order to be promoted as radically new.

One of the validating strategies defining mass cultural products as 'art' is to invoke a relation to an older, high cultural tradition or a specific artist and his

works. Within pop music we can observe this process in the self-conscious naming of bands with their own artistic aspirations. (Steely Dan and Soft Machine both appropriated phrases or titles from the novelist William S. Burroughs for example; Steppenwolf borrowed their name from a Hermann Hesse novel.) Nor should we forget that many bands are the main activities or sidelines for art students and artists at a certain stage in their careers – for example Mike Kelley, Raymond Pettibon, Dexter Dalwood, etc. *ad infinitum*. According to Jacksie Records's press release, *With Coyote Eyes* was inspired by a painting by the Dutch modernist Kees van Dongen. Van Dongen's subject was, allegedly, the entertainer Mathilde Willink, who, again according to the press release, 'was kept in a state of "cuteness", created and fostered by showbiz media'.[9] There is, therefore, an intimate, and for Gander deliberately self-reflexive, relationship between van Dongen's painting and the photo with its sullen blonde on the next page: both are images of sexuality constructed by the media and designed to promote particular products of the culture industry. The historicity of van Dongen's portrait reminds us that, however crude and simplistic its operations in comparison to the micro-managed marketing strategies of our time, the culture industry is a product of modernity's aspirations, not an invention that ended modernity, or, for that matter, modernism.

It is this double-edged concern with the function and the history of the sign that makes Gander such a peculiarly interesting and important artist. In some ways he is an appropriation artist, or at least someone who borrows tropes from mass culture. That, of course, is what an archetypal post-modern artist like Cindy Sherman did. When she made her 'Untitled Film Stills' series Sherman didn't copy film stills from Hollywood movies, but, like Gander, made images that mimed such pictures and tried, perhaps, to make plain

LIVERPOOL JOHN MOORES UNIVERSITY
LEARNING SERVICES

the foundational ideology hidden within their originals. But Gander does not simply show us the effect; like a modernist with the language of his medium as a principal subject, he shows us the apparatus by which the sign that causes those effects is constructed, and thus the ideology it both produces and is produced by.

This is not the most blatant of comparisons, but we might see what Gander does as rather similar to the work of a painter like Robert Ryman, where the obvious brush strokes in what appear to be (but aren't) white monochromes are primarily concerned with their status as brush marks. By transferring that late modernist attention to the detail of visual language to the way that signs work in everyday life, Gander shows us how the rhetoric of mass culture actually functions (and how it often affects to display mass culture's own apparent opposition to itself). If late modernism, particularly as theorized by Greenberg, asks of its practitioners an attention to the specific rhetorical forms of their chosen medium, Gander's concern is frequently directed towards the rhetoric of rhetoric itself. He is, therefore, able to show us how design works; he makes work that illustrates how the closure of the gap between art and life was achieved by commerce, in a language we don't (or didn't) understand, but which we accepted anyway.

The lecture, delivered with the accompaniment of what may be the most idiosyncratic power-point presentation in history, is vital to Gander's practice. It allows him to include performance in his range of activities: rather than just using this form to elucidate his oeuvre, Gander makes it an extension of that work. We not only learn more about what he does, he does what he does as an artist in our company. As an audience we make the journey with him, joining the dots between signs that shouldn't otherwise connect: signs as diverse as the route directions around the Barbican Centre in the City of London,

the different maps used to depict the routes and stations of the London Underground and the coincidental homomorphism between the ground plan of the NatWest Tower in London and the bank's corporate logo. These meandering associations are a form of the Situationist *dérive*, the 'drift' through urban space in which, through chance encounter, the structure of society and the ideologically parsed relations of signs and objects may be made clear. Situationist philosophy is important to us in understanding Gander's work – even if as an artist he does not directly articulate such thought. Alongside the *dérive* we need to consider the idea of *détournement*: the modification of the everyday signs of advertising or direction through their defacement or conjunction with other signs, thereby revealing their latent meanings.

Gander begins his *Loose Associations Lecture* with a meditation on pathways – the way in which we negotiate space being entirely apposite both for the form his lecture takes and its subject – and what planners call 'desire lines'. These are the paths that the public creates to move across space, going where they want to go, in opposition to the routes laid out for them by designers and planners, which may take another direction altogether. (Next time you cut across the grass to get somewhere, rather than sticking to the path, you are helping to create a desire line; you are, effectively, reconfiguring space to suit you, rather than having a certain conception of space, an ideology, imposed on you.) He contrasts these lines with the guidelines painted around the Barbican Centre – a utopian architectural project that took three decades to complete and so, inadvertently, models changes in the history of utopia as an idea [106–107]. As anyone who has been there, and finally returned, will attest, the Barbican is an ideal that you can't readily find your way into, and once there can't readily escape. Gander's approach here is,

Ryan Gander: left **106** *Loose Associations Lecture*; right **107** *Loose Associations Lecture*; each work a photographic detail of a projection from performances by the artist in 2002–06; opposite **108** *In search of the perfect palindrome*, 2005, C-print, 21 x 14.7 cm (8 ¼ x 5 ¹³⁄₁₆ in)

perhaps, optimistic and humane rather than scientifically critical; throughout the lecture he returns repeatedly to the way in which signs are modified from their planned uses to assume wholly new meanings. (One example of this is the way in which the classic Arne Jacobsen Series 7 chair becomes, in Lewis Morley's photograph of Christine Keeler, a substitute for the body and a shield protecting the model's nakedness.)

Gander demonstrates how we adapt our own communication systems (our relationship to ideology) to find our way around spaces and through syntax, where the moves we should make are normally prescribed for us. The Situationist project of *détournement*, in reality, if not in its ideality, reserved in the 1960s for an elite, revolutionary minority, becomes in Gander's eyes an unconscious practice of everyday life, undertaken by everyone. Hal Foster, in his bleak vision of our contemporary, overdesigned, wholly administered culture, goes back to the modernist Karl Kraus to invoke the possibility that a freshly autonomous art might 'provide culture with running-room'.[10] Gander, I think, finds that room within culture, but it is not artists who are making space for it; rather it is art that is made about it.

At a register above that of the commodity, Gander's work deals with how signs are inserted into the way we speak – our discourses – to become common

currency and function as though they have always been there. The marketing of a pop group is one example; politics is another. When Gander exhibited his 'mitim' project in spring 2005, I couldn't help being reminded of the way in which certain words seem to enter discourse spontaneously [108]. What I had in mind was the word 'robust', which now permeates the speech of politicians and the secretariat, as if it had always been there. Yet if you undertook a discourse analysis of speeches made by such types before 1997–98, however, 'robust' would be largely absent. Either consciously, after due consideration by a committee, certain politicians decided that this sign could best represent their policies and activities, or unconsciously, in the wake of occasional use by an individual, the word entered culture at a new level, and with a modified, and malleable, meaning. 'Mitim' is a word (and a process) that illustrates this operation within language; it is 'how to plant a word in history'.[11]

'Mitim' means 'a mythical word newly introduced into history as if it had always been there'[12] and is *itself* a word newly introduced into history. Gander

publishes his correspondence with the journalist and media consultant Alice Fisher discussing the process by which such a word might be introduced to history, and in publishing it, necessarily introduces the word. Such introductions are usually sub-cultural, and then transmitted into the mainstream (so Gander's use of the word within the art world gives it a chance; though as it's a noun to describe language, which doesn't much interest the mainstream media, it has less chance of acceptance than one which describes people). As Fisher says, words used in specialist style magazines – those catering for youth culture – that are made up or modified to describe a new phenomenon, often get taken up by larger magazines and newspapers, because they 'assumed we knew best because we were talking about something they didn't understand'.[13]

Gander's work, at this level, addresses an aspect of what has become known as 'spin' – the inflecting and directing of language whilst it remains disarmingly neutral. It therefore also addresses the vital question of responsibility in how we use and understand language. This also is central to the oeuvre of the performance artist and video maker Carey Young (b. 1970). Whilst Young's work addresses commercial, managerial and administrative language – the 'discourse of the secretariat' – and behaviour in a variety of ways, as for Gander it is the play between the instability of the sign and the simultaneous claim for its stability that is her concern. Young's genius lays in her ability to both ape the discourse of the secretariat and define, with alarming accuracy, how the use of language in this discourse disempowers those to whom it is addressed. The subjects of this language, in a totally administered, managerial society, are you and me, as consumers, employees, and as citizens.

Young's project with the Henry Moore Institute, realized as *Disclaimer* (2004), is a fine example of how she analyses the profound effects of ordinary

language [11–13]. Disclaimers, as Young pointed out in an interview with Jon Wood, allow 'an author, publisher or (often corporate) organization to protect themselves by renouncing responsibility for what they or their employees have said'.[14] A disclaimer thus permits language to have an apparent absolute value whilst simultaneously having absolutely no content or responsibility. Young understands this in sculptural terms – that disclaimers are a form of negative space. 'They create an absence, a near-silence – the retraction of communication back into itself, so that what has been said is also termed unsaid.'[15] If we consider the sign as an abstract form here, much of what Young says about it echoes the philosopher Jacques Derrida's ideas about the inherent instability and play of the sign. Whereas Derrida was concerned with achieving an ethical treatment of the sign – a responsibility towards language – Young exposes how its potential is employed, to utterly unethical ends by those who've never heard of, far less read or understood Derrida. As Young remarks:

> I am particularly interested in disclaimers in a political sense, as a signifier of the fluidity of corporate power. The spread of disclaimers can be linked to the same neo-liberal value system that gave us the collapse of corporations such as Enron and WorldCom – the evasion of truth, the hiding of key information from the public, the absence of corporate responsibility. The fact that disclaimers increasingly encircle us should, in this sense, be seen as a cause for concern. They represent an act of imagination in which a problem has been pre-visualised, and then a protective legal structure created so that the disclaimer-user is protected. In this sense disclaimers are contracts created to make us into powerless players in a legal performance that may be enacted in the future.[16]

An important element of Young's work – the way that the lecture is used in social domains beyond the art gallery, and the way in which she also draws upon those domains as her rhetorical source for art – seems to owe a debt to

LIVERPOOL JOHN MOORES UNIVERSITY
LEARNING SERVICES

the German artist Joseph Beuys. But where Beuys's work often appeared romantically utopian, Young uses the lecture to map the way in which utopia can become compromised and commoditized. Outstanding examples of this are her lecture/performances *I am a Revolutionary* (2001) [109], and *Everything You've Heard is Wrong* (1999) [110], subsequently recorded as videos, and *Optimum Performance* (2003) [7], originally staged at the Whitechapel Gallery, London. All three pieces are based upon an investigation of language commonly used in a business environment, and in particular upon so-called motivational rhetoric. *I am a Revolutionary* places Young in an empty office, where she works with a personal trainer on her presentation and communication skills. Through the glass wall of this space we see other office workers going about their tasks seated in identical, claustrophobic cells. Again and again, Young stalls over a line from a longer speech; the line is 'I am a revolutionary.' She repeats the phrase, attempting apparently to make it credible to herself, as if it needed to be a real condition of her life. For the trainer, by contrast, there is no difficulty to the statement, these are just words, empty signs to be paraded before an audience, and given content only by the degree to which that audience believes in them, and the effectiveness of the performance with which they are delivered.

Everything You've Heard is Wrong was originally delivered by Young as a performance at Speaker's Corner in Hyde Park in London. Speaker's Corner is, or was, both a model of democracy and of one notion of the public sphere. It was a place where any individual could stand up and make speeches that were almost unregulated in their content. It was a site where opinions could be aired and listened to, where speech and ideas that lay out-side mainstream discourse could enter into the public domain, or perhaps be even further marginalized through the very form of their delivery in

what quickly became a favourite spot for ill-thought rants and sophistry. Young inserted her performance into the competing voices of this Babel. Wearing a smart, anonymous business suit, she delivered a lecture on successful business communication.

The lecture, of course, went unheard by those around her busily haranguing their audiences (to whom it might have proved useful) and probably went a long way towards baffling the crowd that Young attracted. In making this piece, in this place, however, Young made a number of important points about speech and democracy. Firstly she emphasized the degree to which a 'science' of communication and persuasion has entered the public sphere. Discourse, whether delivered by politicians, members of the secretariat or business leaders, is not 'natural' – it is coached, it is phrased in particular

109 Carey Young *I am a Revolutionary*, 2001, single-channel video still, colour and sound, 4.08 mins

110 Carey Young *Everything You've Heard is Wrong*, 1999, video, colour and sound, 6.35 mins

ways and it is calculated to achieve particular effects. Young deliberately contrasted this with the untutored and therefore marginalized speech of those who would freely participate in the public domain. What that contrast made clear was how what is proclaimed as the space of 'free speech', the modern-day 'public sphere' of the mass media, is at best weighted against, or at worst closed to, those who do not possess the necessary training, the necessary language, to communicate according to the terms of its discourse. Secondly, by using the language of corporate communication – rather than a political speech, which might, despite its fluency and inflection of language, have been rather lost amongst the other political points being delivered around her – Young emphasized the degree to which the discursive worlds of commerce and politics have become intertwined in the public sphere.

Optimum Performance used an actor, also wearing an anonymous business suit, to deliver a motivational address of the kind given by star salesmen or particularly effervescent chief executives to an audience in an art gallery. Again, Young contrasted the forms of language that supposedly exist in different spheres of discourse. The effect of this contrast in a gallery was similar to that of *Everything You've Heard is Wrong*, but rather different in the object of its attention. Art audiences are, after all, a particular social grouping with particular forms of speech – a discursive community. However, in using the phrase 'discursive community' to describe such an audience to itself, I would have a reasonable chance of being at least partially understood, which would not be the case were I speaking of that audience to others at Speaker's Corner or even on BBC Radio 4's *Today Programme*. That is to say, art audiences have their own specific signs that denote things or events – what other discursive communities, premised upon different uses of language would call jargon – and those abbreviated signs may denote more complex concepts which are taken as understood by such audiences. So an art audience would understand that in the dissonance between discourses – between theirs and that of motivational managerialism – an important point was being made. There was a reflexive consciousness for all parties to *Optimum Performance* that was lacking at least in the reception of *Everything You've Heard is Wrong*. Furthermore that Whitechapel audience would mostly have been aware of how much the language of managerialism has entered the art world.

One of the consequences of the economic and social shifts of late capitalism is the degree to which institutions of culture – universities, art galleries and museums – are now required to appraise both the objects of their scrutiny and practice, and their modes of operation, in forms that were once completely alien. We might imagine that the relatively arcane world

of art is one where the central topics of discourse address aesthetics and history. Sadly, truth, beauty, historical affinity and even historical context are increasingly endangered discourses in the professionalized art world. Art is now more than ever a commodity within a 'creative economy', an intangible asset as valuable as any brand – that is, valuable as long as it is properly promoted and consumed by an audience. This suggests that most art criticism, within the mass media, which was once a necessary part of the aesthetic and historical discourse of art, is little more than response to the kind of promotional strategies that Ryan Gander scrutinizes in popular music. (And given the propensity for newspapers and magazines to be 'media partners' with art institutions in promoting exhibitions, such criticism increasingly only cuts one way.) The discourse of art, amongst commercial gallerists and artists, is thus increasingly concerned with its subject's media status as commodity. Where in the 1970s it was vital for artists to get their work on the cover of *Artforum*, now it is crucial for gallerists that artists are favourably interviewed in as many 'quality' Sunday newspapers as possible, prior to their next commercial show. This does not necessarily sell more work, but it establishes that artist as a branded commodity in a world of branded commodities.

At the same time those responsible for cultural institutions have learned to speak the language of the secretariat, both in order to justify their continued funding by adhering to that secretariat's agendas, and to be understood within it. That agenda might be increased accessibility – that is, ever more populist and undemanding shows to increase attendance, because the secretariat understands numbers rather than critical engagement as its (spurious) measure of democracy. (Elitism and difficulty are now very dangerous things to believe in.) If it is not purely commodity, art may be a project of amelioration for the very ills which the secretariat fosters elsewhere

through economic and social policies that foment anomy and exclusion. In either case the demand is made that art is apprehended through a discourse once alien to it. The successful 'intellectual', or museum administrator, is that individual who can, within the discursive community of the secretariat, promote culture as if it were no more than entertainment or social work.

This is not, of course, a wholly new phenomenon. In 1961 Hannah Arendt bemoaned the activities of those intellectuals 'whose sole function is to organize, disseminate, and change cultural objects in order to persuade the masses that *Hamlet* can be as entertaining as *My Fair Lady*'.[17] Likewise, Adorno, in exile in America during the 1940s, had bitterly remarked that 'when I was confronted with the demand to "measure culture" I reflected that culture might be precisely that condition that excludes a mentality capable of measuring it'.[18] By reiterating in *Optimum Performance* the business language that permeates museums and galleries in their offices and committee meetings, in the gallery space where, as art's discursive community, we still expect to encounter a discourse of aesthetics or of history, Young made explicit those fundamental shifts in the ideology of art's institutions, the demands to measure and to entertain.

What *I am a Revolutionary* highlighted, I'd suggest, was not simply the way in which words become empty of meaning until charged by performance, but the way that the utopian discourse of art and politics, and specifically that of modernism, has been co-opted to the service of corporate enterprise. Chief executives can now proclaim themselves 'revolutionaries' for overthrowing the established operating practices of the organizations they manage. Such overthrows usually involve a number of casualties, in the form of redundancies 'operational-rescaling'. The argument for the historical necessity of increased shareholder return can be as easily packaged in the idealizing

discourse of revolutionary transformation as those of social justice and subjective liberty. Equally the place for artistic creativity is now the corporate sphere: the word 'artist' may be happily appropriated to cover anyone from finance director to graphic designer, regardless of practice. Here Young uncovers what was, perhaps, a fundamental problem within 1960s conceptual art; even as it tried so hard to scrupulously analyse the languages of art, conceptualism's separation of art from a specific material practice in order to address as object the rhetoric of art, meant that anyone could be an artist, without actually practising as one.

There's an inadvertent complicity between the form of art that would most rigorously scrutinize language (and this includes the tradition in which Young works) and those who would happily abuse it by vitiating its content. If we imagine that Young is just criticizing those who would claim that all signs are malleable and wholly context-dependent – that is 'performative' – then we need, perhaps, to examine her complex, witty project through the filter of Derrida's essay on signs and performativity 'Signature Event Context'.[19] Here Derrida makes a critique of the speech-act philosopher J. L. Austin's assertion that certain statements are only of meaning in specific, performative contexts – a deliberately constrained argument for the absolute meaning of certain forms of words. Derrida argues that such performance is only possible through citation, through the grafting of signs into new contexts, and that a sign that was not capable of such grafting would not be recognizable as a sign. Statements are, therefore, not anchored to meanings, but only to the contexts of their recitation. This comes close, it would seem, to the dire situation of language claimed as his prerogative by Lewis Carroll's character Humpty Dumpty, that 'words mean what I want 'em to mean' – a charge often naïvely levelled at Derrida, whose sensitivity to the potential

of language far exceeded that of his critics. It also, certainly, comes close to the situation that Young establishes in *I am a Revolutionary*.

To say 'I am a revolutionary' is the kind of performative statement that Austin wouldn't have considered; he kept to the mundane. In what contexts can we imagine these words as appropriate: at the barricades, in a manifesto, in a wider context of social utopianism? Do they work in an office, or a corporate conference? That businessmen can imagine they might employ them means that such words are capable of what Derrida calls 'citational grafting', and that communication functions as much as a condition of difference between the contexts in which the sign is placed as it does as a condition of any natural relation between the sign and a specific context. The question for Derrida – as it is, I suspect, for Young – was not so much that signs slide between meanings, but rather, define the ethics and the responsibilities that inform their use. If, rather than deluding ourselves to the absolute value of language, we accept that a sign is both malleable and that it may be used unethically, we assume a responsibility for our use of language. In addition, we accept an onus to be critical, engaged participants in the public sphere, capable of challenging any discourse with which we are presented, including this one, rather than accepting its language as immanent and transparent in meaning.

What Young and Gander are both doing, in the domain of language, is an equivalent project to the scrutiny of aesthetics undertaken by Afrassiabi and Rothschild amongst others. If, as Foster remarks, a primary form of the 'perverse reconciliation' of art and life lies in design,[20] another product this reconciliation has adopted is language itself – both through the uncritical appropriation of the syntax of modernist art's discourses and through the treatment of the sign as being infinitely malleable. One of the more astute

opposite 111 Gillian Wearing *Signs that say what you want them to say, and not Signs that say what someone else want you to say*, 1992–93, R-type colour print, 122 x 92 cm (48 ¹⁄₁₆ x 36 ¼ in)

works by a young British artist was Gillian Wearing's *Signs that say what you want them to say, and not Signs that say what someone else want you to say* (1992–93) [111], – an ironic assertion of literalness whose performative style was quickly mimicked to sell Volkswagens. Gander and Young show us that we should not make such statements without first owning the context in which the statement is made and without first disclaiming responsibility for what we say – language just isn't that innocent. What we can do is analyse our own language, and be wary of the content of signs with which we are presented, rather than being dazzled by the spectacle of their carefully designed packaging.

opposite 112 Nigel Cooke
Smile For The Monkey Man
(detail), 2001–02, oil on
canvas, 183 x 244 cm (6 x 8 ft)

CHAPTER SEVEN

THE END OF HISTORY
art & catastrophe

There exists a rather odd interest amongst young artists in the aftermaths of parties. In *Untitled IV (Balloons)* (2005) [53], Anne Hardy shows us a basement or a bunker strewn with streamers, cigarette butts and balloons. We might be looking at the remains of a birthday celebration or a farewell party, at something illicit, hurried, and perhaps shamed. The symbols on the wall suggest a technocratic use is more proper for this space. At some point it's been used for planning. Could these be the last signs of its occupants, trapped by some catastrophe and partying in the face of adversity? Or are we looking at the last celebration of a group of less-than-puritan extremists before they undertake a suicide mission? Hardy, quite deliberately, doesn't give us enough information to answer that question. What the ambiguity of her work does leave us with is a strange sense of bathos. But these remains are not simply pathetic and funny; they are charged with a premonition of disaster.

113 David Burrows *Green Celebration Disaster*, 2001, C-print on aluminium, 120 x 120 cm (47 ¼ x 47 ¼ in)

Green Celebration Disaster (2001) [113], a photograph by David Burrows (b. 1965), is more obviously artificial than Hardy's, which if it is staged nonetheless gives us a sense of the photographer intruding on a real space. The catastrophic event, in one form or another, is absolutely fundamental to Burrows's work, whether in his photographs or installations. With its low angle, its shallow plane of focus and low angled lighting, *Green Celebration Disaster* has affinities with Cindy Sherman's 'Disaster Pictures' made in the early 1990s. But there was a sense of the personal about Sherman's pictures, as if the eructations that she showed us were solely the consequence of a

vast glut, an overconsumption by the body. It's all gone wrong in Burrows's picture too, but amidst the balloons and birthday cake, the champagne bottles and streamers, there are splashes and trails of spilt liquid, green bile, and blood. Those organic signs of trauma – of the interior splashing over the safe limits of body or bottle – are not real; in Burrows's work, unlike Sherman's, they're not even realistic, and are perhaps the more horrifying for that. That Burrows uses his trademark MIRRA card and polyethylene foam to simulate what could easily be rendered cinematically 'real' achieves two things. Firstly he uses the difference between what we see and what we should see to accentuate the unease we feel, because it is unexpected. Secondly, this difference makes a formal reference to the use of abstraction and assemblage in the history of modernism and therefore refers to the history of modernity. Here the abstraction of ideology implicit with 'formalism' is forced back upon itself to recount events. In doing so, Burrows suggests that it is not just an event that has been catastrophic. It is perhaps modernity itself that is, necessarily, always a catastrophe for someone, and modernism's failure therefore may lie in its retreat from depicting that fact.

But if historical context is at all relevant to the art made at a particular moment, what is it that impels these artists to concentrate so much upon disaster? Sherman's 'Disaster Pictures' can be readily understood as a bilious response to the economic and artistic excesses of the 1980s – a decade when, in the West, people made too much money, bought too many things, ate too much and took too many drugs. In short, Sherman's pictures were a rather puritan riposte, through abjection, to the apotheosis of consumer capitalism, to a world where everything, all the time, was not enough. For artists now, such egregiousness may be horrifying, but it is no longer a novel context in which to work.

The catastrophe as subject is rather, I'd argue, a consequence of two things, which are not wholly unrelated. The first of these is the promise, and problem, of progress. Politicians and citizens alike may recoil from the kinds of over-indulgence that characterized the high points of the 1980s stock market boom, but equally not many believe in promising less rather than more. Fundamental to the general idea of modernity, whether carried along by capital or state socialism, and however tempered by regulation, is the idea that next year you will have more than you did this year. Consumption is the motor of the economy; it, rather than our relation with others, is the measure of success and the sign of modernity. This is not, I'd suggest, the proper measure of modernity as it was understood in the European Enlightenment, but rather an appropriation of the Enlightenment's norms and ideals (including democracy) to the service of late capitalism. One of the effects of this is explained by Habermas, when he remarks that 'a materialist West encounters other cultures ... only through the provocative and trivializing irresistibility of a leveling consumer culture'.[1] The catastrophes that afflict the West now (9/11; the Madrid train bombings; suicide bombers in London and whatever else may follow), as well as those massacres that daily happen in Iraq, are largely a sign of the way that this version of modernity works, seeking to subsume other cultures in its materialism, rather than extending a hospitality towards them, a hospitality that, rationally, could acknowledge differences.

This schism of modernity between an imagination of unimpeded tech-nological and economic progress (carried forward under a shibboleth of democracy and freedom itself dependent on massive inequality), and an ideal of rational exchange between critically aware, differing, and increasingly antediluvian but hospitable equals, is perhaps the slippage that leads to the historical 'earthquakes' of our immediate moment. I'd suggest that some of

the most important art of our immediate moment responds to and analyses this slippage. It looks critically and widely at the terror that is provoked by modernity acting as an intellectual and economic model, and also at the structural violence implicit in modernity itself. I'd also suggest that the recent history of British art, and the longer term denigration of art as a cultural form that *can* deal responsibly with history leads to self-consciousness and self-negation expressed through superficiality within such art.

The second overarching phenomenon of our times is a generalized state of individual civic terror. The catastrophe that has come to dominate all recent thinking in Western culture about 'the event' is the attack upon New York's World Trade Center (WTC) in September 2001. The events which have followed that incident have led to a pervasive fear of attack and the growing imposition of a 'state of exception' through the proroguing or subversion of the rule of law in the USA and UK in order, apparently, to preserve the rule of law. We now live in societies that are often in justifiable fear of their own shadows. Catastrophes may not even be a consequence of terrorism; if we do not worry about chemical or biological attack, or 'dirty' nuclear bombs (as opposed to the so-called 'clean' ones possessed by nation states), there's always the fear of a pandemic such as 'bird flu', or the everyday terror of job insecurity whilst sustaining the massive personal debts on which consumer capitalism depends.

It seems to me that it is this general state of being terrorized, a wider fear, and exploitation, of catastrophe, as well as the specific historic reference to 9/11, which informs Burrows's recent work. After all, certain of his 'catastrophic' pieces, for example the severed head, rendered in bubble gum, of *My Favourite Personality* – based upon the pop singer George Michael, despite its striking resemblance to Saddam Hussein [114] and the all-purpose folk-devils of *Twisted Firestarters* [115–118] were realized before the attack on the WTC.

LIVERPOOL JOHN MOORES UNIVERSITY
LEARNING SERVICES

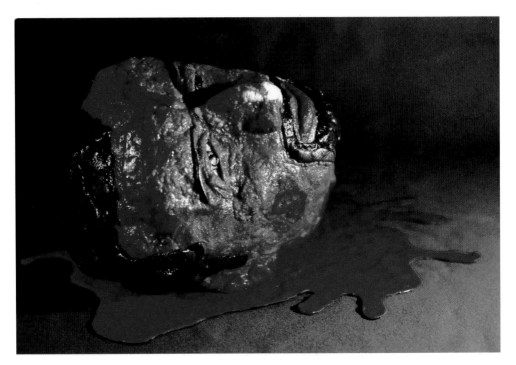

David Burrows: above **114** *My Favourite Personality, (non identical bubble-gum head),* 1998, C-print, 120 x 90 cm (47 ¼ x 35 ⁷⁄₁₆ in); opposite **115, 116, 117, 118** *Twisted Firestarters, (non identical bubble-gum head),* 1998, C-print, 120 x 90 cm (47 ¼ x 35 ⁷⁄₁₆ in)

That the latter four characters are caricatures of the pop group The Prodigy is strikingly symbolic of the way in which consumer capitalism can fix as commodity a spurious dissent or marginality. That structural violence (whether on the global or national scale) to which other cultures would respond with violent rebellion or armed resistance is, in the West, converted into a fantasy of violence for spoiled teens. Folk-devilry becomes a marketing ploy: despite your mimesis of subversion, terror or resistance, no harm will come to you for you pose no threat; the mimesis of threat is what constitutes the consumable commodity. *Modern Domestic Disaster* (2002) [119], is a reference to the minor catastrophe of machinery gone wrong in the home rather than attack by terrorists, and *Snowy Landscape With Wreckage* (2002)

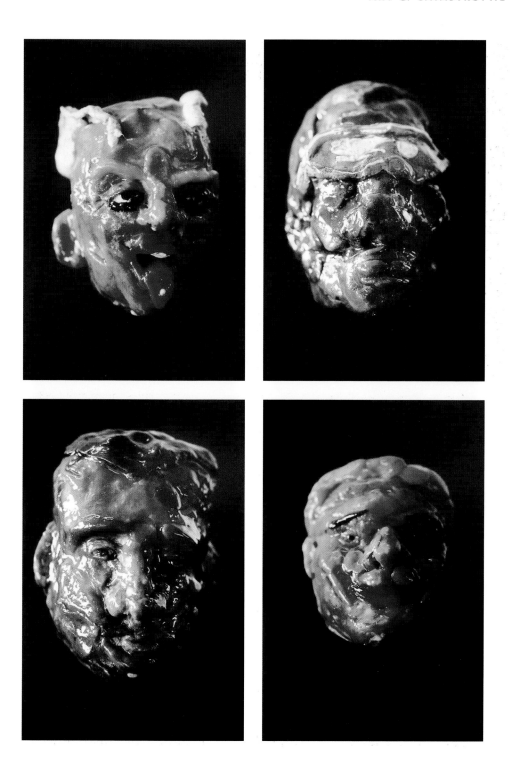

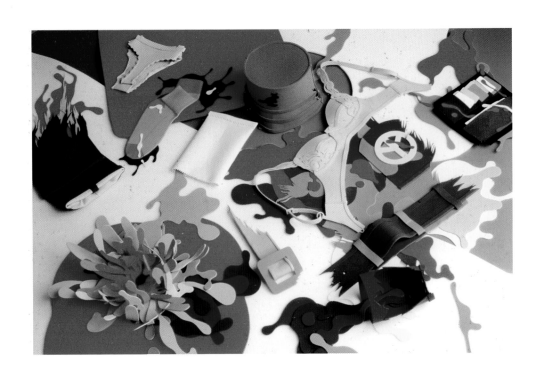

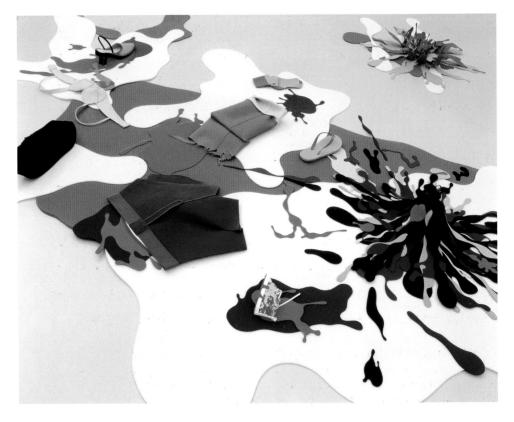

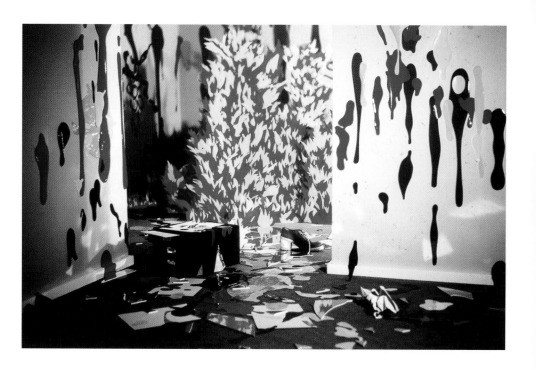

[120], has its effect on our consciousness through its intimation of that everyday terror of the plane crash that almost everyone experiences each time they fly. Yet we cannot, I believe, look calmly upon works such as Burrows's deliberately cartoon-like *Fire on the 13th Floor* (2002) [121], without recalling the real inferno as planes were flown into the WTC, and perhaps adding to that our memories of Hollywood's premonitions of disaster and slaughter in the form of mass entertainment, from films such as *Towering Inferno* to *Independence Day*.

Yet there is a wry humour to Burrows's work here: the artist knows his historical points of reference, and he demonstrates that the convulsion of history as an effect of religious fundamentalism is not, simply, a novel consequence of friction between secular (or even Christian) occident and

David Burrows: opposite above **119** *Modern Domestic Disaster*, 2002, polyethylene foam, dimensions variable; opposite below **120** *Snowy Landscape With Wreckage* (detail), 2002, polyethylene foam, dimensions variable; above **121** *Fire on the 13th Floor*, 2002, C-print on aluminium with matt seal, 101.7 x 152.5 cm (40 $\frac{1}{16}$ x 60 $\frac{1}{16}$ in)

spiritual orient. (As if contemporary events could be reduced to the simplistic binary of a clash between opposing civilizations and world views.) Martin Luther's tract, nailed to a church door in 1517, sparked a century and a half of vicious religious wars across Europe, yet his thesis is seen as a foundational document of Western civilization. This is not, I think, the artist following Marx's assertion that history repeats itself as farce, but is instead a frank observation that terror is at much at home in our culture as it is manifested in the external threat of some dreadful, alien other. (As Fredric Jameson comments, if 'Christianity seems to dissolve fairly effortlessly into classical German philosophy ... the Germanic tribal tradition seems to lead directly into modernity itself; if you place Luther and Protestantism squarely in the middle of this historical development, the idea may seem less parochial.')[2]

Burrows's *Revolutionary Army of the Infant Jesus Attack* (2002) [122], is the expression of a hitherto rather preposterous idea – once posed by the filmmaker Luis Buñuel in *That Obscure Object of Desire* (1977) – of a potential fundamentalist Christian terrorist group. Yet it is an idea that is only a stone's throw, a mild hyperbolization, away from George W. Bush's proclamation of a 'crusade' against terror, and the wider attitudes of some American citizens towards liberal social values. European intellectuals, such as Habermas when he remarked in response to the events of 9/11, seeming to speak on behalf of European intellectuals as a whole, that the 'fundamentalist recourse to a set of beliefs ... feeds on a substance that apparently disappeared from the West'.[3] But Habermas misunderstood the 'war against terror' when he assumed that the neo-conservative impulse in the USA nonetheless observes the 'differentiation between religion, secular knowledge, and politics'[4] that fundamentalists fail to respect. For Christian fundamentalists have found it easier on the whole to hijack the apparatus of American democracy to obscure

122 David Burrows *Revolutionary Army of the Infant Jesus Attack*, 2002, polyethylene foam, MIRRA card, polyboard and colourcover, dimensions variable

those boundaries, and where it seemed expedient some have resorted to acts of terror against legitimate institutions like abortion clinics. Burrows is fond of the kind of 'only just' bathetic extensions of history that *Revolutionary Army of the Infant Jesus Attack* typifies: *New Life* appropriated Luther's protest against the grotesqueries of the late medieval Catholic Church to denounce those of the contemporary mass media and propose an iconoclasm whereby our latter-day saints, celebrities and TV 'personalities', are torn down and rejected. Burrows's pose as a Luther or Savonarola for our time is, of course, parodic. His is a deliberately faux fundamentalism: one which shows that we are too much

LIVERPOOL JOHN MOORES UNIVERSITY
LEARNING SERVICES

in love with false idols for such a project to succeed, but also one which warns us that such a general dismissal might not prevent a few extremists from trying to cleanse society by violent means.

One of the striking features of *New Life* was that the parody of ruin in the gallery didn't only evoke the mass-mediated experience of terrorist attacks, but wasn't actually that different from some of the dilapidated, disastrous public housing projects in east London. Again, it was only just hyperbolic. As an art historical reference one was quickly drawn to Rachel Whiteread's *Demolition Series*, with the difference that, in Burrows's world, life was expected to continue in the collapsed remains of utopian architecture. What characterized the exhibition was what might be termed a 'structural violence': that rather than a violent 'event' being an exterior effect that brought our society to collapse, violence itself was a condition that was simultaneously constitutive of and catastrophic for that society. In other words, the very organization of our lives, and the lives of others, depended upon a certain, measured violence; as if we needed other people's, even our neighbours', lives to be catastrophes in order that our own might proceed equably.

Yet, if we are to act rationally, if we are to act hospitably, then we dare not neglect our neighbour's welfare. And as the Archbishop of Canterbury, Dr Rowan Williams has pointed out, the sheer ethnic and cultural complexity of London, the city's gathering of the life of several continents, means that we are inescapably involved in the life of others. 'Suddenly the question, "Who is my neighbour?" has a very clear answer: my neighbour, the person who lives next door, is the suffering stranger in Africa or South East Asia or wherever poverty, disease and disaster are found. My life is as much bound up with theirs as with the lives of people who happen to be more like me. And there is nothing abstract or idealistic about the command to love this neighbour:

this is the most realistic command that could be given.'[5] Whether in east London or in Africa we are someway distant from such an embrace: Burrows's recent work perhaps suggests that violence is conditional for us. Yet we might, in its dissolution of conventional boundaries and exploration of new relationships, see London as a city and, being a Londoner, as capable of producing new forms of art that might allow us to think otherwise. This is, I'd argue, an art of landscape and of surface, of rethinking modernism (which can be simultaneously both local and cosmopolitan) and reappraising national identity and cultural traditions. This is therefore an art which looks towards the past and rethinks it for the future. Burrows helps us to define the context in which this art is made.

So too, does Nigel Cooke (b. 1973) – one of the most thoughtful painters of his generation. For Cooke, the sense of violence as a seemingly inescapable condition of modern life is also fundamental – though in a very different way from Burrows. Whilst his large, meticulously detailed paintings can certainly be related to the pressing question of how art might deal with history, he is also working out issues that the artist himself understands as fundamentally modernist. As Cooke puts it, he's making 'paintings about nature but also about the nature of painting'.[6] Central to that nature is death: not only social and individual death, but also the 'death' so routinely assigned to painting by cheap journalism, and, as the painter is acutely aware, the medium's capacity to 'consume every threat and turn it into a character trait'.[7] Painting has continually been declared dead or obsolete since the 'invention' of photography in the early nineteenth century, yet it shows a remarkable capacity to reinvent itself: we could indeed argue that it is only with its 'death', the end of its responsibility for the retrospective construction of history and representation of the world as it is, that painting may become both

123 Nigel Cooke *Ghost on the Happy Trail* (detail), 2004, oil on canvas, 183 x 366 cm (6 x 12 ft)

proleptic – anticipating a world that might be – and analytical – appraising the ideological conditions and rhetorical formations of its own language. Cooke is right in the sense that painting is rather 'un-dead' than dead, able to vampirically revivify itself through its vitiation of other 'living' media; but the medium needed to die in order to become historically useful.

Cooke's paintings are usually large and characteristically have low horizon lines where debris-strewn fields abut pitch-black skies or graffitied walls. In works such as *Ghost on the Happy Trail* (2004) [123], or *Silva Morosa* (2002–03) [124], we look at what seem to be post-apocalyptic vistas, where civilization has been erased, and where, in the latter painting, it is already being overgrown by a peculiarly mordant rather than indifferent nature. We are still in the register of the catastrophe. With *Silva Morosa*, however, were

124 Nigel Cooke *Silva Morosa* (detail), 2002–03, oil on canvas, 183 x 244 cm (6 x 8 ft)

it not for the graffiti still visible amid the encroaching wilderness, and the skull's empty eye sockets, nose and mouth that are figured from branches, leaves and vines, we could even be in the terrain of an artist of the ruin such as Piranesi: that is, we are faced with some aspect of 'the Gothic'. But a painter in the early twenty-first century is not, innocently, a participant in the Gothic as a stylistic variant of high art, but rather understands that style through its adoption into mass cultural forms such as the horror film.

Jake Chapman, one of the key artists of the yBa generation, became a mentor for Cooke early in the painter's career. In a catalogue essay for Cooke, Chapman observed: 'Both visual art and the horror film genre are exemplary in being able to symbolically return psychic material which could not be exchanged in social life…. In horror films it is the socially pervasive and

LIVERPOOL JOHN MOORES UNIVERSITY
Aldham Robarts L.R.C.
TEL 0151 231 3701/3324

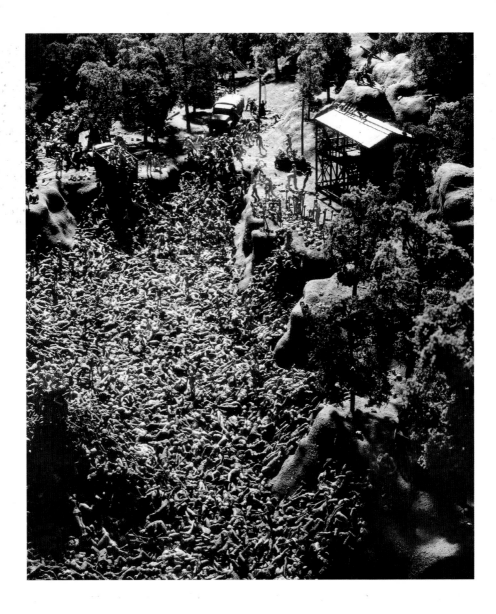

iniquitous view of death which can only tolerate its return from exile once its libidinal investment is sublimated into theatre.'[8] Chapman's claim can be extended to narrative cinema as a whole (since almost any cinematic genre sublimates into fantasy the psychic violence produced by the subjective degradation of industrial or post-industrial capitalism). It can also be given a historical duration (interestingly, at least in the critic Franco Moretti's view, one initially yoked to the emergence of mature forms of capital in the

opposite **125** Jake and Dinos Chapman *Hell* (detail), 1999–2000, mixed media, dimensions variable; above left **126** Nigel Cooke *Don't Mess with my Message* (detail), 2002, oil on canvas, 123 x 193 cm (48 ⁷⁄₁₆ x 76 in); above right **127** Nigel Cooke *Don't Mess with my Message* (detail), 2002, oil on canvas, 123 x 193 cm (48 ⁷⁄₁₆ x 76 in)

nineteenth century)[9] that encompasses the shift of the Gothic from a literary and minor, painterly, genre to wider mass cultural forms such as cinema, comics and rock music.

Cooke's paintings are most particularly interesting because they manage, in their detail, to combine the playful sadism of the modern horror film with a suggestion that the structural violence implicit in capitalist societies – which the sublimations processed within mass culture so successfully deflect into continued consumption – somehow might exceed the forms in which those sublimations are commodified. At their heart then is the fantasy that fantasy itself might not be transformed into objects or recuperated through social conscience but, rather, must become perversely redemptive and transformative of the individual. It's no accident, I think, that Cooke's early watercolour *American Psycho* (2001) shares a title with a novel by Bret Easton Ellis whose protagonist is, perhaps in reality, perhaps only in his fantasies, a serial killer whose sadistic excesses are the only aspect of his life not mediated through commodities. Minute in the overall scale of things, in the foregrounds of Cooke's paintings, there are heads jutting out of the detritus;

128 Nigel Cooke *Smile For The Monkey Man* (detail), 2001–02, oil on canvas, 183 x 244 cm (6 x 8 ft)

perhaps still attached to bodies buried in the refuse of their society (in the manner of Beckett's Winnie up to her neck in sand, or the protagonists of *Endgame* living in dustbins) or more likely severed and scattered. The beheading of citizens has, after all, signalled the collapse of civilizations since the Huns tied the severed heads of their victims to their saddles and marked their passage across Europe with a trail of skulls.

Certainly Jake Chapman understands Cooke's subjects as 'de-cerebrated', and Oliver Koerner von Gustorf, as 'chopped clean off, bodiless'[10] [126–127]. As Koerner von Gustorf observes, 'each one is a prototype of a young, hip media culture' of the sort that proliferates in London's Hoxton, New York's Williamsburg or Berlin's Kreuzberg, usually working in TV or 'media', rather than in 'art' as it used to be understood. So they are, in a rather clichéd way, the kind of victims who so often crop up in horror movies (trendy young

129 Nigel Cooke *Smile For The Monkey Man* (detail), 2001–02, oil on canvas, 183 x 244 cm (6 x 8 ft)

urbanites exposed to the horrors of rural life in *Texas Chainsaw Massacre*, or to a predatory primitivism that their own excesses cannot match in *Cannibal Holocaust*, and elsewhere to the psychopathic tendencies of fellow city dwellers). There's also a clear connection between Cooke's miniaturization of the apocalypse and that which Jake and Dinos Chapman have practised in *The Disasters of War* (1997) and *Hell* (1999–2000) [125]. Furthermore, Cooke shares with them a fascination with irrational violence that filters into the Chapmans' work from Nietzsche via the work of Georges Bataille.

I've already drawn attention to the extent to which Bataille's negative strain of philosophy, posing a stringent anti-idealist critique of modernism from within, may be useful to us in understanding contemporary artists as they once again confront and extend the issues first raised by modernist art. That critique is not new to British art; whilst the Chapmans have referenced

130 Nigel Cooke *Hitler's Bunker with Locust Horde*, 2000, oil on canvas, 214 x 153 cm (7 x 5 ft)

Bataille more overtly than most of their peers, they belong to an artistic tradition using Bataille's ideas which begins, in Britain, in the mid-1970s with the ideas and work of Paul Buck and Paul Hammond.[11] Cooke is also very clearly in this tradition. His paintings are of a world where the human condition – so massive, so vital to us as humans – is reduced to mere marginal detail. Trauma is not even so terrible that it must be closely scrutinized, as Goya did; rather it occurs in dispassionate detail, much as Callot depicted the horrors of the Thirty Years War to make them seem all the more bestial, all the less heroic. What's changed for artists such as Cooke is that this suffering is irrelevant in an amoral world.

Jurisdiction of this world is no longer – if it was ever – in the hands, or eye, of God. We must understand Cooke's universe, much as we can understand Bataille's philosophy, as being fundamentally Nietzschean. The rulers here, if they rule rather than merely dispassionately observe and act, are insects (as in

Hitler's Bunker with Locust Horde (2000) [130]) and apes (*Don't Mess with my Message* (2002) [126–127]; *Smile For The Monkey Man* (2001–02) [128–129]); or else we witness the prevailing oversight of a disembodied eye (*Cathedral of Erotic Misery* (2000); *Scandalous Magic Par Excellence* (2001); *Universe as Message Vista* (2002) [133]). From these eyes radiate forks of lightning, simultaneously destructive and life-giving. (One theory of life's formation on earth hypothesizes its origin in amino acids formed from electricity passing through pools of water on volcanic rocks to form a kind of 'organic soup'.) But whether there is life or not is not an issue to those who seem to prevail in this monstrous world. Discussing Cooke's painting, Chapman invokes Bataille's line 'The sun is nothing but death':[12] an appropriate summation of the physical and moral world that Cooke depicts; a space of endless catastrophe without value.

However, it is in their relation to contemporary events that Cooke's paintings reveal the limitations of Bataille's thought – just as the real historical

131 Nigel Cooke *Don't Mess with my Message*, 2002, oil on canvas, 123 x 193 cm (48 7/16 x 76 in)

Nigel Cooke: above **132** *Smile For The Monkey Man* (detail), 2001–02, oil on canvas, 183 x 244 cm (6 x 8 ft); opposite **133** *Universe as Message Vista*, 2002, oil on canvas, 25.5 x 35.5 cm (10 $\frac{1}{16}$ x 14 in)

catastrophe of the Second World War revealed the extent to which Bataille descended into an impotent, narcissistic nihilism, after offering up in the 1930s both a startlingly accurate commentary on Fascism as it emerged and a compelling challenge to idealism, especially as it was played out by the dilettantes of surrealism. Confronted by historical events, Bataille's critique robs both the individual and society of any capacity to act: rather one rejoices in and submits to one's own annihilation, because the only stimulus – a self-centred, erotic one – lies in the deaths of others. As Michel Surya has observed, 'without question, Bataille considered that nothing joyful or luminous binds humanity together. He does not hide the fact of looking to the death of others to awaken the being in each one of us.'[13] The consequence of this is to refuse those separate but related practices towards the other which Habermas calls 'tolerance' and Derrida terms 'hospitality'. For Bataille, the

other exists only for *my* momentary awakening, *my* momentary gratification, and: as a subject I have no obligations towards the 'other'. Bataille's thought induces historical passivity in the face of the authority of violence *and* the violence of authority, and undermines the rational self-affirmation that would resist such force. If the extension of the public sphere through mass mediation undermines the critical acumen or rationality that would give the citizens the opportunity to participate in history (and this is the potential latent within modernism which I suggest is being revived or at least scrutinized by some contemporary British art), then Bataille's philosophy, and much of the art stemming from it, appears to abrogate that same possibility by refusing to engage with anything other than a mockery of self and other.

Cooke's paintings do have something to say about our own time, however. Their message is not sanguine; their world may be amoral, but they are not silent. Indeed, though I do not know if Cooke shares the fantasy of horror he depicts, I'd argue – and this is a consciously large claim – that as Conrad in

'Heart of Darkness' truthfully depicted the structural violence implicit in Western colonialism through the moral corruption of the individual, so Cooke successfully renders the violence that is implicit in both the internal structure of contemporary capitalism and the moral corruption of its antagonistic relations with others. The violence done to humanity within them is structural (that is, it is a consequence of historical catastrophe) *and* indifferent. After all, catastrophes happen and in the larger scale of things what do they matter? Death is nothing personal; no more personal than the indignities enacted on human subjects by the economic and political systems in which they live. There is no purpose to our being here, and the planet that we think is so important, the lives we think are so important, remain utterly meaningless to the universe or nature. Crucially, as a commentary on the mass culture that assuages those indignities, this futility of life, this violence, is also comedic. Art here performs a parodic mimesis of that which it critiques – a strategy which Cooke shares with Jake and Dinos Chapman.

In these paintings a tragedy is being enacted behind a horror-movie fright mask – just as it is in the operations of popular culture or the mass media's evacuation of historical acuity, and historical event, from the public sphere. Looking at the severed heads I am reminded of a number of real or imagined executions: one is the fantasy of the Situationist Raoul Vaneigem, in *The Revolution of Everyday Life*, where debating village elders, dispensing wisdom, are decapitated and their heads skewered on stakes; the other the real beheadings and 'disappearances' perpetrated by totalitarian regimes from Pol Pot's Cambodia to Galtieri's Argentina and Pinochet's Chile, as well as the executions carried out on foreign workers by terrorist groups in Iraq. The irrational fantasy of 'liberty' allows, or even encourages, the descent into real terror. Bataille's headless avatar for his *Acephale* project surrendered the

capacity to articulate its subjective position in relation to others, so despising rationality that it willingly negated its capacity to use it. Cooke's painting is symbolic of the extreme effects of a withdrawal from rational exchange, and the fundamentalist catastrophes that may be the only response to rationality. At the same time it enacts precisely such a withdrawal from the public sphere into the cartoon world of mass culture – that is, it acts irresponsibly and, moreover in a tradition of British art that from Buck to the Chapmans has already made such negations in the name of a radical nihilism.

However, like Orpheus's severed head still singing, these decapitations may continue to communicate. Cooke's victims are symbolic of the violence that erupts when one or all parties abrogate a mutual investment in rationality and the limiting of behaviour through law – the defining parameters of the public sphere. Structural violence then erupts either as a return of the repressed, as simmering dissatisfactions are avenged, or descends into a systemic maintenance of existing social relations through extreme repression. It's striking how much terrorism is committed in the name of democracy and freedom; that 'holy warriors' who lay claim to irrational spiritual authority occupy both sides of conflicts.

This is where we live now, inhabiting a world of terrorism, counter-terrorism and the state's abrogation of its constitutional obligations. And we live in fear of our lives, largely because we have lost the capacity to speak and think critically for ourselves, thanks to the disempowering effects of the mass media's debasing of historical process into sensation and sentiment, and the sublimation of agency into consumption. Cooke's paintings may not just be signs of an indifferent universe, indicating that we needn't really care because we are all dead anyway, but also act as an inadvertent warning about the potential for catastrophe in our society.

LIVERPOOL JOHN MOORES UNIVERSITY
LEARNING SERVICES

CONCLUSION

a new reality is better than a new movie[1]

Art is not entertainment; art is not some novel element in a 'creative' or 'knowledge' economy whose prime function is to produce placid, contented, brand-conscious consumers. Art tells us something about the world we inhabit, and about ourselves, and it tells us using languages and forms that are not always transparent, that do not placate but rather may make us angry. Art stretches and challenges us with the difficulty of what it says and how it says it. Or rather, it should: clearly very little art makes such an exercise upon us now. Nor has most art ever done this: for every demanding modernist there were a dozen forgettable salon painters. It is, nonetheless, too easy to dismiss all recent art, and often such dismissals are conducted for the rare manifestation of precisely those virtues that I have just outlined above, rather than for their absence. Most contemporary art, whether yBa or what's followed, has failed as 'art' not for the kind of reasons put forward by the 'but is it art?' brigade of the British middle-class media or the Harold Acton parody aesthetes who haven't yet come to terms with modernism, but because it has no aspiration to be more than entertainment, to be more than placebo, to be anything more than just more product. Most recent art is, like this book, like a radio or television programme, like a CD or DVD, like a Hollywood or art-house movie, like the human subjects that consume them, one more commodity on the conveyor belt. Don't worry if you don't like the look, or the message, of this one, there will be another along in a minute, with equally little to offer in the way of real effect.

Whether it is because of art's failure to continue the ideologically loaded task of representation within culture from which it was dismissed in the mid-nineteenth century – having been replaced by new technology – or whether it is because of its failure to adequately challenge us and concentrate our attention upon the historical and subjective consequences of the machine age, we seem to have come to the end of what art has to offer. We prefer the produce of mass culture. We can argue, perhaps, about diagnosing the moment at which art became nothing more than an expensive branch of the entertainment industry. But we surely can no longer expect it to fulfil the kind of abrasive, dissident, engaged role within culture that it took up as its traditional formal modes (figurative painting and sculpture) were rendered obsolete by photography and film and outstripped in their capacity to accurately record human experience by precisely the conditions of life they sought to represent. That is, we have reached an endpoint in a process of cultural enervation and can no longer expect art to adhere to the precepts of modernism now, however fought over and diverse those precepts were in the past; any more than we should expect it to revert to a mythical, prelapsarian role of adequate representation and emotional or spiritual 'movement' through 'beauty', addressed to discerning, patrician audiences.

Oddly enough, I'd insist that we can at least hope for a kind of dissent, a refusal by certain forms of art to be 'product' and for a kind of affirmation, a belief in the capacity of art to communicate something beyond platitudes of 'truth and beauty'. It may not be the dominant tendency in contemporary art, and for it to remain something less than fashion it may be that it has to stay that way, but what distinguishes the best of contemporary art, from the local and global community that is 'London', is that it finds new ways to talk about old issues; rediscovers an old syntax and rhetorical felicity to discuss

contemporary life. Yet if art could be understood as pertinent within the pre-industrial era and therefore comment upon industrial modernity, how can it remain relevant when the terms of modernity have shifted? In the post-industrial, post-modern age how can an art that looks over its shoulder address the present, let alone anticipate the future? The contemporary artist starts to look something like Benjamin's Angel of History, propelled into the future whilst contemplating with horror the catastrophe over which it advances.[2] The answer to this problem of relevance lies, I think, in how we understand, or misunderstand, modernity. 'Modernity' is not a distinctive feature of the nineteenth and twentieth centuries dependent upon the transformation of Western culture by technology: what is 'modern' is the moment in which individuals and communities find themselves – this much we can learn from Hegel.[3] But we may extend this definition, and this is where contemporary art that continues modernist debates is valuable to us. Habermas suggests that the 'finding' of oneself in a particular moment is dependent upon the emergence of a consciousness of where that moment, and you, stand within history, and upon a parallel consciousness of one's potential to intervene in it. For Habermas, modernity is where you live it and how you announce it: a project consciously endorsed at a certain point in history by a community that discovers itself as communal and in agreement.[4]

The potential latent within that endorsement – the capacity to intervene in history – presumes as an ideal, perhaps never to be realized, public sphere where individuals and communities can deal with each other rationally and respectfully. At the heart of such a sphere is a concern for one's own language, though not with technical felicity for its own sake – for that way there lies, in one direction, the art of the aesthetes' salon and in the other a sterile, academic formalism. Rather, artists are to articulate difficult ideas, but

not necessarily transparently: as such, this would assume a certainty over the development of ideas which they cannot be presumed to possess as an innate consequence of the idea. Equally, one is able to listen, attentively and critically, to other people's difficult and different ideas and hospitably acknowledge that difference, and be prepared to have one's own ideas changed in consequence. In such an ideal world statements are not made as dicta but as provisions to be refined and developed.

We are clearly a long way from this situation, living in a world racked by terror initiated by individuals, communities and states that have lost all respect for otherness, if they ever had it, and for civilized behaviour – even as they proclaim themselves to be the crusading vanguard of a civilization. If art is simply entertainment, it refuses any role in such a public sphere – indeed, like mass entertainment and mass media it annihilates the possibility of anything other than a non-functioning simulacrum of a public sphere. Such art not only evacuates history from its content, it also refuses any responsibility to the world it inhabits even as it assumes a posture of responsibility and 'radical' engagement. As J. J. Charlesworth put it, describing the work of the group 'Common Culture', but in a condemnation which may stand for the more general activity of many contemporary artists (and not only British ones):

> The obsession with authenticity and anti-elitism has led to a situation where art celebrates the basest, most mediocre forms of everyday life as authentic representations of the life of ordinary people. This kind of fawning, inverted condescension towards the masses is symptomatic of an art that has lost faith not only in its own potential to engage people's intelligence and imagination, but also in their capacity to deal with it. (...) Giving up on contemporary art's imaginative engagement with the common culture has led many artists to fill the void with the negation of culture per se.[5]

LIVERPOOL JOHN MOORES UNIVERSITY
LEARNING SERVICES

But there are certain aspects of contemporary art from London which seem to me to attempt to shift art back towards a role within the public sphere and which attempt to address history. That is, in the terms of contemporary philosophers such as Habermas, art once again attempts to be 'modern'. In the terms of a modernist thinker such as Karl Kraus, art tries to provide culture with 'running room' – and we shall see that this is not room in which to run away, but rather a space in which to gain some perspective on events. It seems to me that in part this return to modernity is a consequence not so much of a general condition of British art, but rather an effect of the social, economic and cultural changes that London in particular has experienced over the last decade. Furthermore, this return has been expressed not so much through figurative use of the common culture but by a reclamation of particular, once neglected, aesthetic forms, and of particular modes of art, notably abstraction, assemblage and performance. I'd argue that such a return is neither conservative nor elitist – at least not in the pejorative sense in which that word is so readily deployed by media demagogues and politicos prepared to speak on behalf of 'ordinary people'. It suggests, instead, that some artists have begun to realize that the potential to engage with one's own culture and time can only be found in those modes and aesthetic forms which have proved unassimilable, or at least problematic, to the culture industry, because they demand critical attention from artist and audience alike.

As the excesses of yBa have been recuperated into the longer history of British art, we have witnessed the emergence of a new art in London that addresses potential and central issues within modernist art, but not addressed through pastiche. Rather, in the work of artists as diverse as Alexis Harding, Peter Peri, Eva Rothschild and Shahin Afrassiabi, we have seen a return to questions raised by modernism and the reappraisal of such questions in terms

of our own time, of our relationship to both 'modernity' as a technological and economic phenomenon of the twentieth century, and to the history of modernist art that accompanied it. This is art that diagnoses a fundamental fissure in modernism between rationality and the pursuit of a spiritual absolute through the use of modernist aesthetics; it diagnoses a failure of the utopianism that accompanied one strain of modernism, observing how the purity of its abstract forms and their potential to become something, was vitiated in the moment that abstraction became 'design' or even architecture, because what was realized was only a compromised emulation of an ideal – a product. Such an observation is not simply historical; it is hugely important to our own time.

What we also see, in the work of video artists such as Wood and Harrison, is a fresh perspective on the relationship of the human subject to a world of products. Whilst video as a new technology for art has, at least in the last two decades, become a medium that mimes the visual spectacle of mass culture within the legitimating context of the art gallery, Wood and Harrison refuse both spectacle and remote broadcast as characteristics of the medium (which are amongst its central rhetorical forms) and concentrate instead on another of its capacities – transitivity. Or to put it another way, in the specific use they make of that characteristic, the recognition by the human subject of its latent capacity through its mismatch to the supposedly ideal world that it inhabits. Wood and Harrison's work suggests that there is more substance to video art than either big screens and Hollywood sentiment, or technical incompetence and A-level nihilism posturing as the authentic message 'from the streets' for a jaded art market.

Accompanying such tendencies has been the emergence of an art that addresses language – indeed, Wood and Harrison's project itself might be seen

as directly addressing the language of video as a medium. Such an analysis of the sign can be seen in part as a legacy of neo-conceptualism in the 1990s, but I'd argue that its recent practitioners have an eye on earlier approaches to language. We cannot fully understand Carey Young, in establishing, very rapidly, a body of work that critically appraises the transformation of the art world into a commercial property, and which parodies the linguistic appropriations from culture of the 'society of the secretariat', without reference first to Beuys and secondly to Marcel Broodthaers – who like Young delivered a somewhat baffling performance at Speaker's Corner. What's common to the projects of Young, Ryan Gander and Caroline McCarthy is a concern with exposing the attempt, through design, to eliminate the infinite potential of language; and no matter whether that attempt at apodicticity is motivated by 'utopian' concerns or those of pure commerce. All such attempts at controlling the limits of language are bound by the same intention to make one reading seem entirely natural. This is, then, a reading of ideology that is concealed within language – the capacity of a particular form of language to seem natural rather than composed. Theirs is also art that makes plain the degree to which we, as much as our world, are shaped by language.

Caroline McCarthy's art is equally concerned with the question of veneer, with the construction of a layer between a mundane reality and a promoted perception of luxury or exotic difference. The issue of boundaries, whether expressed as surfaces, layers, lines or edges has become of crucial interest to a generation of artists based in and around London. Where yBa, when it addressed identity, was concerned with its representative icons, these artists prefer to scrutinize and question the boundaries between one thing, or one person, and another. Much new art from London is fundamentally about living

with difference and the problems that may entail. I'd argue that this is as true of Clare Woods's and George Shaw's painterly approaches to the rural landscape and suburbia, in their exposure of hidden tensions, flawed ideals and broken promises, as it is to Anne Hardy's photographic spaces where you become increasingly concerned about which side of a dividing line you're on.

That question of boundary – which for modernism became so focused on where the work began and ended – is also crucial to understanding the work of artists such as Steffi Klenz, James Ireland, Mauricio Guillen and Tania Kovats. For Kovats in particular that boundary is not simply spatial, whether for geographies or bodies, but rather is equally concerned with how we recognize our relationship to time. In a recent conversation, discussing the directions her work had taken since a studio visit in the middle of 2004, Kovats remarked that, having been so much concerned with demarcation, she was no longer sure about where things should begin and end.[6] In this we recognized an odd affinity – again with neo-conceptualism – because that very formal and thematic problem had been addressed by Martin Creed in a neon made for the façade of Tate Britain: the work + the whole world = the whole world. It was a sign that, in the overall scheme of things, your work may not make a difference to the sum total, but at the same time can be an integral part of it.

An art that returns to the address of history, that looks, through however jaundiced an eye, at our own time, is necessarily an art concerned with the event, with the disaster, with catastrophe. We live in a time of terrors, real and imagined; inflicted upon us, and inflicted upon others in our name. What use would there be for a culture that did not critically apprehend this? And we have, amidst the welter of distracting entertainment that so often exploits an eroticism of catastrophe, seen the emergence of art that captures the temper of our times – not through slogans or polemic – but rather in a self-conscious

bathos or mordant withdrawal from engagement. I'd suggest that the compromises within these distancing strategies are in large part the consequence of art's migration over the last twenty-five years away from a position where artists might contemplate, without self-conscious irony, the general conditions of their history rather than its local effects. Unlike the novel, say, which always managed to just about sustain such a perspective, and which has allowed writers like Ian McEwan and Ronan Bennett to distil or allegorize the anxieties of the present for both present and future audiences, art after 1980 largely, and thankfully, withdrew from any sense of historical consciousness. Art presumed 'the end of history' long before think-tank intellectuals such as Francis Fukuyama got around to announcing it. On the one hand, it retreated into solipsistic spirituality; on the other, it emerged as banal spectacle, a mimesis of mass culture neatly packaged for a wealthy niche market.

Young artists are still struggling to get out from under the burden of that misapprehension. At least, with painters such as Nigel Cooke and more diverse practitioners like David Burrows, we have the beginnings of an art that might articulate the anxieties, rather than rehearse the experiences, of a history that is anything but over. In particular we contemplate the consequences of fundamentalism both as something inscribed in our own culture and as exterior effect. In Cooke's paintings and Burrows's installations we get an artist's impression of the concealed structural violence within our society and of the violence that modernity – understood only as technological and material progress – can provoke.

One of the virtues of such art is that it refuses to clarify complexity and provide us with good versus bad. Habermas remarks that 'fundamentalism (which is that simplistic division) is the panicked reaction to modernity'.[7] To

which we might add that if there is one form of fundamentalism that refuses modernity as a spectacle of commodities and a latent rationality, there is another, that of the West, which is panicked by the possibility that modernity might be something other than the historical stasis and sedated subjects of consumer capitalism.

That we have such art is, I think, a consequence of London's idiosyncrasies as a city; as a model of local space as it encounters the global. Recent events have demonstrated to a somewhat startled wider audience that here there is a world in one metropolis. Londoners did not need bombs on the underground or buses to discover this: we knew it every time we got on a tube or a bus and the voices around us were Mandarin Chinese, French, German, Spanish, Serbo-Croat, Urdu or any one of a myriad of African languages, usually being shouted into a mobile phone.

In my introduction I remarked that London is expensive, boorish, dirty and surprisingly dangerous. (And at that time I meant in terms of violent crime and badly driven cars.) That's still true, but London is also a model of hospitality, a place where boundaries between self and other have to be rethought and renegotiated on a more or less continuous basis. This hospitality is not an obvious, 'touchy-feely' embrace, it's often grudging or inadvertent; it's learned, and any member of an immigrant community from the 'Windrush' generation to the Poles and Czechs who arrived with their countries' accession to the EU will tell you that it has been, and remains, a painful learning process.

That different sense of self and place has its consequence in art: it also leads to a questioning of the relation between London as an international city and Britain as a nation state in a world where nation states look increasingly like a mad, bad and dangerous idea. It has helped foster an art that sees

'hospitality' – the attentive exchange with the other, rather than their neglect or contempt – as conditional for one's culture in the widest sense.

In arguing for a new art from London I am, hopefully, providing a sample of what's happening, right now, in what is, right now, the most exciting city for art in the world. The whole art scene is beyond any book: parts of it are boring, parts are disgusting, and some days you go into a gallery or a studio and you remember why it was you loved art in the first place because what you see challenges everything you've started to take for granted about the world. Nonetheless it remains that in the overall scheme of things, the work plus the whole world does equal the whole world and yet we still don't know if art made a difference to that equation. Art may be able, at its best, to tell us, in surprising and insightful ways, about how our society works, about what it feels like to be alive, right now. But when art starts to overtly propose models for social change or a certain type of life it's usually only a step away from fitting comfortably into a gallery as a commodity rehearsing the illusion of a progressive society, or worse, becoming a mouthpiece for some politician's social agenda. This other art, this 'new' art, might be premised by 'hospitality' as exchange, might demand critical attention where a society of banality wants entertainment, but it doesn't announce these changed conditions for art as a programme. Perhaps artists have learned enough by now to be historically self-conscious about manifestos. What's more, this new art is still only a faint glow: whether that glow is the first glimmer of a revived modernity or the last gleaming of modernism's historical responsibility and acuity it is both too early, and too late, to tell.

NOTES

CHAPTER ONE

1 BBC survey 'Born Abroad: An immigration map of Great Britain', based on 2001 UK census data. See http://news.bbc.co.uk/1/shared/spl/hi/uk/05/born_abroad/html/overview.stm

2 B. Latour (C. Porter, trans.), *We Have Never Been Modern* (Harvard University Press, 1993), p. 122.

3 'Artnotes', *Art Monthly*, No. 239 (September 2000), p. 22.

4 *Le Monde*, 9 June 2005.

5 J. J. Charlesworth, 'The Art of the Third Way', *Art Monthly*, No. 241 (November 2000), p. 8.

6 T. Adorno (R. Hullot-Kentor, trans.), *Aesthetic Theory* (Continuum, 2002), *passim*.

7 R. Kaufman, 'Aura, Still', *October*, No. 99 (Winter 2002), p. 48.

8 G. Agamben (K. Attell, trans.) *State of Exception* (University of Chicago Press, 2005). Agamben is, of course, specifically concerned with the legal forms by which democratically constituted authorities abrogate democracy and the rule of law in order to preserve it. I am consciously extending, and perhaps compromising, the term to describe the condition of the subject in a global metropolis who is at once the subject, *rather than the citizen*, of the British nation state. The subject simultaneously inhabits an economy that reduces the authority of the nation state to mere managerialism – a crisis of function, for the state, that can only be overcome by an increasingly fundamentalist and, in Foucault's terms, socially 'disciplinary' reaction.

CHAPTER TWO

1 See J. Spalding, *The Eclipse of Art: Tackling the Crisis in Art Today* (Prestel, 2003); D. Kuspit, *The End of Art* (Cambridge University Press, 2004) and, purely as an experiential nadir in its dismissal of all forms of the visual, J. Carey, *What Good are the Arts?* (Faber, 2005).

2 As Rosalind Krauss points out, despite their deep hostility to the Greenbergian doctrine of pictorial 'flatness' the vanguard artists of the late 1960s were 'committed modernists nonetheless'. See R. Krauss, *"A Voyage on the North Sea": Art in the Age of the Post-Medium*

Condition (Thames & Hudson, 2000), p. 24.

3 J. Habermas (F. G. Lawrence, trans.), *The Philosophical Discourse of Modernity* (MIT Press, 1987).

4 R. Krauss, 'Grids', *The Originality of the Avant-Garde and Other Modernist Myths* (MIT Press, 1985), p. 9.

5 Ibid, p. 10.

6 See R. Krauss, 'Overcoming the Limits of Matter: On Revising Minimalism' in J. Elderfield (ed.), *Studies in Modern Art, 1: American Art of the 1960s* (Museum of Modern Art, 1991), pp. 124–25, for the unresolved tension between two apparently similar monochromes.

7 G. Salvetti, *Il Novecento I*, Vol. 9 of *Storia della Musica* (EDT, 1977) cited in G-P. Biasin, *Montale, Debussy and Modernism* (Princeton University Press, 1989), p. 11.

8 For an excellent survey of the debate concerning framing and the edge of the work after modernism, see J. C. Welchman, 'In and around the "Second Frame"' in P. Duro (ed.), *The Rhetoric of the Frame: Essays on the Boundaries of the Artwork* (Cambridge University Press, 1996).

9 R. Sheppard, *Modernism – Dada – Postmodernism* (Northwestern University Press, 2000), pp. 11–22. See also his comments on Robert Musil's novel *Törless*, p. 32.

10 J. J. Charlesworth, *Painting by the Skin of Your Eyes* (Andrew Mummery Gallery, 2003).

11 Ibid.

12 Rose-Carol Washton Long, for example, sees this process of 'stripping' and 'veiling' as making the abstracted object more meaningful in personal, epiphaniac, terms the further it is removed from recognition. We can see the process at work in the *Improvisation* works of 1911, where recognizable forms that appear in studies have been abstracted in the final painting. See the chapter on Kandinsky in Sheppard's *Modernism – Dada – Postmodernism*.

13 B. Ruf, 'An Introduction and a Conversation', *Eva Rothschild* (Kunsthalle Zürich/JRP/Ringier Kunstverlag, 2004), p. 5.

14 I am, necessarily, condensing modernism's tensions and differing aspirations and phobias. Modernism is neither 'simply' utopian in its aspirations for modern life

LIVERPOOL JOHN MOORES UNIVERSIT
LEARNING SERVICES

nor unproblematically opposed to modernity; nor is it just concerned with the rhetorical specificities of its expressive media, which I necessarily concentrate on here, and which, in the wake of Greenberg's formulations around modernist painting, has come to define modernist practice and criticism in American academia. For a wide-ranging discussion of the sheer diversity of modernism, and of the critical headings under which it has been classified, see *Modernism – Dada – Postmodernism*, pp. 1–30.

15 The very idea of a vanguard is itself a product of one form of modernism, the historically redemptive and progressive strain; and the problem of an ending, if there has been an ending, equally a product of its other, personal and spiritual, strain, however bound up that becomes in the teleological notion of an end to history, which we find, for example, in Bloch's melding of a Judeo-Christian eschatology to the utopian hopes of Socialist revolution. Not all 'modernisms' are necessarily so overtly Hegelian – as any study of either the importance of Bergsonian thought to the circles around Apollinaire before 1914, of the complex exchange between materialism and Jewish Messianism in Walter Benjamin's writing, or in Bataille's critique of Hegel, coming from the influence of Alexander Kojève and directed within and against Surrealism would suggest.

16 H. Foster, *Design and Crime and other diatribes* (Verso, 2002), p. 19.

17 One of the few artists of the 1960s and 1970s who, in Benjamin Buchloh's words, anticipated 'the complete transformation of artistic production into a branch of the culture industry', was Marcel Broodthaers. See B. Buchloh, 'Introductory Note', *October*, No. 42 (Fall 1987), p. 5.

18 Conversation with Eva Rothschild, August 2004. If there is a British sculptor of the 1960s who points a way forward to a contemporary reinterpretation of broad modernist concerns, it is perhaps Phillip King rather than Caro.

19 Conversation with Eva Rothschild, August 2004.

20 See R. Morris, 'Notes on Sculpture, 1–4' in *Continuous Project Altered Daily: The Writings of Robert Morris* (MIT Press, 1996). The title refers to a 1969 exhibition by Morris. Jonathan Monk has recently revived the idea of the exhibition as transitory archive and continuous

process rather than fixed moment in an exhibition of the same title at the ICA, London.

21 Conversation with Eva Rothschild, August 2004.

22 Of the artists in 'Early One Morning' this book excludes Barclay and Lambie because they are based in Glasgow, which is increasingly an art centre with a distinctive and different temper from London.

23 J. J. Charlesworth, 'Not Neo but New', *Art Monthly*, No. 259 (September 2002), p. 8.

24 Conversation with Shahin Afrassiabi, May 2005.

25 A. Benjamin, 'Malevich and the Line', lecture delivered at Architectural Association, London, 1 February 2005.

26 Conversation with Shahin Afrassiabi, May 2005.

CHAPTER THREE

1 *"A Voyage on the North Sea"*, p. 30.

2 F. Jameson, 'Transformations of the Image in Postmodernity', *The Cultural Turn: Selected Writings on the Postmodern, 1983–1998* (Verso, 1998), p. 99.

3 *"A Voyage on the North Sea"*, p. 31.

4 Ibid, p. 30. We might, however, see essays such as Campus's 'Video as a function of reality' (1974) as the beginning of such a theorization.

5 R. Dorment, 'A Room with a view', *Daily Telegraph* (7 May 2003).

6 Conversation with John Wood and Paul Harrison, June 2005.

7 M. Jennings, *Dialectical Images: Walter Benjamin's Theory of Literary Criticism* (Cornell University Press, 1987), p. 172, cited in M. Bratu Hansen, 'Room for Play: Benjamin's Gamble with Cinema', *October*, No. 109 (Summer 2004), p. 26.

8 W. Benjamin, 'The Formula in Which the Dialectical Structure of Film Finds Expression' in H. Eiland and M. W. Jennings, *Walter Benjamin: Selected Writings. Vol. 3, 1935–1938* (Belknap Press of Harvard University Press, 2002), p. 94.

9 For a compelling critical revision of *Ballet mécanique* see M. Turvey, 'The Avant-Garde and the "New Spirit": The case of *Ballet mécanique*', *October*, No. 102 (Fall 2002), pp. 35–58.

10 F. Léger, 'If you don't like holidays', *L'Intransigeant*, No. 21 (October 1929).

11 See A. Darley, *Visual Digital Culture: Surface Play and Spectacle in New Media Genres* (Routledge, 2000), cited in Bratu Hansen, 'Room for Play', p. 44.

12 'Room for Play', p. 45.

13 J. Starobinski, *Portrait de l'artiste en saltimbanque* (Skira, 1970) and *Montale, Debussy and Modernism*, pp. 20–21.

14 'Room for Play', p. 45, and I'd like to acknowledge here a larger debt to Bratu Hansen's extraordinarily acute and perceptive essay, which allowed me to think productively about Wood and Harrison's 'slapstick'.

CHAPTER FOUR

1 J. Milne, 'Introduction', *Laing Solo 2004–05* (Laing Art Gallery, 2004).

2 Conversation with Anne Hardy, April 2005.

3 'Anne Hardy interviewed by Natalie Frost', *Laing Solo.*

4 See G. Bataille, '*Pousser*', *Documents No. 5 (1929)* and '*Figure humaine*', *Documents No. 4 (1929)* (translated in *October*, No. 36 (Spring 1986)) and A. Michelson, 'Heterology and the Critique of Instrumental Reason', *October*, No. 36 (Spring 1986).

5 P. Wright, *On Living in an Old Country: National Past in Contemporary Britain* (Verso, 1985).

6 C. Woods, 'Picture: Scarecrows', *Frieze*, No. 56 (January–February 2001).

7 A. Conan-Doyle, 'The Adventure of the Copper Beeches', *Strand Magazine* (1892).

8 J. Barrell, *The Dark Side of the Landscape: The Rural Poor in English Paintings, 1730–1840* (Cambridge University Press, 1980).

9 See for example, R. Williams, *The Country and the City* (Chatto & Windus, 1973).

10 T. Morton, 'If...', *Frieze*, No. 67 (May 2002), p. 57.

11 Email from Caroline McCarthy, August 2005.

12 'Transformations of the Image in Postmodernity', p. 111.

13 Ibid.

14 Conversation with Caroline McCarthy, March 2005.

15 M. Hutchinson, 'An Art of Escape', *Caroline McCarthy: AIB Art Prize* (Temple Bar Gallery and Studios, 2002), p. 12.

CHAPTER FIVE

1 Conversation with Steffi Klenz, March 2005.

2 In Pope's case I'm thinking particularly of his work from the 1970s, with its affinities to Brancusi, and the rather more allusive connection to Morandi, highlighted by Norbert Lynton in his essay for Pope's appearance at the 1980 Venice Biennale,
rather than more recent material. See *Nicholas Pope, British Pavilion, Venice Biennale 1980* (British Council, 1980).

3 T. Kovats, 'Coast', *Lost* (Ikon Gallery, 2000), p. 32.

4 B. Hepworth, Letter to E. H. Ramsden, 28 April 1943 (Tate Gallery Archive).

5 T. Kovats, 'Landscapes', *Lost*, p. 12.

6 Letter from Helen Barff, June 2005.

7 Conversation with Helen Barff, May 2005.

8 Letter from Helen Barff, June 2005.

9 Ibid.

10 Ibid.

11 L. Byatt, 'Foreword', *All of the Known Universe: James Ireland* (Spike Island Publications, 2003), p. 10.

CHAPTER SIX

1 S. Freud, 'Fetishism' (1927) in J. Strachey (ed. and trans.), *The Standard Edition of the Complete Works of Sigmund Freud*, Vol. XXI (Hogarth Press, 1961), pp. 152–57.

2 Email from Ryan Gander, August 2005.

3 R. Gander, *Appendix* (Artimo, 2003), p. 72.

4 T. W. Adorno and M. Horkheimer, (J. Cumming, trans.) *Dialectic of Enlightenment* (Verso, 1997), p. 123.

5 Reproduced in *Appendix*, p. 72.

6 Press release for Perl Gray, 'With Coyote Eyes', Jacksie Records (Manchester, 2002).

7 *Appendix*, pp. 62–4.

8 Ibid, p. 69.

9 Press release for Perl Gray, 'With Coyote Eyes'.

10 *Design and Crime*, p. XIV.

11 R. Gander and A. Fisher (eds), *Mitim* (STORE, 2005).

12 Ibid.

13 Ibid.

14 C. Young, *Disclaimer: A Fellowship Project* (The Henry Moore Institute, 2004).

15 Ibid.

16 Ibid.

17 H. Arendt, 'The Crisis in Culture' cited in F. Furedi, *Where Have All the Intellectuals Gone?* (Continuum, 2004), p. 112. For a useful, if brief and infuriated, analysis of the extent to which market values and social agendas have penetrated both academia and the arts in the UK, Furedi, pp. 92–113, is a good place to start.

18 Cited in T. Y. Levin, 'Elements of a Radio Theory: Adorno and the Princeton Radio Research Project', *Musical Quarterly*, Vol. 78, No. 2 (Summer 1994), pp. 316–24.

19 J. Derrida, 'Signature Event Context' in A. Bass, (trans.) *Margins of Philosophy* (Harvester Press, 1982). I am, necessarily, distilling Derrida and Austin's arguments here, and addressing only one part of Derrida's critique of performative language.

20 *Design and Crime*, p. 19.

CHAPTER SEVEN

1 G. Borradori, *Philosophy in a Time of Terror: Dialogues with Jürgen Habermas and Jacques Derrida* (University of Chicago Press, 2003), p. 33.

2 F. Jameson, 'End of Art or End of History?', *The Cultural Turn*, p. 79.

3 *Philosophy in a Time of Terror*, p. 33.

4 Ibid.

5 Dr Rowan Williams, Archbishop of Canterbury: sermon delivered at Southwark Diocesan Centenary Eucharist, Lambeth Palace, 2 July 2005.

6 Conversation with Nigel Cooke, September 2004.

7 Ibid.

8 J. Chapman, 'The New Spirit in Death Painting', *Nigel Cooke* (Modern Art, 2002).

9 F. Moretti, *Signs Taken for Wonders: Essays in the Sociology of Literary Form* (Verso, 1988).

10 O. Koerner von Gustorf, 'Painting as Endgame: Nigel Cooke's Pathology of the Downfall', *db-art.info magazine*, 2003.

11 For an extended discussion of the transmission of Bataille's influence and, in particular, its effects on the Chapman brothers, see my 'Up Yer Solar Anus: Georges Bataille in the recent history of British art, from Paul Buck to Jake and Dinos Chapman' in C. Townsend (ed.), *The Art of Jake and Dinos Chapman* (Thames & Hudson, forthcoming 2006).

12 G. Bataille, 'The Pineal Eye' (1930) in A. Stoekl (ed.), *Visions of Excess: Selected Writings 1927–1939* (University of Minnesota Press, 1985). See also A. Stoekl, *Politics, Writing, Mutilation: The Cases of Bataille, Blanchot, Roussel, Leiris, and Ponge* (University of Minnesota Press, 1985) and D. Hollier (B. Wing, trans.), *Against Architecture: The Writings of Georges Bataille* (MIT Press, 1992).

13 M. Surya (K. Fijalkowski and M. Richardson, trans.), *Georges Bataille: An Intellectual Biography* (Verso, 2002), pp. 242–43.

CHAPTER EIGHT

1 My subtitle is taken from the poet Amiri Baraka with profound respect, whose work 'A New Reality is Better Than a New Movie!' can be found in his 1975 volume *Hard Facts*, and more readily in W. J. Harris (ed.), *The LeRoi Jones/Amiri Baraka Reader* (Thunder's Mouth Press, 1991).

2 W. Benjamin, 'Theses on the Philosophy of History' in H. Arendt (ed.), *Illuminations* (Schoken, 1969).

3 G. W. F. Hegel (J. Sibree, trans.), *The Philosophy of History* (Basic Books, 1956).

4 *The Philosophical Discourse of Modernity.*

5 J. J. Charlesworth, 'Common Culture', *Art Monthly*, No. 242 (December 2000–January 2001), p. 43.

6 Conversation with Tania Kovats, July 2005.

7 *Philosophy in a Time of Terror*, p. 76.

ACKNOWLEDGMENTS

In addition to the artists who feature in this book, who were so generous with their time and forthcoming about their work, the staff and owners of various galleries, and those who offered advice, opinion and support, I'd like to thank my scrupulous and felicitous editor Rebeka Cohen and Jamie Camplin at Thames & Hudson, who persisted with ideas about what this book should be for several years before I got around to writing it. And I guess that my biggest acknowledgment should go to the artist who I wanted to include in the book after my first studio visit, but who decided that subsequent events – notably that she married me – might make such an inclusion appear nepotistic.

1 Layla Curtis, *The United European Union*, 1999. Collaged EU road maps. Photo Marc Domage. Courtesy the collection Claudine & Jean-Marc Salomon, France.

2 Tobias Ingels, *West Pier*, 2002. Super 8. Courtesy the artist.

3 Tania Kovats, *Rocky Road*, 1999. Acrylic composite and MDF. Courtesy the artist.

4 Tania Kovats, *The British isles*, 2004. Ink on matte acetate paper, pins, timber. Private collection.

5 Layla Curtis, *The United European Union* (detail), 1999. Collaged EU road maps. Photo Marc Domage. Courtesy the collection Claudine & Jean-Marc Salomon, France.

6 Steffi Klenz, *Tottenham Hale*, 2003. C-type print. Courtesy the artist.

7 Carey Young, *Optimum Performance*, 2003. Performance at the Whitechapel Gallery documented on video, colour and sound. Courtesy the artist and IBID Projects, London/Vilnius.

8 Robert Ellis, *Beaconsfield art space* (Vauxhall), 1996. Cardboard, glue, Perspex. Courtesy the artist and Beaconsfield, London.

9 Alexis Harding, *Kingsize (Double)*, 2004. Oil and gloss paint on MDF. Courtesy Marella Art Contemporanea, Milan.

10 Eva Rothschild, *Mass Mind*, 2004. Perspex. Courtesy Stuart Shave | Modern Art and the Modern Institute, Glasgow.

11 Carey Young and Massimo Sterpi, *Disclaimer: Access*, 2004. Inkjet print mounted on board. Courtesy the artist and IBID Projects, London/Vilnius.

12 Carey Young and Massimo Sterpi, *Disclaimer: Value*, 2004. Inkjet print mounted on board. Courtesy the artist and IBID Projects, London/Vilnius.

13 Carey Young and Massimo Sterpi, *Disclaimer: Ontology*, 2004. Inkjet print mounted on board. Courtesy the artist and IBID Projects, London/Vilnius.

14 Mauricio Guillen, *3–0*, 2001. C-print and sound. Courtesy f a projects, London.

15 David Burrows, *New Life*, 2004. Mixed media. Courtesy f a projects, London.

16 Shahin Afrassiabi, *Aluminium Stand*, 2004. Aluminium, vinyl and steel. Courtesy the artist.

17 Sarah Lucas, *Sod You Gits*, 1990. Photocopy on paper. © the artist. Courtesy Sadie Coles HQ, London.

18 Alexis Harding, *Ruinart II*, 2001. Oil and gloss paint on MDF. Private collection, Portugal.

19 Alexis Harding, *Double Crossed*, 2005. Oil and gloss paint on MDF. Courtesy the artist and Andrew Mummery Gallery, London.

20 Alexis Harding, *Pulmonary III*, 2005. Oil and gloss paint on MDF. Courtesy the artist and Andrew Mummery Gallery, London.

21 Alexis Harding, *Interior of the artist's studio*, London, 2002. Photo courtesy the artist and Andrew Mummery Gallery, London.

22 Alexis Harding, *Liar*, 1998. Oil and gloss paint on stainless steel. Private collection, Sydney.

23 Peter Peri, *Rotary*, 2003. Graphite on unbleached paper. © the artist, courtesy the artist and Carl Freedman / Counter.

24 Károly Keserü, *Untitled (0204)*, 2004. Acrylic and thread on linen. Courtesy the artist.

25 Peter Peri, *Projection 6*, 2004. Acrylic and enamel paint on canvas. © courtesy the artist and Carl Freedman / Counter.

26 Peter Peri, *Monstrance*, 2002. Graphite on unbleached paper. © courtesy the artist and Carl Freedman / Counter.

27 Eva Rothschild, *Night of Decision*, 1999–2000. Woven photocopies. Courtesy the artist, Stuart Shave | Modern Art and the Modern Institute, Glasgow.

28 Eva Rothschild, *Burning Tyre*, 2004. Tyre, incense. Courtesy Stuart Shave | Modern Art and the Modern Institute, Glasgow.

29 Eva Rothschild, *Fort Block*, 2004. Lacquered wood. Courtesy Stuart Shave | Modern Art and the Modern Institute, Glasgow.

30 Eva Rothschild, *Your Weakness*, 2003. Ebony, lacquered wood. Courtesy Stuart Shave | Modern Art and the Modern Institute, Glasgow.

31 Shahin Afrassiabi, *Display with Nails & Paint* (detail), 2001. Wood, cement, house paint, aluminium, wallpaper, TV, carpet, light bulb, drain pipe, painting, box of nails, electric cable. Courtesy the artist.

32 Shahin Afrassiabi, *Display with Nails & Paint* (detail), 2001. Wood, cement, house paint, aluminium, wallpaper, TV, carpet, light bulb, drain pipe, painting, box of nails, electric cable. Courtesy the artist.

33 Shahin Afrassiabi, *Jalousie gelocht als blendschutz*, 2000. TV, fan, carpet, wood, Evian water bottle, wallpaper, painting, lamp, cable. Courtesy the artist.

34 Shahin Afrassiabi, *Display with Table*, 2002. Steel, plastic, wood, synthetic materials, glass,

neon light, cable, cardboard, paint, washing up liquid. Courtesy the artist.

35 Shahin Afrassiabi, *Window 2000*, 2000. Wood, steel, plastic, paper, glass. Courtesy the artist.

36 Pedro Cabrita-Reis, *Longer Journeys*, 2003. Painted aluminium, standard plywood doors and fluorescent lights. Photo PCR Studio / Tânia Simões. Courtesy the Philip Morris / Tabaquiera collection.

37 Ori Gersht, *Rear Window I* (Vauxhall), 1998. C-type print. Courtesy Andrew Mummery Gallery, London, CRG Gallery, New York, Angles Gallery, Los Angeles and Noga Gallery, Tel Aviv.

38 Ori Gersht, *Rear Window II* (Vauxhall), 1998. C-type print. Courtesy Andrew Mummery Gallery, London, CRG Gallery, New York, Angles Gallery, Los Angeles and Noga Gallery, Tel Aviv.

39 Ori Gersht, *Border Line, Colour Block I*, 2000. C-type print. Courtesy Andrew Mummery Gallery, London, CRG Gallery, New York, Angles Gallery, Los Angeles and Noga Gallery, Tel Aviv.

40 Ori Gersht, *Border Line, Colour Block II*, 2005. C-type print. Courtesy Andrew Mummery Gallery, London, CRG Gallery, New York, Angles Gallery, Los Angeles and Noga Gallery, Tel Aviv.

41 Ori Gersht, *Border Line, Colour Block III*, 2005. C-type print. Courtesy Andrew Mummery Gallery, London, CRG Gallery, New York, Angles Gallery, Los Angeles and Noga Gallery, Tel Aviv.

42 John Wood and Paul Harrison, *3-Legged*, 1996. Video (Hi8 transferred to DVD). Collection of Cesar Cervantes, Mexico. Courtesy f a projects, London.

43 John Wood and Paul Harrison, *Hundredweight*, 2003. Six-channel video installation (Mini DV transferred to DVD). Courtesy the artists and f a projects, London.

44 Vito Acconci, *Blindfolded Catching*, 1970. Super 8 film. Courtesy Acconci Studio.

45 John Wood and Paul Harrison, *Plastic Bag* from the series *Twenty Six (Drawing and Falling Things)*, 2001. Video (Mini DV transferred to DVD). Courtesy New Art Gallery, Walsall and f a projects, London.

46 John Wood and Paul Harrison, *Hundredweight*, 2003. Six-channel video installation (Mini DV transferred to DVD). Courtesy the artists and f a projects, London.

47 Clare Woods, *Finger Post*, 2004. Household gloss on aluminium. © the artist. Courtesy Stuart Shave | Modern Art, London.

48 Anne Hardy, *Drift*, 2004. C-print diasec mounted. Courtesy Maureen Paley.

49 Anne Hardy, *Cell*, 2004. C-print diasec mounted. Courtesy Maureen Paley.

50 Anne Hardy, *Untitled III (Office)*, 2005. C-print diasec mounted. Courtesy Maureen Paley

51 Anne Hardy, *Swoop*, 2003. C-print diasec mounted. Courtesy Maureen Paley.

52 Anne Hardy, *Lumber*, 2003. C-print diasec mounted. Courtesy Maureen Paley.

53 Anne Hardy, *Untitled IV (Balloons)*, 2005. C-print diasec mounted. Courtesy Maureen Paley.

54 Clare Woods, *Charley Boy*, 2004. Enamel on aluminium. © the artist. Courtesy Stuart Shave | Modern Art, London.

55 Clare Woods, *House of Hill*, 2001. Enamel on aluminium. © the artist. Courtesy Stuart Shave | Modern Art, London.

56 Clare Woods, *Failed Back*, 2004. Enamel on aluminium. © the artist. Courtesy Stuart Shave | Modern Art, London.

57 George Shaw, *Scenes from The Passion: The Way Home*, 1999. Humbrol enamel on board. Photo Edward Woodman. Courtesy the Wilkinson Gallery, London.

58 George Shaw, *Souvenirs*, 1999. Photo courtesy the Wilkinson Gallery, London.

59 George Shaw, *Scenes From The Passion: Back of the Club and the Bottom of the Steps*, 2001. Humbrol enamel on board. Photo Peter White. Courtesy the Wilkinson Gallery, London.

60 George Shaw, *Ash Wednesday, 8.00am*, 2004–05. Humbrol enamel on board. Photo Peter White. Courtesy the Wilkinson Gallery, London.

61 George Shaw, *Ash Wednesday, 8.30am*, 2004–05. Humbrol enamel on board. Photo Peter White. Courtesy the Wilkinson Gallery, London.

62 George Shaw, *Scenes from the Passion: The Blossomiest Blossom*, 2001. Humbrol enamel on board. Photo Peter White. Courtesy the Wilkinson Gallery, London.

63 Caroline McCarthy, *Endeavor (1944)*, 2004–05. 1944 dinner packaging, vinyl tablecloth, kitchen table. Photo the artist. Courtesy the artist, Parker's Box, New York and Hoet Bekaert Gallery, Ghent.

64 Caroline McCarthy, *Promise*, 2003. Dinner packaging, plastic plant pots, wire, wood. Photo the artist. Courtesy the artist, Parker's Box, New York and Hoet Bekaert Gallery, Ghent.

65 Caroline McCarthy, *1, 5, 11, 21, 27, 32, 33, 40, 55, 56, 64, 79, 87, 92, 112, 123, 127, 164, 27001, 27004: (from the Humbrol series)*, 2000–03. Found plastic bottles, Humbrol enamel paint, glass shelving. Photo the artist. Courtesy the artist,

Parker's Box, New York and Hoet Bekaert Gallery, Ghent.

66 Caroline McCarthy, *Souvenirs (Blue) and Golden Wonder*, 1998. Paper (swimming pools cut from holiday brochures), crisps, wire, shelving. Photo Peter Abrahams. Courtesy the artist, Parker's Box, New York and Hoet Bekaert Gallery, Ghent.

67 Helen Barff, *Drawing done by touch in blacked out car – gear stick*, 2004. Pencil on paper. Courtesy the artist.

68 Steffi Klenz, *Dagenham East*, 2004. C-type print. Courtesy the artist.

69 Steffi Klenz, *Dagenham Heathway*, 2004. C-type print. Courtesy the artist.

70 Steffi Klenz, *Beacontree*, 2004. C-type print. Courtesy the artist.

71 Tobias Ingels, *The Big Sleep*, 2002. Mini DVD. Courtesy the artist.

72 Layla Curtis, *The United European Union 2002*, 2002. Collaged EU road maps. Photo courtesy FXP Photography.

73 Layla Curtis, *The United European Union* (detail), 1999. Collaged EU road maps. Photo Marc Domage. Courtesy the collection Claudine & Jean-Marc Salomon, France.

74 Tania Kovats, *Vera*, 1997. Plaster, flocking, steel bracket. Private collection.

75 Tania Kovats, *Basalt*, 2004. Acrylic compound, polyflake, graphite, pigment, timber. Courtesy the artist.

76 Tania Kovats, *Strike*, 2001. Acrylic compound, polyflake, graphite, pigment, MDF timber. Courtesy Contemporary Arts Society, Eastbourne, UK.

77 Tania Kovats, *Basalt (inverted)*, 2004. Acrylic compound, polyflake, graphite, pigment, timber, MDF. Courtesy the artist.

78 Tania Kovats, *Schist No. 9 (black and crimson)*, 2001. Wax, pigment, oil paint, polyflake, lead, sulphate. Private collection.

79 Tania Kovats, *Pilgrim No. 2*, 1999. Pencil on paper. Private collection.

80 Helen Barff, *Rabley Farm Object – Felt Series*, 2005. Felt, metal hinge. Courtesy the artist.

81 Helen Barff , *Rabley Felt Object – Felt Series*, 2005. Felt, metal cog. Courtesy the artist.

82 Helen Barff, *Drawing done by touch in blacked out car – steering wheel*, 2004. Pencil on paper. Courtesy the artist.

83 Helen Barff, *Thames Series – Photogram*, 2005. Photographic paper. Courtesy the artist.

84 Helen Barff, *Rabley Farm Object – Photogram*, 2005. Photographic paper. Courtesy the artist.

85 Helen Barff, *Skateraw Stone, no. 26 – Photogram*, 2005. Photographic paper. Courtesy the artist.

86 Helen Barff, *Skateraw Stone, no. 18 – Photogram*, 2005. Photographic paper. Courtesy the artist.

87 Jo Broughton, *Gas Works No. 1, Canvey Island*, 2005. Panoramic photograph. Courtesy the artist.

88 Jo Broughton, *Gas Works No. 2, Canvey Island*, 2005. Panoramic photograph. Courtesy the artist.

89 Jo Broughton, *Harbour, Canvey Island*, 2005. Panoramic photograph. Courtesy the artist.

90 Jo Broughton, *Motorway, Canvey Island*, 2005. Panoramic photograph. Courtesy the artist.

91 Jo Broughton, *Seaside, Canvey Island*, 2005. Panoramic photograph. Courtesy the artist.

92 Jo Broughton, *Pylon, Canvey Island*, 2005. Panoramic photograph. Courtesy the artist.

93 James Ireland, *Let's Go Away For A While*, 1999. Glass tank, water, mirror, green plastic bag, black plastic bag, fluorescent tube. Courtesy f a projects, London.

94 James Ireland, *How and Why*, 2001. Mixed media and slide installation. Courtesy f a projects, London.

95 James Ireland, *How and Why*, 2001. Mixed media and slide installation. Courtesy f a projects, London.

96 Mauricio Guillen, *Mingle*, 2004. C-print. Courtesy f a projects, London.

97 Mauricio Guillen, *Property Line*, 1999. C-print. Courtesy f a projects, London.

98 Carey Young, sequence of video stills from *I am a Revolutionary*, 2001. Single-channel video, colour and sound. Image courtesy the artist and IBID Projects, London/Vilnius.

99 Ryan Gander, Stuart Bailey and Will Holder, *An evening with Perl Gray*, 2002. Documentation of an event at NAi Rotterdam, The Netherlands. Photo courtesy the artist and STORE, London.

100 Ryan Gander, Stuart Bailey and Will Holder, *An evening with Perl Gray*, 2002. Documentation of an event at NAi Rotterdam, The Netherlands. Photo courtesy the artist and STORE, London.

101 Ryan Gander, Stuart Bailey and Will Holder, *An evening with Perl Gray*, 2002. Documentation of an event at NAi Rotterdam, The Netherlands. Photo courtesy the artist and STORE, London.

102 Ryan Gander, *The Mechanics of Form 2 – z, x, y,*

2001. Contact print. Courtesy the artist and STORE, London.

103 Ryan Gander, *The Mechanics of Form 2 – z, x, y*, 2001. Contact print. Courtesy the artist and STORE, London.

104 Ryan Gander, *The Mechanics of Form 2 – z, x, y*, 2001. Contact print. Courtesy the artist and STORE, London.

105 Ryan Gander, *The Mechanics of Form 2 – z, x, y*, 2001. Installation – light-box, film, sheepskins. Courtesy the artist and STORE, London.

106 Ryan Gander, *Loose Associations Lecture*, 2002–06. Detail of projection from a performance by the artist. Courtesy the artist and STORE, London.

107 Ryan Gander, *Loose Associations Lecture*, 2002–06. Detail of projection from a performance by the artist. Courtesy the artist and STORE, London.

108 Ryan Gander, *In search of the perfect palindrome*, 2005. C-print. Courtesy the artist and STORE, London.

109 Carey Young, *I am a Revolutionary*, 2001. Single-channel video still, colour and sound. Courtesy the artist and IBID Projects, London/Vilnius.

110 Carey Young, *Everything You've Heard is Wrong*, 1999. Video, colour and sound. Courtesy the artist and IBID Projects, London/Vilnius.

111 Gillian Wearing, *Signs that say what you want them to say and not Signs that say what someone else wants you to say*, 1992–93. R-type colour print. Courtesy Maureen Paley.

112 Nigel Cooke, *Smile For The Monkey Man* (detail), 2001–02. Oil on canvas. Courtesy the artist and Stuart Shave | Modern Art, London.

113 David Burrows, *Green Celebration Disaster*, 2001. C-print on aluminium. Courtesy f a projects, London & Frederika Taylor Gallery, New York.

114 David Burrows, *My Favourite Personality, (non identical bubble-gum head)*, 1998. C-print. Courtesy f a projects, London.

115 David Burrows, *Twisted Firestarters, (non identical bubble-gum heads)*, 1998. C-print. Courtesy f a projects, London.

116 David Burrows, *Twisted Firestarters, (non identical bubble-gum heads)*, 1998. C-print. Courtesy f a projects, London.

117 David Burrows, *Twisted Firestarters, (non identical bubble-gum heads)*, 1998. C-print. Courtesy f a projects, London.

118 David Burrows, *Twisted Firestarters, (non identical bubble-gum heads)*, 1998. C-print. Courtesy f a projects, London.

119 David Burrows, *Modern Domestic Disaster*, 2002. Polyethylene foam. Courtesy f a projects, London & Frederika Taylor Gallery, New York.

120 David Burrows, *Snowy Landscape With Wreckage* (detail), 2002. Polyethylene foam. Collection of Wolverhampton Art Gallery. Courtesy f a projects, London.

121 David Burrows, *Fire on the 13th Floor*, 2002. C-print on aluminium with matt seal. Courtesy f a projects, London.

122 David Burrows, *Revolutionary Army of the Infant Jesus Attack*, 2002. Polyethylene foam, MIRRA card, polyboard and colourcover. Courtesy f a projects, London.

123 Nigel Cooke, *Ghost on the Happy Trail* (detail), 2004. Oil on canvas. Courtesy the artist and Stuart Shave | Modern Art, London.

124 Nigel Cooke, *Silva Morosa* (detail), 2002–03. Oil on canvas. Courtesy the artist and Stuart Shave | Modern Art, London.

125 Jake and Dinos Chapman, *Hell*, 1999–2000. Glass-fibre, plastic and mixed media (nine parts). © the artists. Courtesy Jay Jopling/White Cube, London.

126 Nigel Cooke, *Don't Mess with my Message* (detail), 2002. Oil on canvas. Courtesy the artist and Stuart Shave | Modern Art, London.

127 Nigel Cooke, *Don't Mess with my Message* (detail), 2002. Oil on canvas. Courtesy the artist and Stuart Shave | Modern Art, London.

128 Nigel Cooke, *Smile For The Monkey Man* (detail), 2001–02. Oil on canvas. Courtesy the artist and Stuart Shave | Modern Art, London.

129 Nigel Cooke, *Smile For The Monkey Man* (detail), 2001–02. Oil on canvas. Courtesy the artist and Stuart Shave | Modern Art, London.

130 Nigel Cooke, *Hitler's Bunker with Locust Horde*, 2000. Oil on canvas. Courtesy the artist and Stuart Shave | Modern Art, London.

131 Nigel Cooke, *Don't Mess with my Message*, 2002. Oil on canvas. Courtesy the artist and Stuart Shave | Modern Art, London.

132 Nigel Cooke, *Smile For The Monkey Man* (detail), 2001–02. Oil on canvas. Courtesy the artist and Stuart Shave | Modern Art, London.

133 Nigel Cooke, *Universe as Message Vista*, 2002. Oil on canvas. Courtesy the artist and Stuart Shave | Modern Art, London.

A

Acconci, Vito *Blindfolded Catching* 79–80; *80–1*
Ader, Bas Jan 79, 83; *Fall* 79
Adorno, Theodor 26, 171; and Horkheimer, Max *Dialectic of Enlightenment* 154
Afrassiabi, Shahin 28, 29, 34, 39, 60–8, 71, 89, 107, 111, 173, 206; *62, 65, 66, 67*
Agamben, Giorgio 35
Almond, Darren 9
Amsterdam 16
Arendt, Hannah 171
art galleries, growth in number of commercial contemporary galleries 12; as part of international network 14; relationships with artists 7–18; Anthony Wilkinson gallery 95; Gagosian art gallery 14; Hauser & Wirth 14; IBID Projects 95; Modern Art 95
Ataman, Kutlug *Kuba* 13
Austin, J. L. 172

B

Ball, Hugo 151
Balzac, Honoré de 128
Bankside 96
Barcelona 15, 16
Barclay, Clare 62
Barff, Helen 136–40; *118, 136, 137, 138, 139*
Basel Art Fair (at Miami) 14
Bataille, Georges 93–5, 195, 196, 197–99, 200–01; *Pousser* 94; *Bleu du Ciel* 95; anti-idealist critique 94–5, 195–99
Bauhaus 52, 65
Beckett, Samuel 82–3, 194
Beijing 16
Benjamin, Andrew 64
Benjamin, Walter 83, 85, 87, 204
Bennett, Ronan 210
Berlin 15, 16, 194
Berman, Wallace 112
Bernhard, Thomas 30
Beuys, Joseph 137, 166, 208
Biasin, Gian-Paolo 85
Blair, Anthony 16
Boulez, Pierre 30

boundaries, as a political and spatial concept 17, 125–26, 208–09; politics of 19, 147–49; corrosion of state 20, 211; as formal concept in art 49–50, 137; in urban-rural opposition 123–24; indeterminacy as challenge to 137–39
Braun, B. Vivian and Nicholson, Irene, *Beyond this Open Road* 99
Britishness, notions of national identity 99–102; renegotiation of 119–20, 124–126; landscape as symbol of 130–36, 139–45
Broodthaers, Marcel 208
Broughton, Jo 141; *141, 142, 143*
Buck, Paul 196, 201
Buñuel, Luis 186
Burden, Chris 80, 85; *Shoot* 80
Bürger, Peter 55
Burroughs, William S. 159
Burrows, David 18, 32, 178, 181–189, 210; *Fire on the 13th Floor* 185; *Green Celebration Disaster* 178–79; *Modern Domestic Disaster* 182; *My Favourite Personality* 181; *New Life* 33–4, 187–88; *Revolutionary Army of the Infant Jesus* 186–187; *Snowy Landscape With Wreckage* 183–85; *Twisted Firestarters* 181–82; *178, 182, 183, 184, 185, 187*
Bush, George W. 186
Byatt, Lucy 141

C

Cabrita-Reis , Pedro 68; *69*
Callot, Jacques 196
Campus, Peter *Interface* 79; *Optical Sockets* 79
Caro, Anthony 58, 60
Carter, Elliott 30
Cartier-Bresson, Henri 90
Carvalho, Melanie 108
Casebere, James 90
catastrophe, sense of within contemporary life 32–4, 89, 177–201 *passim*, 209–210; as

'entertainment' 185, 191–92, 194–95
Cézanne, Paul 85
Chaplin, Charlie 39, 83, 85–7
Chapman, Jake 191–92, 194, 197
Chapman, Jake and Dinos 195, 200; *192*
Charleston (Sussex) 99
Charlesworth, J. .J. 22, 47–8, 62, 205
Chelsea College of Art 48
Collins, Hannah 16
Conrad, Joseph 'Heart of Darkness' 199–200
Constable, John 98, 140
constructivism 50, 53, 58
Cooke, Nigel 32–3, 178–201, 210; *American Psycho* 193; *Cathedral of Erotic Misery* 197; *Don't Mess with my Message* 197; *Ghost on the Happy Trail* 190; *Hitler's Bunker with Locust Horde* 197; *Scandalous Magic Par Excellence* 197; *Silva Morosa* 190–91; *Smile For The Monkey Man* 197; *Universe as Message Vista* 197; *176, 190, 191, 193, 194, 195, 196, 197, 198, 199*
creative economy 22–3, 84; art as critique of 24–6, 31
Creed, Martin 209
Crewdson, Gregory 89, 90
critical regionalism 30
culture industries 10, 23–4, 31, 159; art as critique of 40, 151–75 *passim*; contemporary art as element within 170, 202–03, 207; this book's complicity with 202; annihilation of public sphere by 205
Currin, John 27
Curtis, Layla 18, 19, 122, 126–29; *The United European Union 2002* 127; *6, 22, 127*

D

Dada 54–5, 111, 115
Dalwood, Dexter 159
Davey, Grenville 58
Dean, Tacita 16

Debussy, Claude 42
Delaunay-Terk, Sonia 65
Deller, Jeremy 9
Demand, Thomas 90
Demarco, Richard 137, 139
Derrida, Jacques 165, 172, 173
design, as expansion of culture
 into economic domain
 110–11, 114, 153–59; closure of
 signification by 114–15, 145,
 159
Duras, Marguerite 30

E
Easton Ellis, Bret 193
Eisenstein, Sergei *Battleship
 Potemkin* 87
Eliot, T. S. 108–09; *The Four
 Quartets* 108; *The Rock* 109
Ellis, Robert 25; *25*
El Lissitzky 39; *Prouns* 64
Emin, Tracey 107
European Union (EU; EEC),
 movement of citizens 16,
 211; imagination of 126–29

F
Forster, E. M. *Howard's End* 100
Foster, Hal 55, 65, 173
Freedman, Carl 50

G
Gabo, Naum 58
Gainsbourg, Serge 156, 158
Gander, Ryan 18, 24, 25, 152–64,
 170, 173, 175, 208; *Brief for a
 12-inch Record Cover* 153–56;
 'mitim' 153, 163–64; *Brown
 Corduroy Lounge Photo
 Shoot* 156–58; *The Mechanics
 of Form* 156–57; *Loose
 Associations Lecture* 161; *152,
 153, 156, 157, 162, 163*
gentrification, in the wake of
 artists 95–7
Gersht, Ori 69–74, 107; *70, 71,
 72–3, 74, 75*
Gibbons, Stella *Cold Comfort
 Farm* 99
Gillick, Liam 9, 156
Godard, Jean-Luc 157
Goya, Francisco 196
Greenberg, Clement 38, 160

Guillen, Mauricio 147–49, 209;
 3–0 31; *Mingle* 147–48;
 Property Line 147; *33, 148, 149*

H
Habermas, Jürgen 40, 55, 180,
 186, 204, 206, 210
Hammond, Paul 196
Hansen, Miriam Bratu 85
Harding, Alexis 27, 29, 40, 42–8,
 49, 50, 53, 60, 70, 74, 151, 206;
 26, 43, 44, 45, 47
Hardy, Anne 89–96, 151, 209;
 Drift 90, 92, 93; *Lumber* 92;
 Swoop 92; *Untitled III (Office)*
 92, 94; *Untitled IV (Balloons)*
 93, 177; *91, 92, 93, 94, 95*
Harrison, Paul (see also Wood,
 John and Harrison, Paul) 82
Harvey, David 128
Heartfield, John 110, 111
Hegel, G. W. F. 204
Helsinki 16
Hepworth, Barbara 27, 39, 58,
 59, 130, 132
Hesse, Eva 48, 54
Hesse, Hermann 159
Hirst, Damien 38
Höch, Hannah 111
Horn, Rebecca *Keep those legs
 from cheating each other* 80
hospitality 188–89, 198–99
humour, use of by
 contemporary artists 82–4
Hussein, Saddam 181
Hutchinson, Mark 116

I
Ingels, Tobias 13, 124–25, 129; *14,
 125, 144, 146*
Iraq 180, 200
Ireland, James 141–46, 209; *How
 and Why* 145; *Let's Go Away
 For A While* 144–45
Ireland, Patrick 42, 46

J
Jameson, Fredric 78, 110–11, 151, 186
Jennings, Michael 83
Jensen, Alfred 42
Johnson, Ray 110
Jonas, Joan *Organic Honey's
 Visual Telepathy* 79

Jones, Kim 85
Judd, Donald 38

K
Kafka, Franz 151
Kandinsky, Vassily 50–3
Kapoor, Anish 130
Kaufman, Robert 26
Keaton, Buster 83, 85
Kelley, Mike 159
Keserü, Károly 48; *50*
Kilimnik, Karen 27
Klee, Paul 108
Klenz, Steffi 19, 120–24, 129, 209;
 23, 121
Kovats, Tania 18, 19, 122, 130–36,
 140, 209; *Basalt* 131; *Pilgrim
 No. 2* 135; *Rocky Road* 135;
 Schist 134; *Strike* 133; *The
 British isles* 135; *Vera* 130;
 20, 21, 131, 132, 133, 134
Kraus, Karl 162, 206
Krauss, Rosalind 41, 42, 77

L
Lambie, Jim 62
Latour, Bruno 11
Laurel, Stan and Hardy, Oliver 83
Le Corbusier, Charles-Edouard
 Jeanneret 39, 56, 62
Léger, Fernand *Ballet
 mécanique* 84–5
LeWitt, Sol 42, 48
Lloyd, Harold 83, 85
London, as model of hospitality
 211; as multi-cultural city
 7–8, 10–11; contrast with
 rural England 97–9; global
 economy, relationship with
 11–12; international origins
 of artists at work 13;
 Barbican Centre 161;
 districts within: Bethnal
 Green 34; Bloomsbury 99;
 Bow 97; Chelsea 99;
 Hackney 7, 13, 34, 95–7, 99;
 Hackney Wick 16; Hoxton
 194; Stoke Newington 7;
 Stratford 7; Vauxhall 70
Long, Richard 119, 130
Lucas, Sarah 38, 120; *Sod You Gits*
 38; *39*
Luther, Martin 186, 187

M

Madrid train bombings 180
Maison Cubiste 65
Malevich, Kasimir 39, 51
Mandel, Ernest 151
mapping, as art 18–9, 34; as
 metaphor for changed
 political and social
 relations 126–29
Martin, Agnes 42, 46
Martin, John 98
Marx, Karl 128
mass culture, as art 38–9, 154,
 158–59, 206; assumed
 syntactical preeminence of
 67–8, 159–60, 111;
 commoditization of dissent
 53, 182, 192; creation of niche
 markets 154; invocation of
 subjective autonomy 152;
 spurious authenticity
 within 154–56, 158
Matta-Clark, Gordon 68, 79, 83;
 Clockshower 83
McCarthy, Caroline 24, 109–17,
 208; Making Something
 Beautiful 116; Souvenirs
 (Blue) and Golden Wonder
 116; 109, 112–13, 114, 117
McEwan, Ian 210; The Cement
 Garden 106
McQueen, Steve 16, 18, 83
Mercier, Mathieu 68
Michael, George 181
modernism, celebration of
 landscape in British
 99–100, 139; crisis of
 organization as theme 47;
 disintegration of subject
 within 83–4; end of 38, 55;
 formalism 60, 62;
 rhetorical aspirations of 42,
 46; entropy and process as
 theme 48, 54, 79–81, 94–5;
 forms of abstraction 51–3,
 179; mysticism within 42,
 48; tension between
 rational and spiritual
 within 207; unification of
 art and life, aspiration for
 55; utopianism within
 53–4, 60–1, 63, 171
 characteristics of, revived:

aesthetics as critique
 27–30, 63–4, 203, 206;
 alienation as modernist
 experience 13, 83;
 appropriation and
 assemblage, as strategies
 65–8, 110–12, 179, 206;
 autonomy, of subject 30,
 61; autonomy, of work of art
 30, 40; critical reflection or
 acuity, capacity for 30, 35,
 203; grid as formal
 structure 41–6, 70–4;
 latency or potential, within
 abstract and figurative art
 19, 50–3, 64
modernity, as incomplete
 project 40, 61, 204; as
 flawed utopia 70–4,
 103–08; as regulation of
 subjectivity 84; failure of
 93, 105; schism within 180
Moholy-Nagy, László 56;
 Lichtrequisit 56
Mondrian, Piet 39, 46
Monk, Jonathan 16
Moore, Henry 130
Moretti, Franco 192–93
Morris, Robert 38, 48, 54, 61
Morton, Tom 104

N

Nash, Paul 99, 139
Nauman, Bruce 39, 79, 82;
 Bouncing Two Balls between
 the Floor and Ceiling with
 Changing Rhythms 82;
 Going Around the Corner
 Piece 79
Neudecker, Mariele 122
Newman, Barnett 46–7
New York 13, 16, 194
Niemeyer, Oscar 63
Nietzsche, Friedrich 195, 196
Nonas, Richard 83

O

Orta, Lucy 16

P

painting, liberation from
 responsibility for
 representation 189–90, 203

Pane, Gina 85
Paris 15, 16
Peri, László 51
Peri, Peter 29, 39, 48–51, 53, 60,
 64, 206; Rotary 48; 49, 51, 52
Pettibon, Raymond 159
Peyton, Elizabeth 27
photography, constructed 89–90
Picasso, Pablo 85
Pitchforth, Roland Vivian 98
Pollock, Jackson 44
Pope, Nicholas 130
Prince, Richard 38

R

Raban, Jonathan Soft City 129
reification 26–7, 53, 64–5
Reinhardt, Ad 46
Reitveld, Gerrit 64
Richter, Hans 46
Rohm, Robert 48
Rothko, Mark 46
Rothschild, Eva 27, 29, 34, 39, 53,
 55–61, 173, 206; Burning Tyre
 56; Early Learning 56; Fort
 Block 56; Mass Mind 56;
 Night of Decision 56; Your
 Weakness 56; 28, 57, 58, 59, 60
Royal College of Art (RCA) 120, 147
Ruf, Beatrice 54
Ryman, Robert 160

S

Salvetti, Guido 42
Sandback, Fred 48
Saret, Alan 54
Sarraute, Nathalie 30
Schwartzkogler, Rudolf 85
Schoenberg, Arnold 85
Schwitters, Kurt 110
Second World War 54, 55
Serra, Richard 48, 54, 60, 79, 85,
 86, 87; Hand Catching Lead
 80, 85; Hands Scraping 80;
 Verb List 81
Shaw, George 28, 34, 103–09,
 209; 'Ash Wednesday' 108;
 Scenes from the Passion:
 Back of the Club and the
 Bottom of the Steps 106;
 Scenes from the Passion: The
 Burnt Tree 104; Souvenirs
 103; Scenes from the

LIVERPOOL JOHN MOORES UNIVERSII
LEARNING SERVICES

Passion: The Way Home 103;
 2–3, *101, 102, 104, 105, 106*
Sherman, Cindy 38, 159, 178–79
Sickert, Walter 98
signification, critique of within
 mass culture 160–75
 passim 207–8; critique of
 within society of the
 secretariat 164–75 *passim*
 207–8; incompetence of
 sign within as revelatory
 116–17, 151, 156–58, 162;
 within public sphere
 162–64, 166–68, 173,
 204–05
Sinclair, Iain 120
situationism 120, 161, 162, 200
Smithson, Robert 38, 48, 122, 123
Starr, Georgina 107
St Ives (Cornwall) 11, 99
Stratford-upon-Avon 16
Stravinsky, Igor 85
structural violence, implicit
 within capitalist modernity
 31, 34, 181, 188–89, 199–200,
 210; in colonialism 199–200
suburbia 103, 107–08
surrealism 54–5

Surya, Michel 198
Svevo, Italo 85; *Confessions of
 Zeno* 87

T
Tallinn 18
Tate Britain 12
Tate Modern 140
Tatlin, Vladimir 64
Taylorization 84
Tervet, Nahum 68
Turner, J. M. W. 132, 140
Turner Prize 18
Tyson, Keith 9

V
Van Dongen, Kees, 159
Vaneigem, Raoul 200
Védrine, Hubert 19
veneer, as pragmatic
 economic and social
 practice 92–3, 117
Vertov, Dziga 157

W
Wall, Jeff 89
Wearing, Gillian 175; *174*
Webb, Gary 62

Whitechapel Art Gallery 56, 60,
 61, 64, 147, 169; 'Early One
 Morning' 56, 61–2
Whiteread, Rachel 188
Williams, Dr Rowan 188
Wood, John (and Harrison, Paul)
 29, 39, 77–87, 207; *3-Legged*
 79–80; *Plastic Bag* 82;
 Hundredweight 80–1, 83,
 85–7; *76, 78, 82–3, 86*
Woods, Clare 19, 97–100, 102–3,
 119, 209; *89, 98, 99, 100*
World Trade Center (WTC),
 attack on 33, 180, 181, 185
Wright, Patrick *On Living in an
 Old Country* 97

Y
Young, Carey 24, 25, 164–75, 208;
 Disclaimer 31, 164–65;
 *Everything You've Heard is
 Wrong* 166–68; *I am a
 Revolutionary* 166, 171–73;
 Optimum Performance 166,
 169–71; *24, 32, 150, 167, 168*

Z
Zittel, Andrea 68